Narrative Design

A 50 Year Perspective
by Visual Storyteller
Kit Hinrichs

Introduction by
Steve Heller

Edited by
Delphine Hirasuna

to Nancy

Kit Hinrichs

NARRATIVE DESIGN · A FIFTY YEAR PERSPECTIVE · 1973 50 2023

CONTENTS

He calls it "narrative design"; I call it "visual story-telling"; neither term does justice to the breadth of the work that is collected in this 50th anniversary retrospective. Kit Hinrichs' design is the confluence of visual – typographic, photographic and illustrative – elements fused together either to tell one or more stories or provide a preview of stories to come. It is characterized by elegant exuberance. But it is also a reminder of the visceral power resulting from perfect scale and composition. Hinrichs' work reminds me of when five decades ago I first saw his work in an Art Directors Club exhibition, I dreamed that one day I'd have the skill and talent to make words and pictures on paper come alive just like he did (ultimately, I gave up in deference to those, like Kit, who really do it so much better).

y challenge, in the Hinrichs tradition, was to make a flat page into a three-dimensional object, an idea that originated for me with a childhood passion for the old dioramas I saw at the Museum of Natural History. More esoterically, I had a fascination with how drop shadows allowed for illusions of dimensionality. Hinrichs' signature work recalls those museum vitrines and inspiring cabinets of wonder filled with incredible objets d'art and more. Using dimensional things as components of graphic design is the kind of illusionary magic akin to the work of Renaissance masters of trompe l'œil, although rather than using paint and brush, Hinrichs' tools are crisp photographs and dimensional shadows, unique letterforms (some made from objects) and the sense that the paper on which they appear is a window rather than a wall. He is a naturalist in a sense. What, however, at times looks natural or easy is the result of his exceptional discipline rooted in strict precision. In this era of expressionistic and brutalist design-making, his orderly complexity has not lost its appeal.

Yet order does not prevent accidents and surprise. For Hinrichs, magic is in the details – and he seems to love including small narrative-enhancing details in almost everything he makes. Hinrichs' work is not

loaded with secret meanings and stylistic agendas – there are no hidden messages – clarity is essential for viewer engagement. If he cannot achieve it with type alone, his choice of illustration is routinely flawless.

Hinrichs bridges two stylistic categories that I call modernism and eclecticism. The former goes back to the pristine simplicity of the International Style. The latter is the pleasure of manipulating vintage arts and crafts to contemporary products. One aspect of his work is a forward-thinking synthesis of exactitude and abstraction influenced by the Bauhaus (i.e., Paul Rand, Lester Beall); the side is a sense of historical revival influenced by the likes of Milton Glaser or Seymour Chwast. Between these two poles, Hinrichs' middle ground is the synthesis of both into what arguably could be slickness, but is more an associative juxtaposition, printed with attention to quality on the best possible papers.

With virtually everything Hinrichs produces, the guiding principle is more is more is more. He is passionate for the image, enthralled by visual relationships and obsessed with making his compositions "just so." I believe that what distinguishes Hinrichs' work is what he leaves in: many designers start with more and end with less. Hinrichs' narrative design is not a process of weeding or reducing as it is about adding the perfect ingredients of this and that.

We are all the accumulation of our own unique life experiences. They shape our lives, create the lenses through which we view the world and give us the passion that drives us. Looking back on my 50-year career, several such experiences come to mind. They inform what I call "narrative design." The following notes are observations that have guided me in my professional life. I hope they give you a window into the mind of a visual storyteller.

Drawing from life. To be an effective designer, it helps to be an active observer of life. Like most designers, I have drawn since I could hold a crayon. From cowboys and Indians to outer space and unexplored jungles, drawing gave me a visual language that allowed me to communicate ideas and experiences that words alone could not accomplish. Now, the images I often recall are gathered from life's experiences, be it '40s comic books, a Renaissance painting, movie titles, a piece of folk art, '60s rock n' roll posters or graffiti art, they are all grist for my graphic mill.

Making the intangible tangible. The ability to visualize and draw ideas in meetings can make abstract ideas tangible and thoughts concrete. It is essential for ensuring your clients and creative colleagues are all on the same page and lets you continue to move more effectively toward a common goal.

As a child, I was lucky to have the opportunity to join my father at Warner Bros. Studio in Burbank, California. He was a sound technician. I vividly remember the lot, where multiple stories were being created before my eyes. Actors to script girls, directors to key grips, wardrobe assistants to make-up artists and a matrix of people were all working together to create a single cohesive and engaging narrative. It was a window into my future as a narrative designer.

A **good education – formal and informal.** At ArtCenter College of Design, I was exposed to a unique collection of professors whose combined experiences and points of view opened my eyes to a world that, as an 18-year-old North Hollywood kid, I couldn't have imagined. Hues, values, scale, texture, the golden section, typography as imagery, variations on a theme, biomimicry, serif, sans serif, "fast and slow" curves, chiaroscuro and typographic hierarchy, to name just a few lessons that were new to me.

An early mantra from my instructors was, "Design is not only about style, it's about ideas." It is often easier to jump ahead and use the latest typeface, hottest photographer or illustrator or fashionable technique for an assignment, before you have solved the basic problem with the right idea. Style and technique are the tools to express good ideas, not a substitute for them.

Midwway through college, I had the opportunity to work in what was then West Germany at a boy's youth home. This was not a design gig, but a chance to do meaningful community service. It became a pivotal moment in my life and career: being exposed to, and living in, a new culture with new customs, foods, language, music, media and politics – all in a divided country in the midst of the Cold War. What better view into an evolving world culture.

I have been fortunate to be in the right place at the right time most of my career, but it was the skills I learned early in life that gave me the ability to recognize opportunities when they arose and the confidence to shift directions in order to capitalize on them when they occurred. In my professional career, I have been an entry-level designer, freelance illustrator, a partner in several design organizations in New York and San Francisco, exhibition and environmental designer, author and founder of several organizations, and yet I always acknowledge how my diverse informal education coupled with a rigorous formalized design education was the Rosetta Stone for any successes I've accomplished.

Designing responsibly. Unlike our fine art colleagues, we are judged by a different yardstick, outside of ourselves, in a public arena. Designers are charged with the commercial success of our work in addition to the visual responsibility we have to our culture. We are often asked to wear several hats in our profession – salesman, confidant and teacher – to clearly communicate a service, product, event or concept usually not of our choosing. A worthwhile challenge. The designer's conundrum is to effectively use our skills for our clients' needs without neglecting our equally important ethical responsibility to create a landscape that always improves and never denigrates our world visual culture.

Making content accessible. To me, access to knowledge may need to be accompanied by an obscure fact, a humorous quote or an engaging metaphor; presented in an interesting, authentic voice, and linked to an arresting image in order to provide an opportunity to open a dialogue with the audience. People need to feel comfortable, and you need to earn their trust before they allow you into their personal emotions.

When I began my career, disruptive technological innovations began to alter the profession on a fundamental level. The discipline rapidly evolved from a handcrafted aesthetic and took a revolutionary digital direction. Although I remain primarily a practitioner of tangible design, it has been invigorating to experience and work in the field at a time of monumental change. When I look at the work being done by the current generation of designers, I see the communication boundaries toppling, replaced by something new, unprecedented, raw and thrilling. The work of tomorrow's trailblazers is never truly finished – not while the rest of our collective design history remains unwritten.

Kit Hinrichs

Principal + Creative Director of Studio Hinrichs, San Francisco

TYPE AS IMAGE, IMAGE AS TYPE

The basic structure of language is both

the words and how we graphically express them.

The choice of the typography, calligraphy

or lettering we use enhances the story, makes

the messages more visually engaging

and gives the language the ability to emphasize

the emotion in the words we use.

Ten Faces
Poster

Created as a fundraiser
for Inneract Project,
an educational design
program for inner city teens,
this poster superimposes
ten typefaces over one
another, using five colors
to turn the shapes and
fragments into an abstract
design. The image was
my unconscious homage
to Jasper Johns numbers
series *0 through 9*.

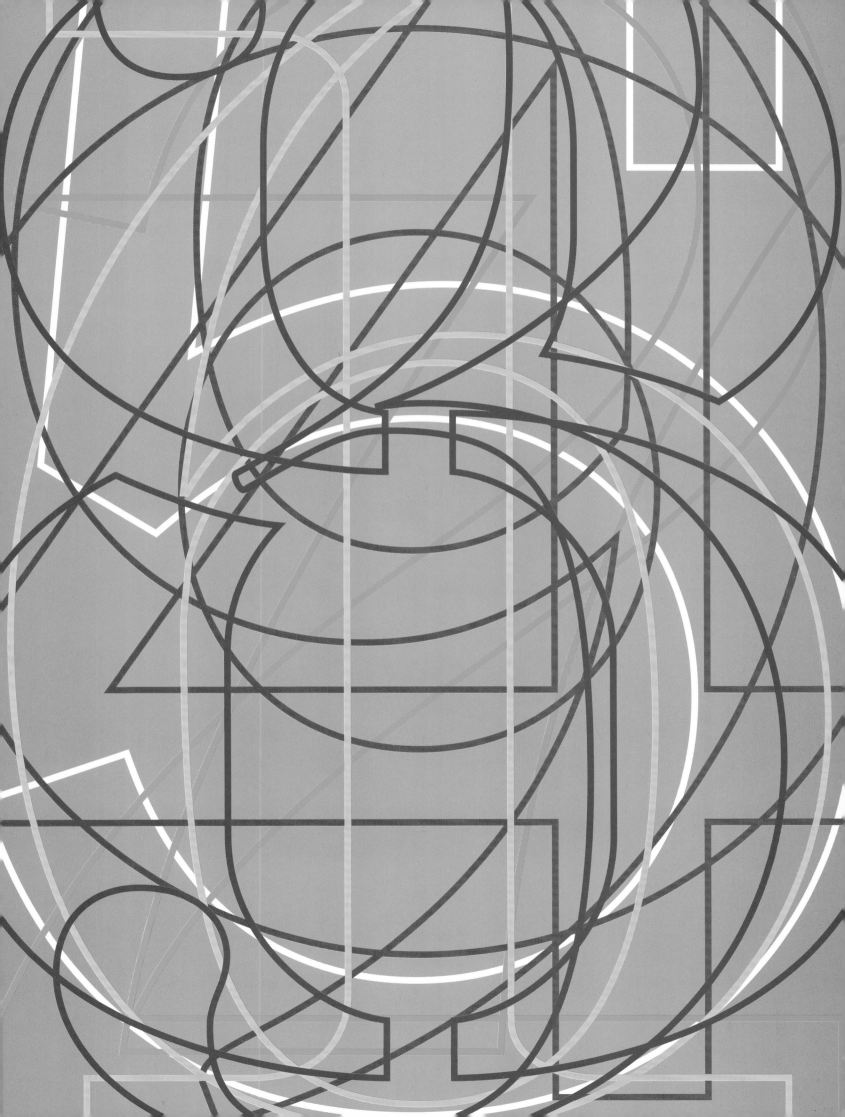

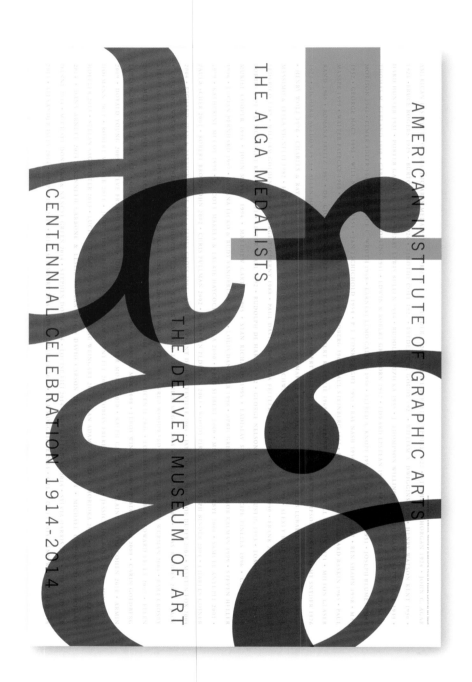

The poster in the image contains the following text:

AMERICAN INSTITUTE OF GRAPHIC ARTS

THE AIGA MEDALISTS

THE DENVER MUSEUM OF ART

CENTENNIAL CELEBRATION 1914-2014

Alphachrome Alphabet Cards

This set of alphabet cards was inspired by 19th and 20th century illustrated alphabet postcards. These cards were all created with patterns found in international cultures.

AIGA Medalist Centennial Poster

Typography is such a strong element in all graphic design, it seemed obvious to celebrate the AIGA's 100th anniversary poster with typography as the main visual ingredient. The typographic pattern behind the obstructed "AIGA" is created with the names of the first 100 years of medalists.

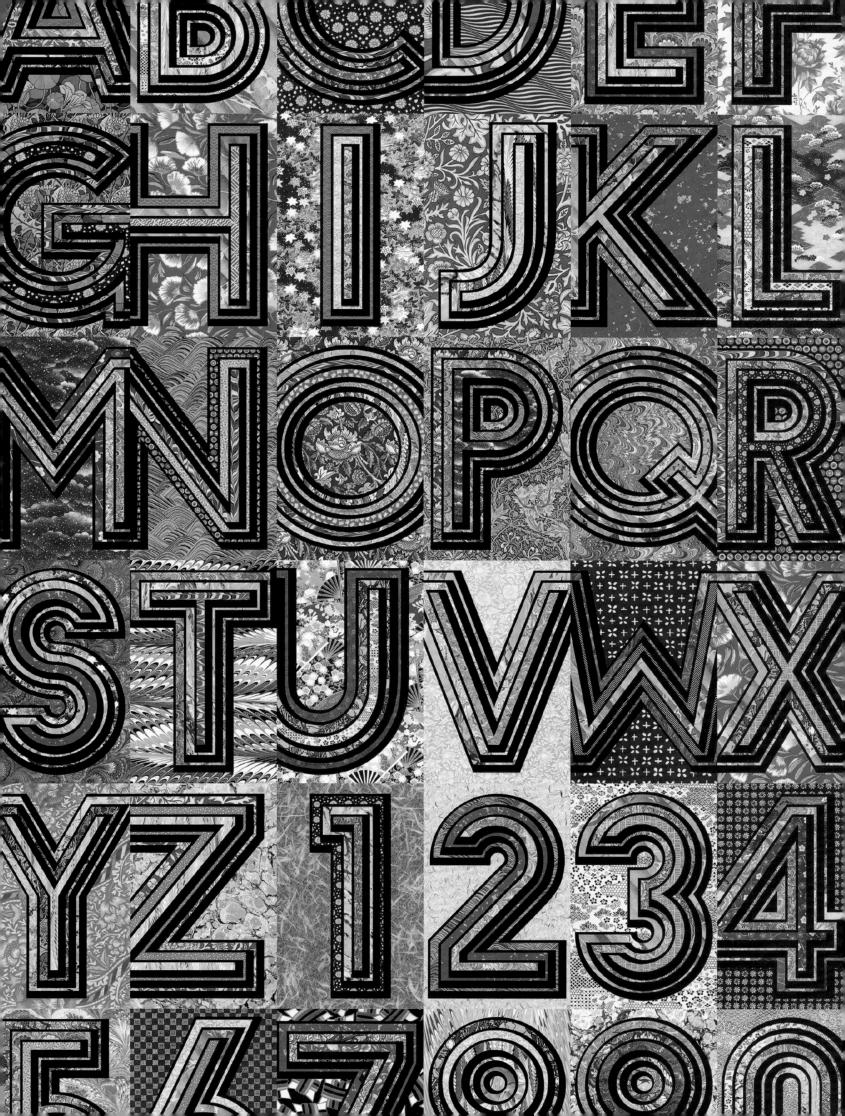

AIGA SF

Alphabetatalia

Stamp

In 2000, the AIGA SF invited dozens of San Francisco area designers to create a postage stamp based on philatelic terms. I was happy to be given "Invert" (stamps accidentally printed upside down) because it presented a great opportunity to visualize the term using only typography. All of the AIGA stamps were displayed in a permanent exhibition, designed by Michael Osborne, at the USPS National Headquarters in Washington, D.C.

IN·VERT:
TO TURN
INSIDE OUT
OR UPSIDE
DOWN

32¢

Potlatch 5

Call For Entries

Poster

For decades, corporate financial annual reports were the mainstay of most graphic design offices, as well as for paper and printing companies. Potlatch Corporation, which made fine printing papers, sponsored one of the most prestigious annual report competitions, and asked us to create a poster for their fifth annual contest. The presentation of historic stock certificates together with printer "make-ready sheets" set the tone for the competition.

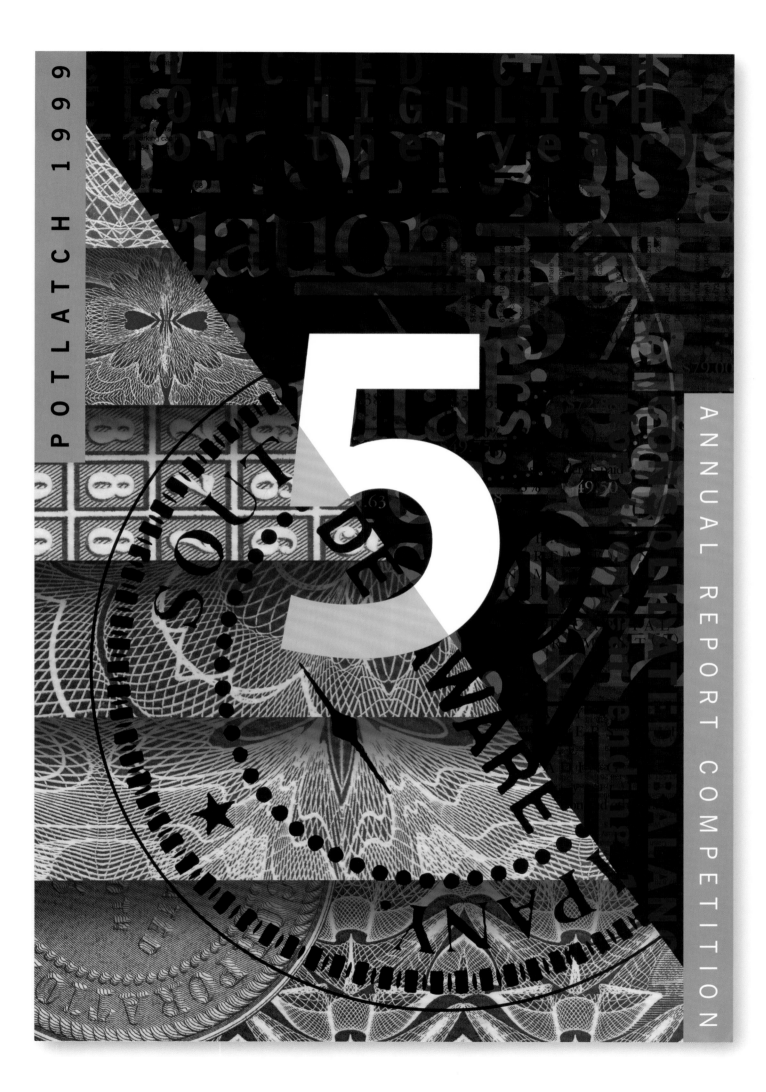

AIGA
Presidential
Vote Poster

In 2000, the AIGA
launched a "Get Out the
Vote" campaign to urge
Americans to participate
in the electoral process.
Graphically shouting
out "VOTE" allowed the
contrasting quote to have
more importance.

A public service initiative of the American Institute of Graphic Arts. Presented by Yupo synthetic paper products.

Bad politicians are sent to Washington by good people who don't vote.

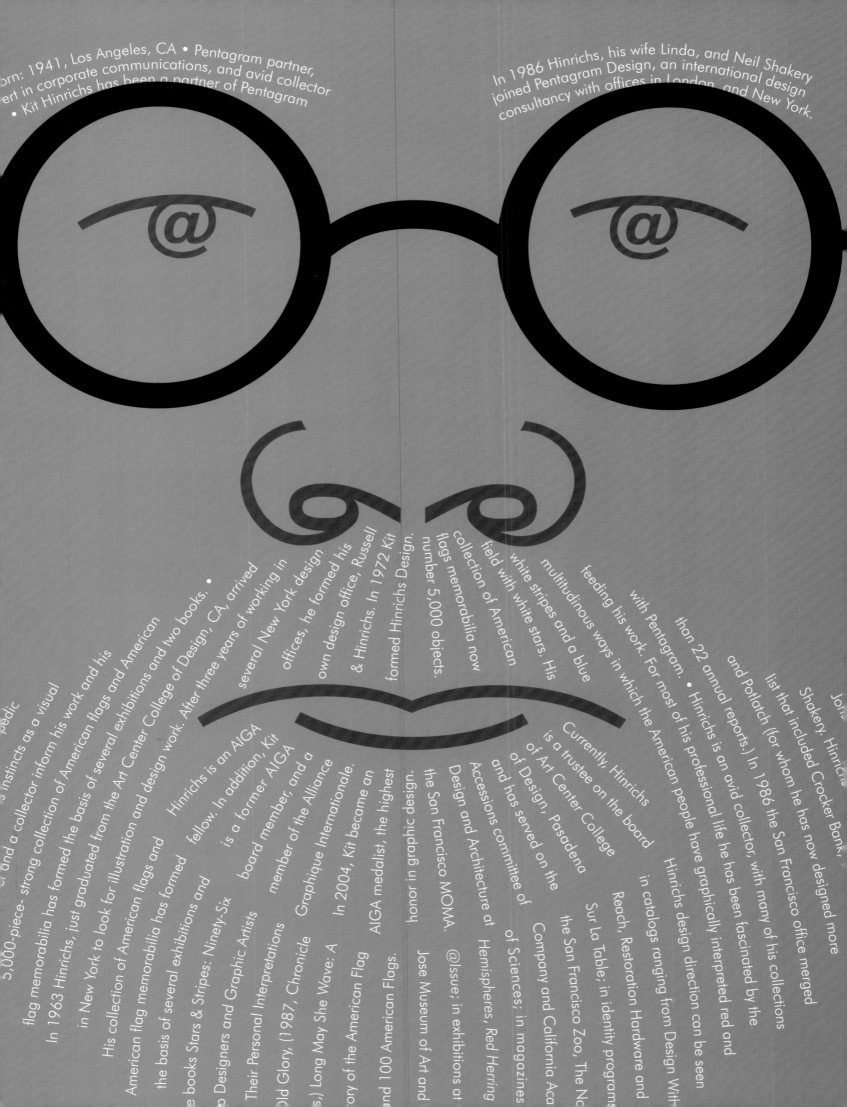

Golden Gate *Girder* Typeface Poster

The rivets and beams of San Francisco's Golden Gate Bridge inspired a special typeface, Girder, printed in international orange, for the bridge's 75th anniversary. Along with making a special poster, the individual letterforms were printed as key chains for sale in the Golden Gate Bridge Welcome Center.

· GOLDEN GATE GIRDER ·

A B C D E
F G H I J K
L M N O P
Q R S T U
V W X Y Z
1 2 3 4 5
6 7 8 9 0

CREATED FOR THE 75TH ANNIVERSARY
OF THE GOLDEN GATE BRIDGE 1937–2012

Storyteller's *Art* Exhibition Poster

For a retrospective of my work at Sacramento State University and ArtCenter College of Design, I chose to create my own self-portrait out of typographic elements. My biography was detailed in my beard and eyebrows. Gloria Hiek created this unique protrait.

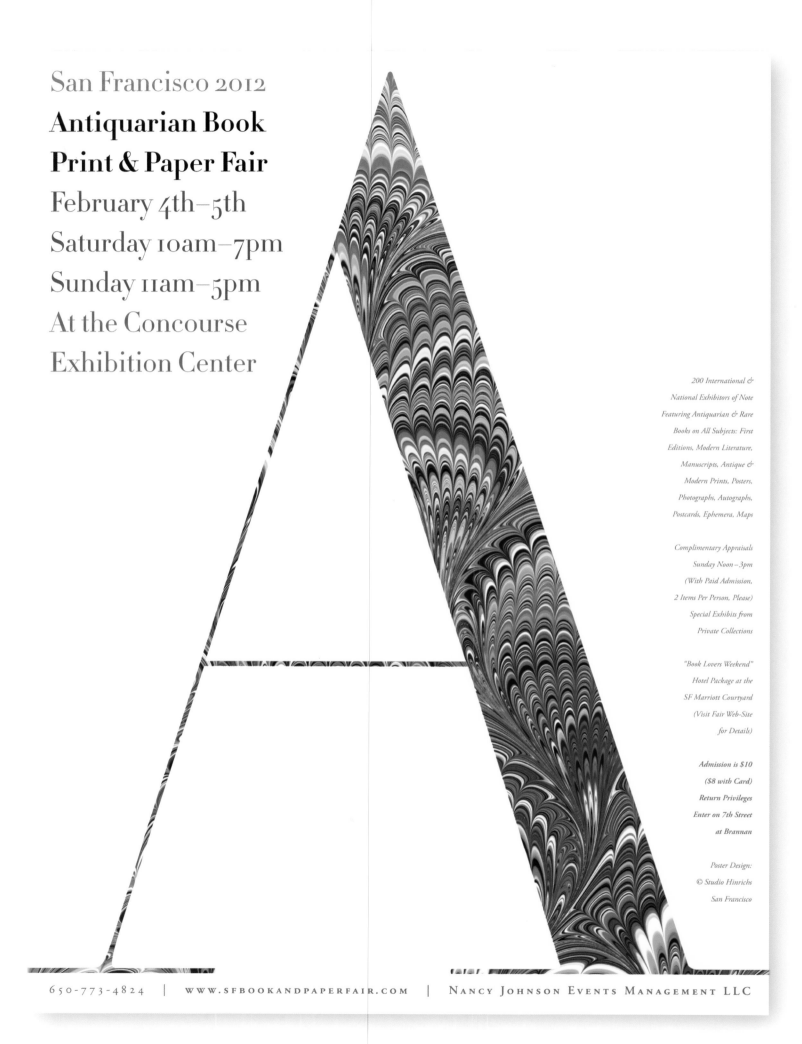

San Francisco 2012
**Antiquarian Book
Print & Paper Fair**
February 4th–5th
Saturday 10am–7pm
Sunday 11am–5pm
At the Concourse
Exhibition Center

*200 International &
National Exhibitors of Note
Featuring Antiquarian & Rare
Books on All Subjects: First
Editions, Modern Literature,
Manuscripts, Antique &
Modern Prints, Posters,
Photographs, Autographs,
Postcards, Ephemera, Maps*

*Complimentary Appraisals
Sunday Noon – 3pm
(With Paid Admission,
2 Items Per Person, Please)
Special Exhibits from
Private Collections*

*"Book Lovers Weekend"
Hotel Package at the
SF Marriott Courtyard
(Visit Fair Web-Site
for Details)*

*Admission is $10
($8 with Card)
Return Privileges
Enter on 7th Street
at Brannan*

*Poster Design:
© Studio Hinrichs
San Francisco*

650-773-4824 | WWW.SFBOOKANDPAPERFAIR.COM | NANCY JOHNSON EVENTS MANAGEMENT LLC

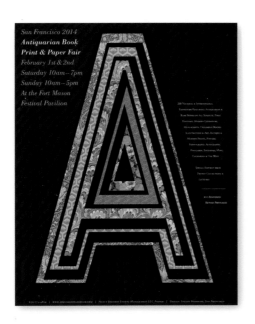
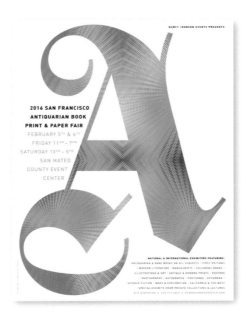
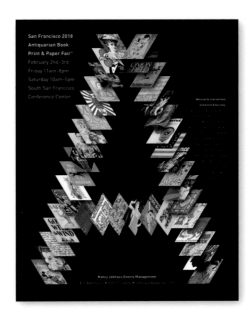

San Francisco Antiquarian Book Fair Posters

Haunting antiquarian book fairs and collectibles markets to feed my obsession with historical ephemera led me to meet

promoter Nancy Johnson who asked if I would develop posters, flyers and postcards for the next antiquarian

book show. I have continued to do so for the biannual event, focusing on a series of "A's" that combined a contemporary

look with historical imagery, a 21st century color palette and international print patterns.

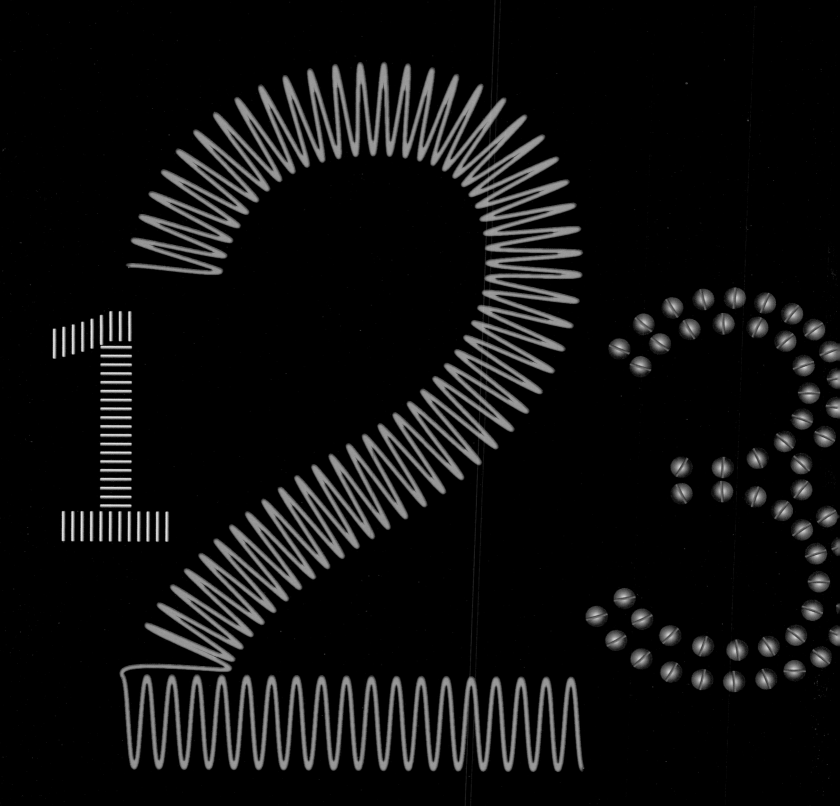

Sappi *The Standard 6*
***Binding* Numbers**

For the past decade, my studio has developed an educational series on printing and design called *The Standard* for Sappi papers. For the volume on bindery techniques, we presented pros and cons, tips and demonstrations of different binding materials – including staples, stitching, Chicago screws, spiral, rivets, etc. Designer Dang Nguyen simulated the numbers for each chapter were created out of actual materials to continue the theme.

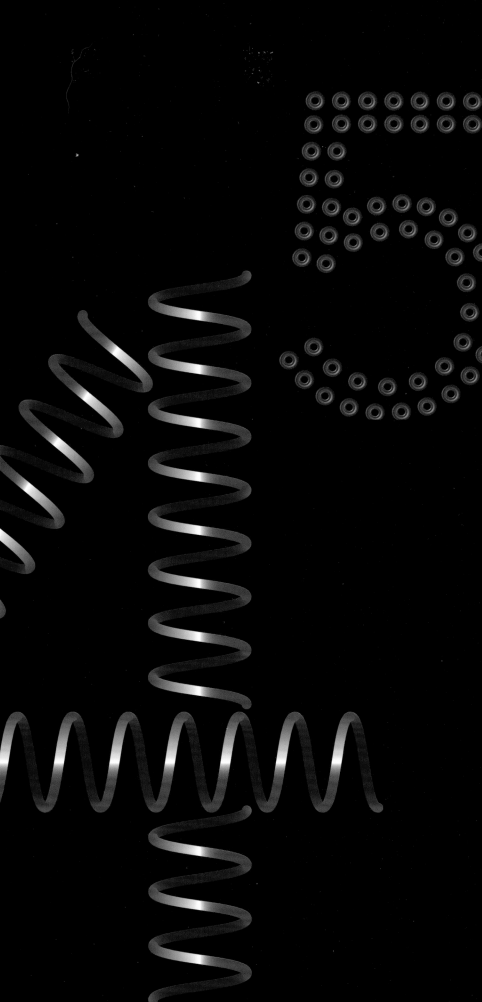

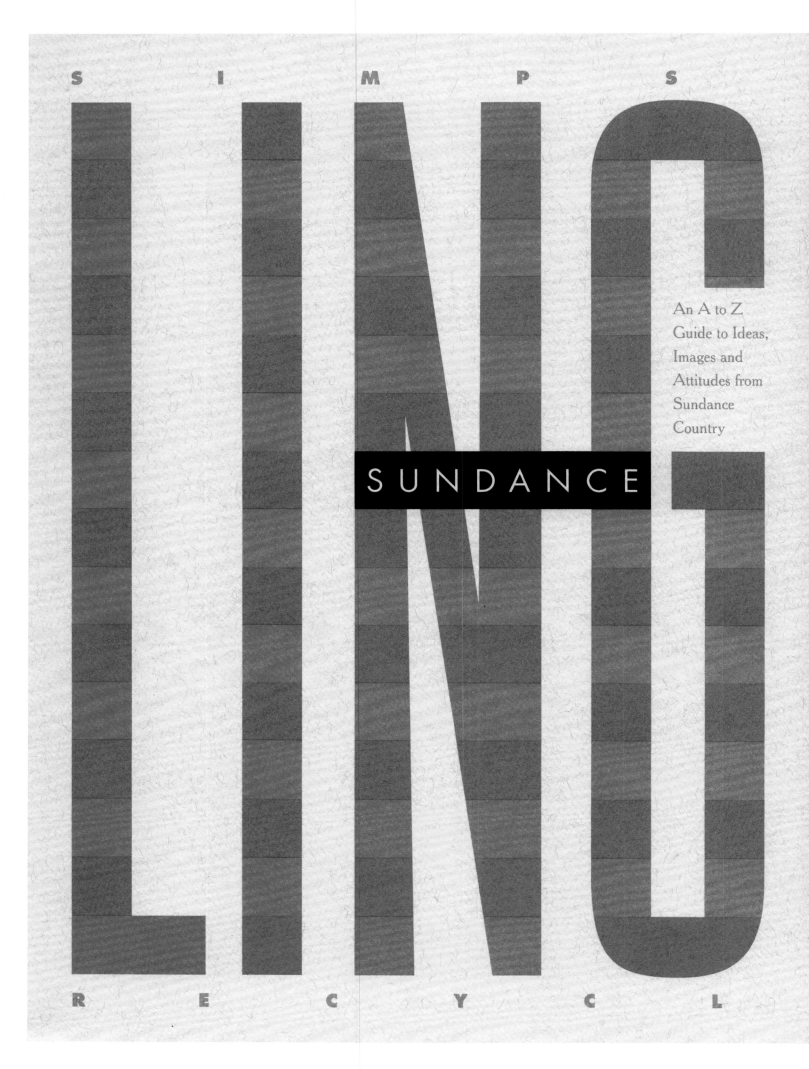

SUNDANCE

An A to Z
Guide to Ideas,
Images and
Attitudes from
Sundance
Country

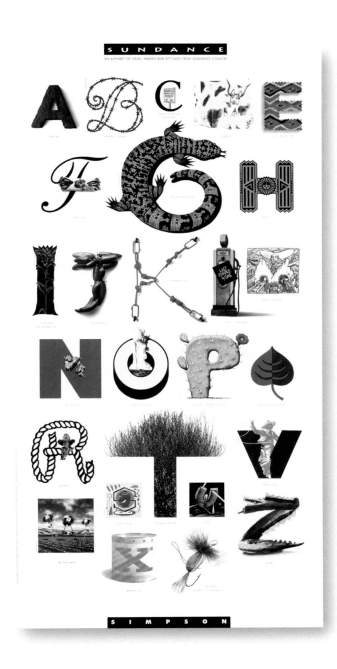

Simpson Paper
Sundance
Promotional
Book and Poster

Simpson Paper's
Sundance brand had a
color palette and textures
that evoked the spirit of
the American Southwest.
To introduce Sundance's
new redefined colors
and recycled content, we
created a book titled
Lingo plus an alphabet
poster with the help of
many designer, illustrator
and photographer friends.
The letterforms give an
A to Z look to descriptive
words of the region,
from Adobe to Zuni.

Applied Graphics Technologies Calendar

Right: A Pentagam colleague invited several designers to illustrate

Applied Graphics 1992 calendar with portraits of notable literary figures.

I chose the 19th century author Herman Melville and hand-wrote the first

sentences of his classic novel *Moby Dick* to illustrate his portrait.

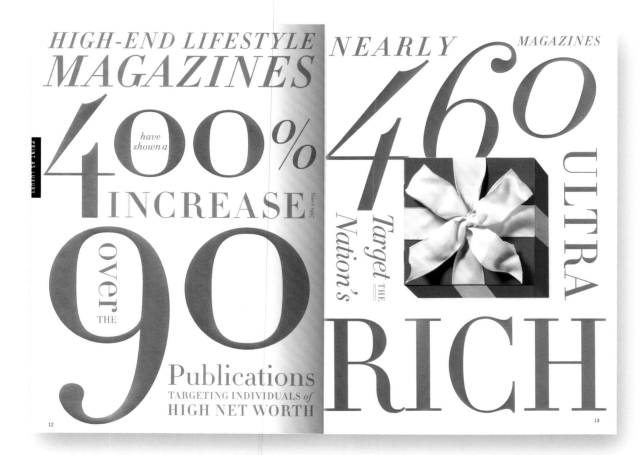

Sappi Paper Promotion

Above: To elevate the elegance of a data-driven promotion for magazines,

we used the oversized Didot typeface in silver to set the stage and represent luxury to a

well-heeled, sophisticated marketing audience.

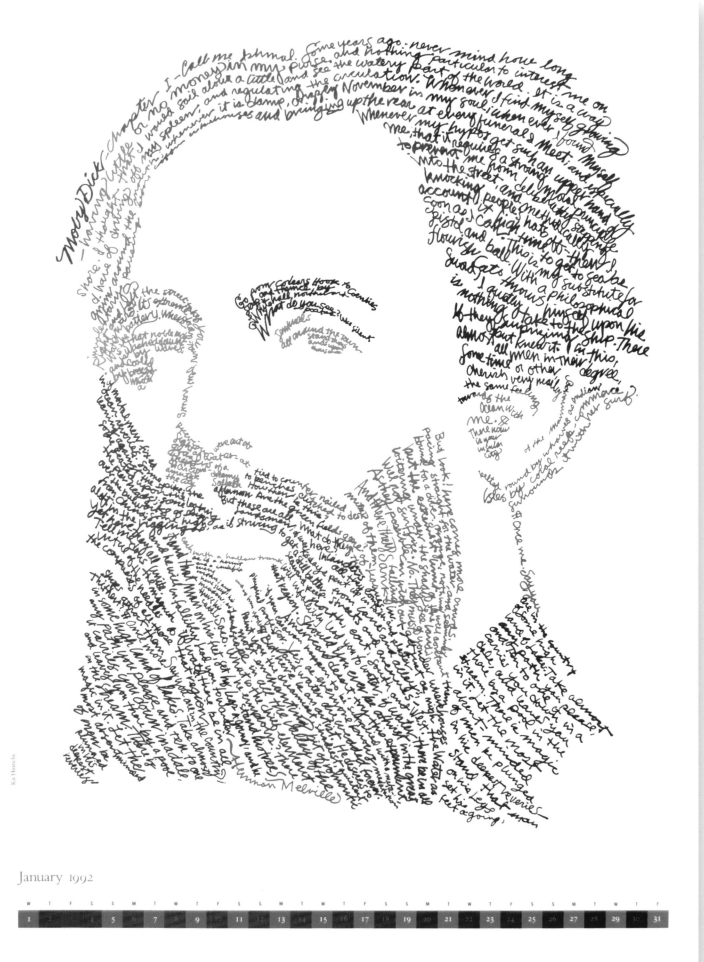

January 1992

365 Typography Calendar

The branding of a typographic calendar was simply achieved through the superimposition of all the typefaces from an individual year on the cover.

This solved two problems: the consistent branding of the 365 Calendar and the definition of each individual year.

365 Typography Calendar

As the use of unique typefaces moved from the hands of the graphic designer "priesthood" into the realm of everyone who uses type on their personal computers, we wanted to make the public aware of the beauty and uniqueness of different typefaces. Each month included a detailed caption with information about the type designer, the historical period and technology of the era alongside major national holidays.

Potlatch
20th Century Design Series

By using the card game Blackjack to imply the 21 different weights found in the typeface Univers, we engaged the viewer in a game of wordplay and broadened their understanding of the word beyond its literal meaning.

BlackJack!

CHOC

@Issue: *Journal of Business & Design*
***Chocolate* Spread**

This headline was for an article on Joseph Schmidt
gourmet chocolates printed in *@Issue*, a design journal
that writer Delphine Hirasuna and I founded together
with the Corporate Design Foundation. Substituting the
"O's" in the word "chocolate" with truffle pieces from
Schmidt's array of fine candies was a simple and effective
way to integrate the subject in the headline.

THE OFFICIAL (AND UNOFFICIAL) GUIDE TO USC LAW SCHOOL

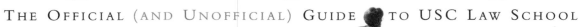

I worked with one of
my favorite illustrators,
Jack Unruh, to combine
words and images into
the cover of New York's
skyline for this Art
Directors Club 1988
call for entries.

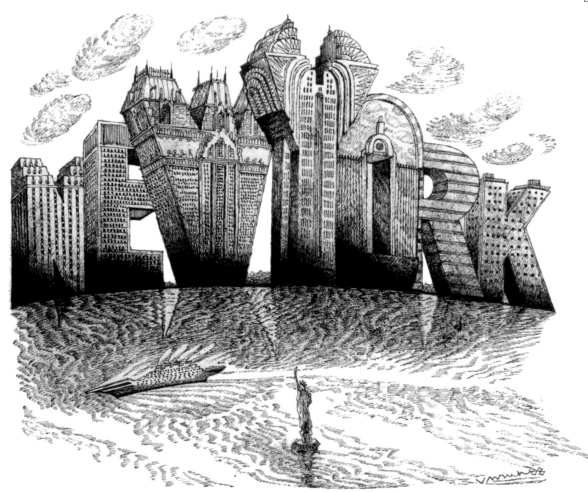

**USC
Law School
Viewbook**

The overhead view of
silhouetted students,
casting shadows across
the campus added a
new perspective for
evaluating USC Law –
its location in sunny
Southern California.

FACE-TO-FACE

Often my work integrates faces, whether human

or not, real or imagined, photographed or

illustrated. Viewers are drawn to facial expressions that

reveal the subject's attitude, mood and personality, even

when the face is of a pet dog or

sci-fi character.

Sappi
The Standard 5
Time Travel Man

The theme of the
Sappi *Standard 5* book,
which focused on
printing special effects,
featured the fictitious
stores of 826 National
tutoring locations.
For the Time Travel Mart,
we built a collage
face out of multiple watch
parts and calendars.

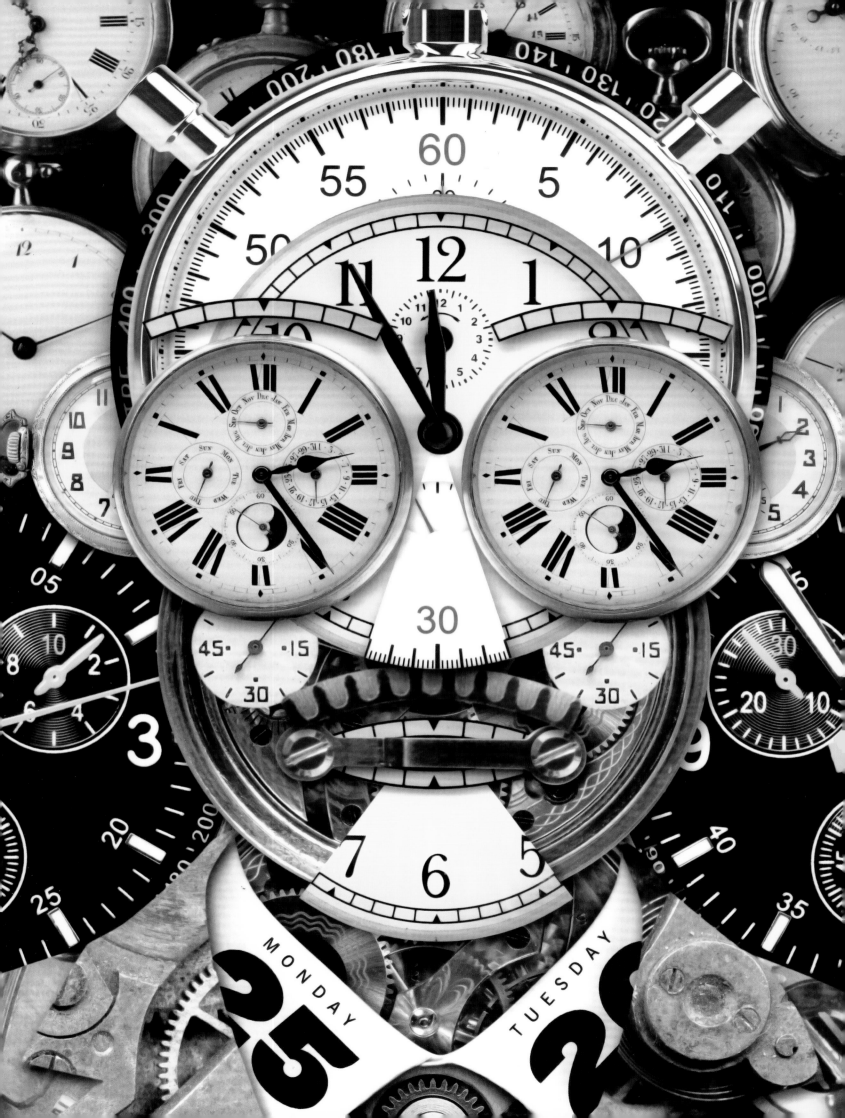

Simpson *Predictions* Promotion

For a Simpson Paper promotion called *Predictions*, we
commissioned portraits of famous prognosticators to
illustrate the concept of how to decipher the possible future.
Personalities such as earthquake scientist Charles Richter,
perpetual weather forecaster Punxsutawney Phil, futurist
architect Frank Lloyd Wright and 20th century transportation
industrialist Henry Ford. In addition, we illustrated science
fiction cartoonist Alex Raymond and *1984* legend George
Orwell, plus New York Yankee coach Casey Stengel. All were
illustrated in a style that was reminiscent of the period
in which they lived or relevant to their expertise.

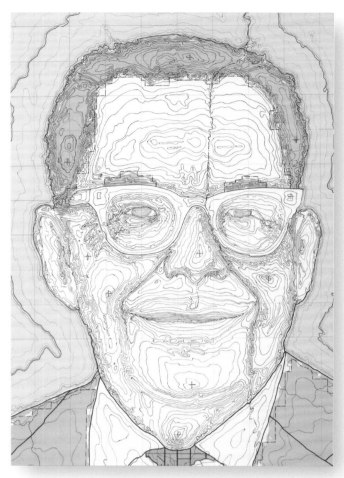

Charles Richter by David Stevenson

Frank Lloyd Wright by David Stevenson

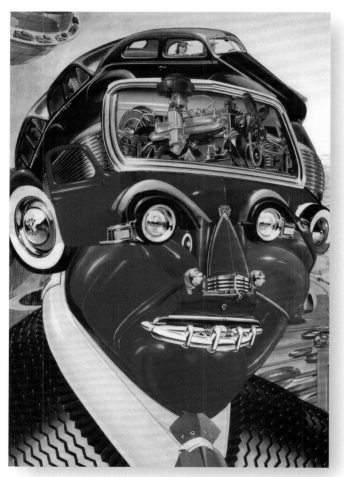

Henry Ford by John Craig

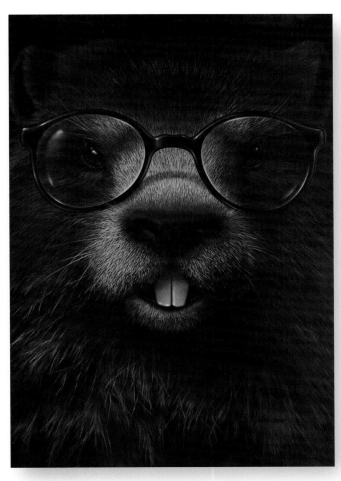

Punxsutawney Phil by William Nelson

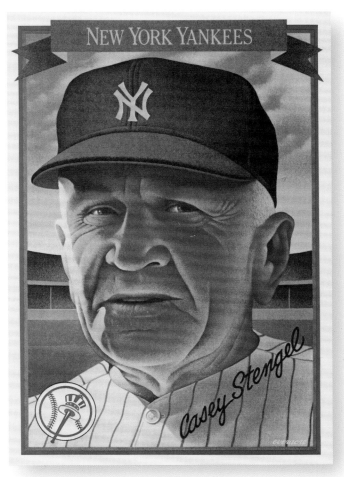

Casey Stengel by Gary Overacre

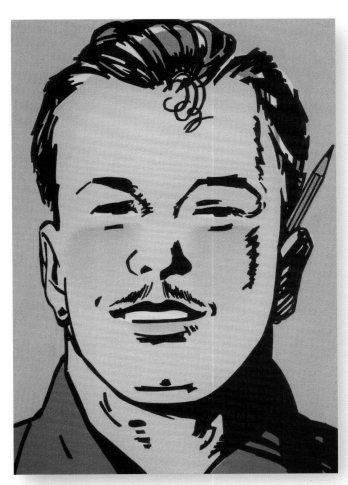

Alex Raymond by Ward Schumaker

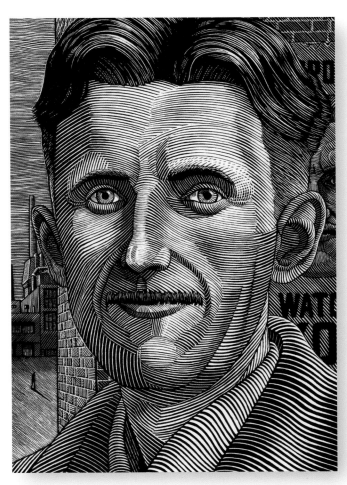

George Orwell by Douglas Smith

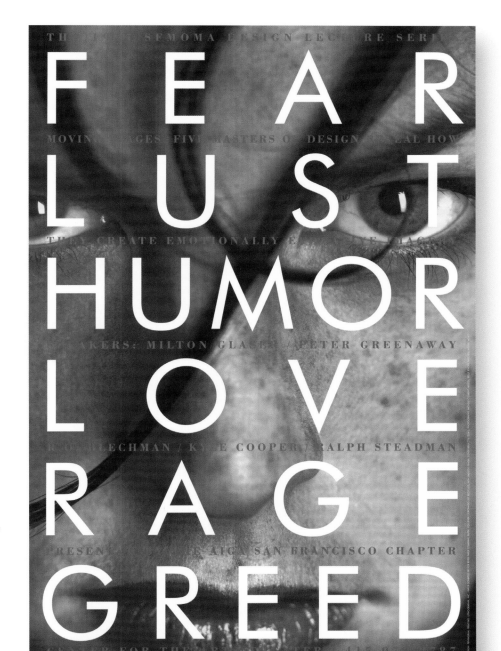

**AIGA SF
Design Lecture
Series Poster**

Good design does more

than decorate. The

simple addition of type

superimposed over this

powerful Michele Clement

photo makes this poster

for the series compelling

and haunting to view.

**Immunex
Annual Report**

The process of

bringing a design to a

biopharmaceutical field is

indicated in the six stripes

illustrated on this cover

art for Immunex. Each

step is unique, yet taken

as a total, it completes a

single idea. These steps

are discovery, rational

drug design, development,

manufacturing, clinical

affairs and corporate

development.

Sappi Paper Promotion

This portrait of the Lone Ranger
captured the essence of the
popular 1950s TV Westerns.
Created by Nancy Stahl as part
of a series on "things that belong
together," he was paired with
Tonto, his faithful companion:
The two belong together just
as print and paper do.

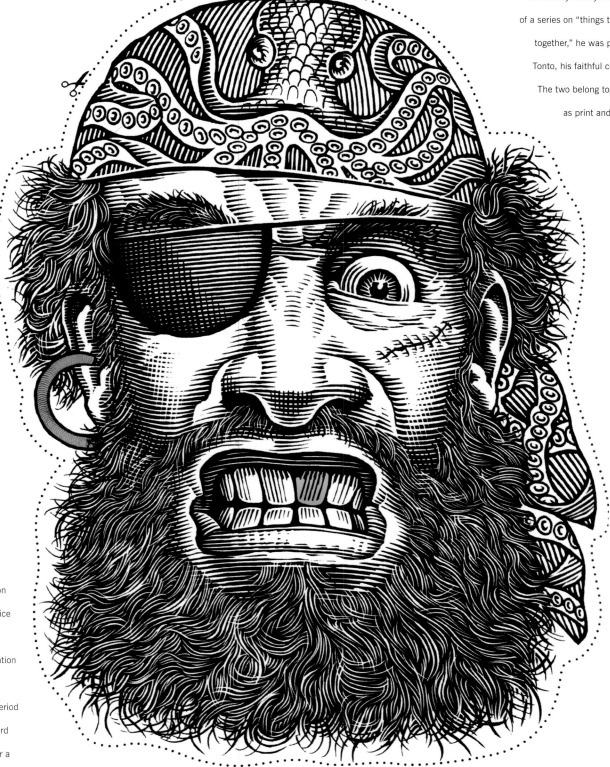

Sappi
The Standard 5
Pirate

It's not only the selection
of the face, but the choice
of the technique to
express it. The combination
of the two defines the
style, technology and period
of time. The scratchboard
art by Bill Sanderson for a
fictitious pirate store
captures an 18th century
look and feel with no
words required.

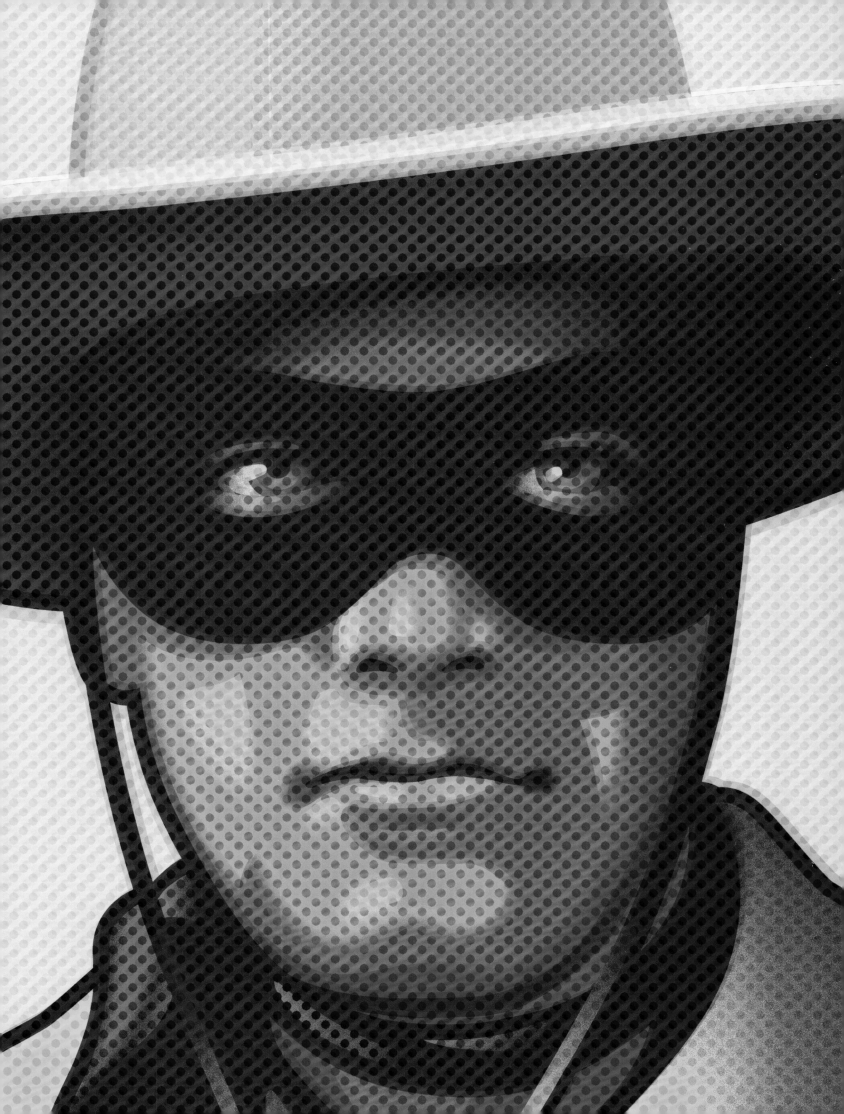

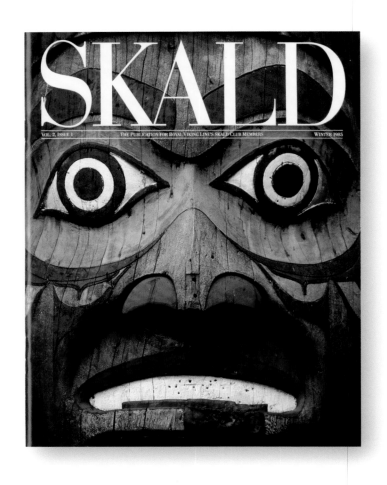

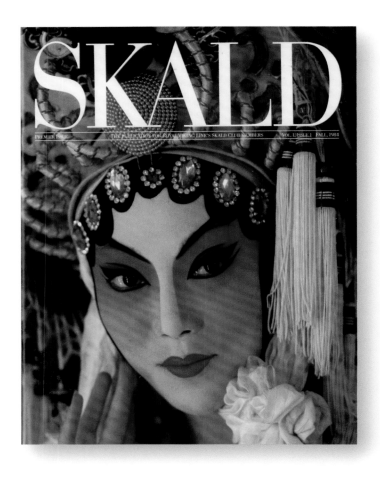

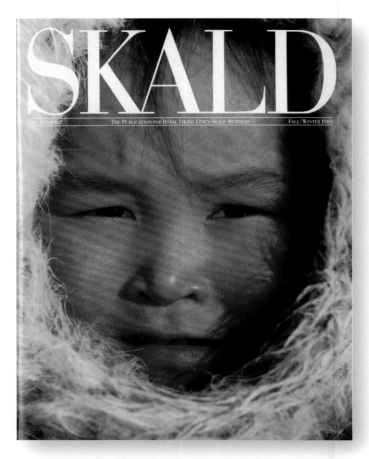

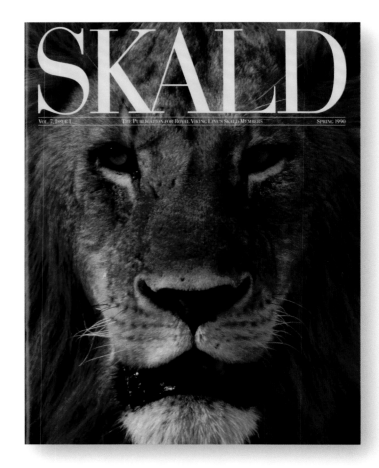

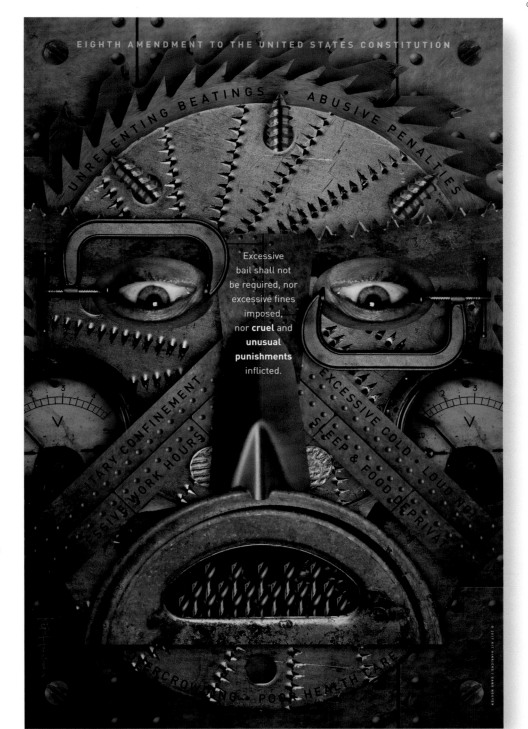

We the People
Eighth Amendment Poster

Asked to contribute to a series of posters commemorating the signing of the Bill of Rights, I was assigned the Eighth Amendment forbidding "cruel and unusual punishment." Considering the many macabre possibilities, I settled on creating an assemblage mask out of menacing, sharp materials.

EIGHTH AMENDMENT TO THE UNITED STATES CONSTITUTION

UNRELENTING BEATINGS • ABUSIVE PENALTIES

Excessive bail shall not be required, nor excessive fines imposed, nor **cruel** and **unusual punishments** inflicted.

SOLITARY CONFINEMENT

EXCESSIVE WORK HOURS

EXCESSIVE COLD • LOUD NOISE

SLEEP & FOOD DEPRIVATION

OVERCROWDING • POOR HEALTH CARE

Skald Magazine

For nearly a decade, we designed *Skald*, a controlled-circulation travel magazine, published by Royal Viking Line. The publication focused on the pleasures of cruising and featured articles on their scenic destinations. Rather than show familiar landmark attractions on the cover, we chose faces that were readily identifiable to the places RVL sailed.

@*Issue***:**

Magazine

Covers

As the design director
of this design and
business publication, I
made it a practice
to feature a relevant face
on every journal cover.
Right: For an issue on
environmental suitability,
we asked The Heads of
State to make a simple
face out of natural
materials. Facing page:
This cover featured
an article on branding
cosmetics by photographer
Gerald Bybee.

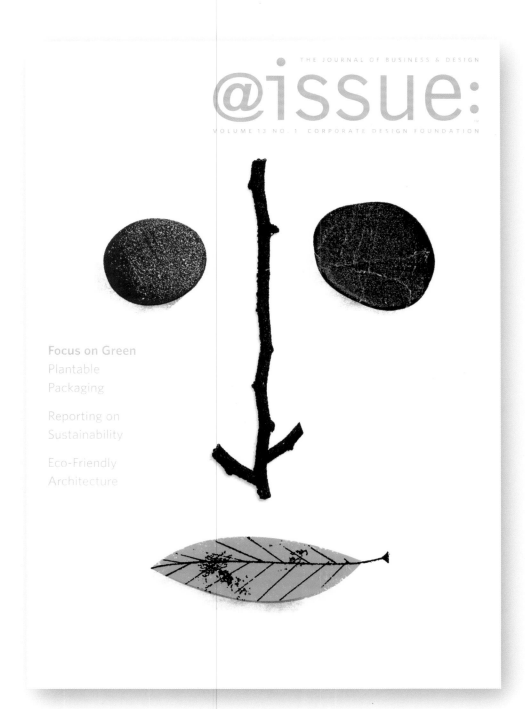

THE JOURNAL OF BUSINESS & DESIGN

@issue:

VOLUME 13 NO. 1 CORPORATE DESIGN FOUNDATION

Focus on Green
Plantable
Packaging

Reporting on
Sustainability

Eco-Friendly
Architecture

THE JOURNAL OF BUSINESS & DESIGN

@issue:

THE JOURNAL OF BUSINESS & DESIGN

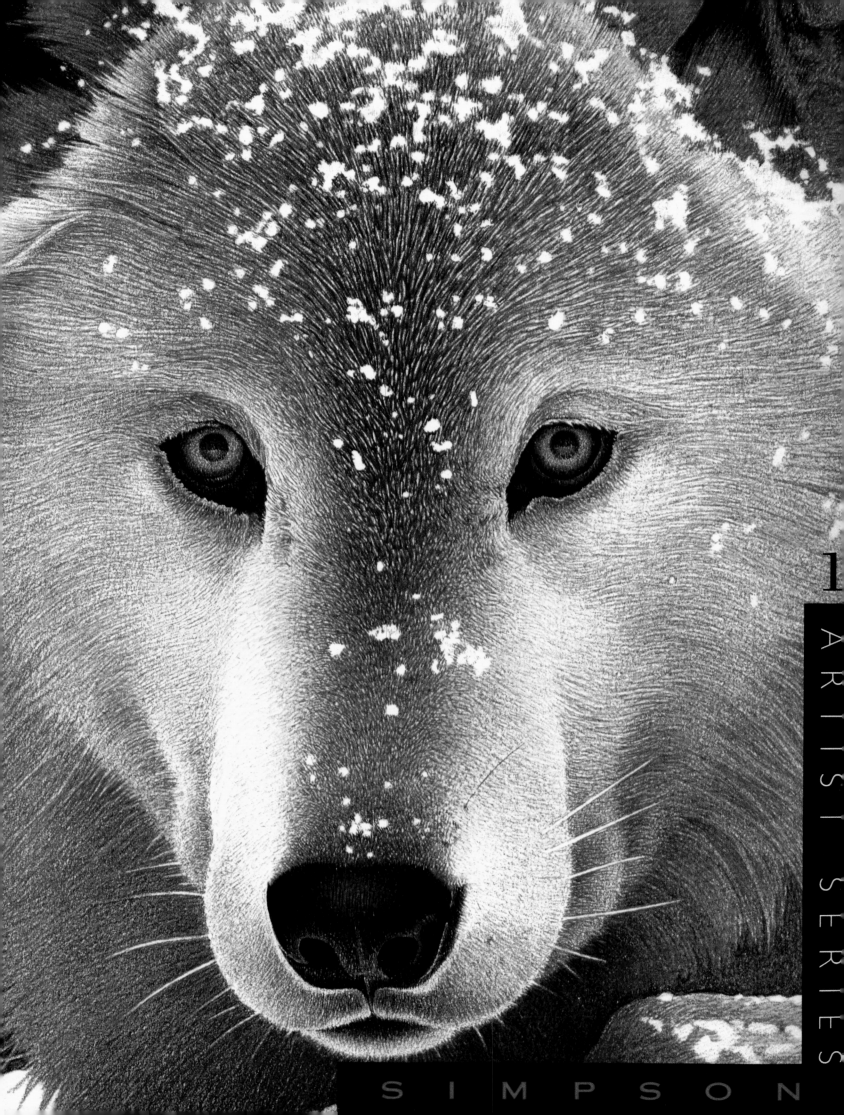

1

ARTIST SERIES

SIMPSON

ArtCenter *Review* Magazine

A quarterly tabloid for ArtCenter, the *Review* covered student, alumni and design industry news. A visual table of contents was shown below the *Review* masthead. As was my preference, each issue featured a face related to a key article. This Noh mask dealt with design in Japan. Most of the covers were photographed by ArtCenter's Steven Heller.

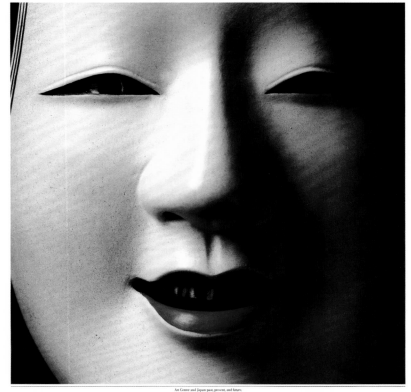

Simpson
Artist Series
Poster

In the 1990s, we created the *Artists Series* for Simpson Paper focusing on different art mediums. This volume of the series emphasized drawing techniques and how the colors and textures of Simpson's uncoated papers could enhance each image. The wolf was drawn by Barbara Banthien.

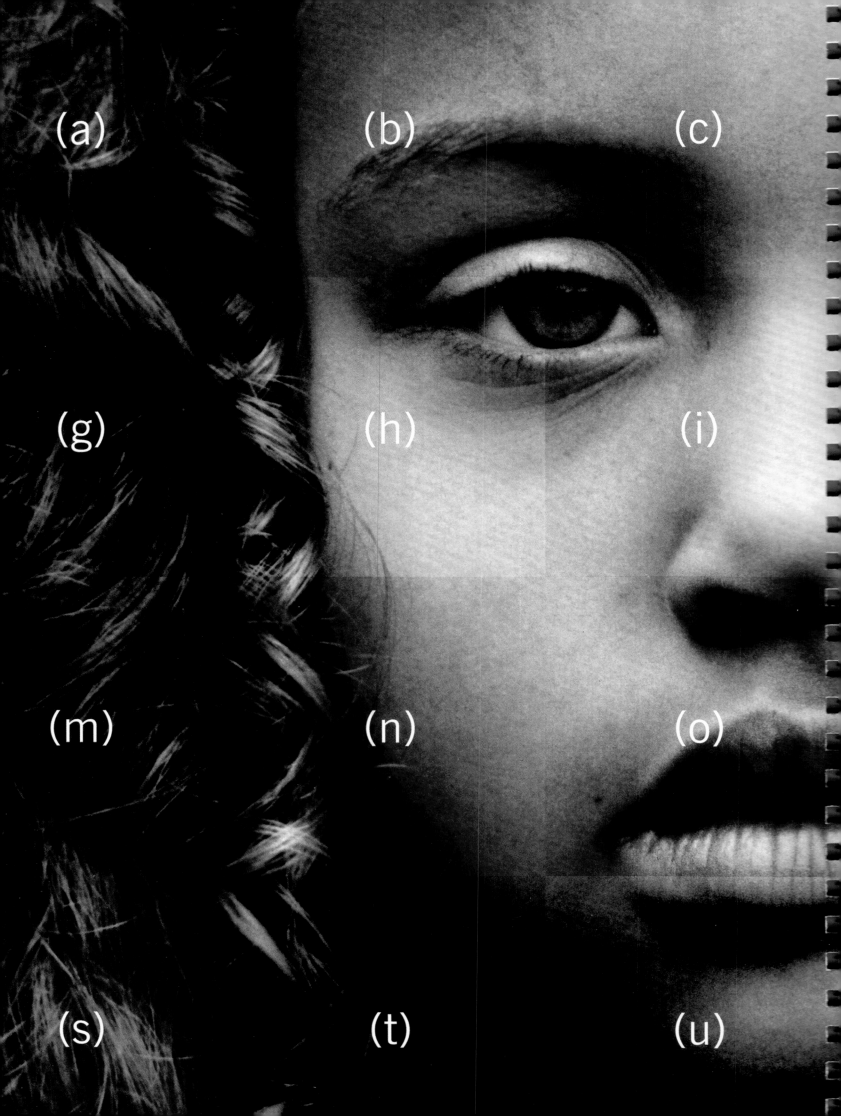

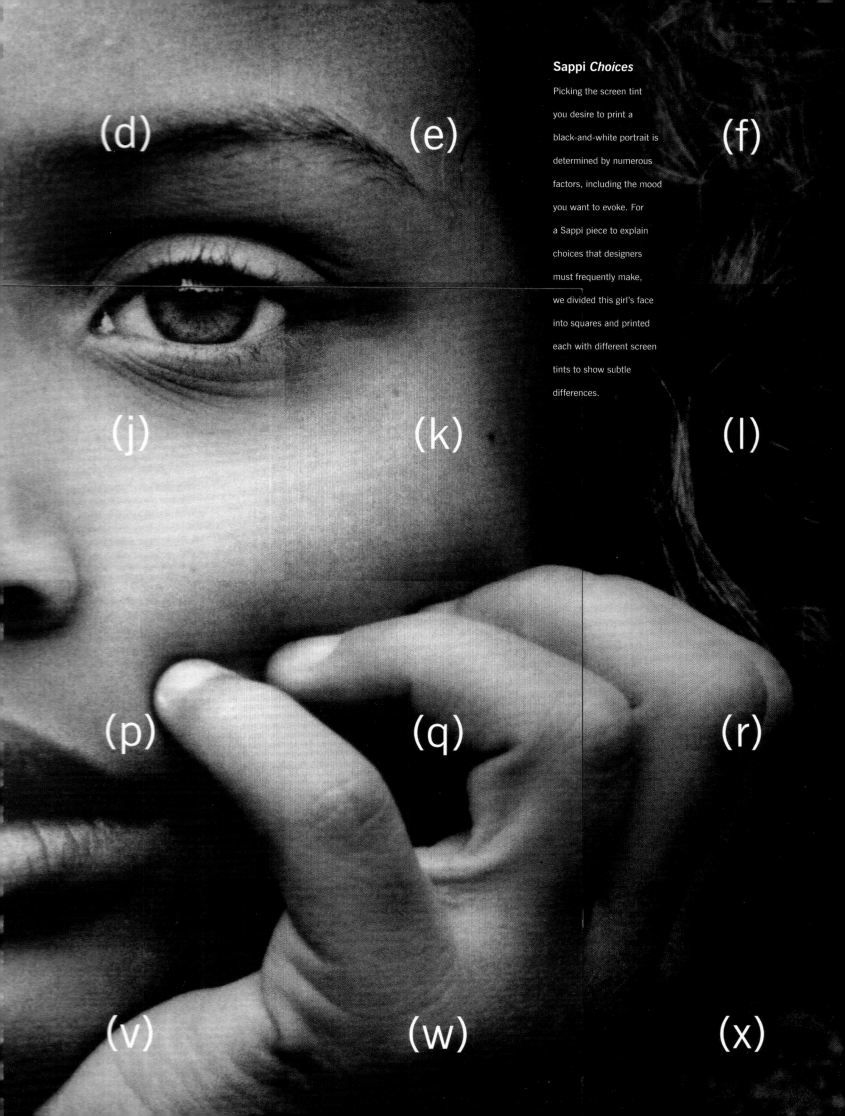

(d) (e) (f)

(j) (k) (l)

(p) (q) (r)

(v) (w) (x)

Sappi *Choices*
Picking the screen tint
you desire to print a
black-and-white portrait is
determined by numerous
factors, including the mood
you want to evoke. For
a Sappi piece to explain
choices that designers
must frequently make,
we divided this girl's face
into squares and printed
each with different screen
tints to show subtle
differences.

Bill Pohlad
Into the Wild
Poster

Into the Wild producer Bill Pohlad asked us to make a limited run poster for the cast and crew of his film. Our poster aimed to capture the mood of the movie by showing the lead actor Emile Hirsch staring into the forbidding wilderness. Only 25 copies of the poster were made, and director Sean Penn thanked us by autographing our poster.

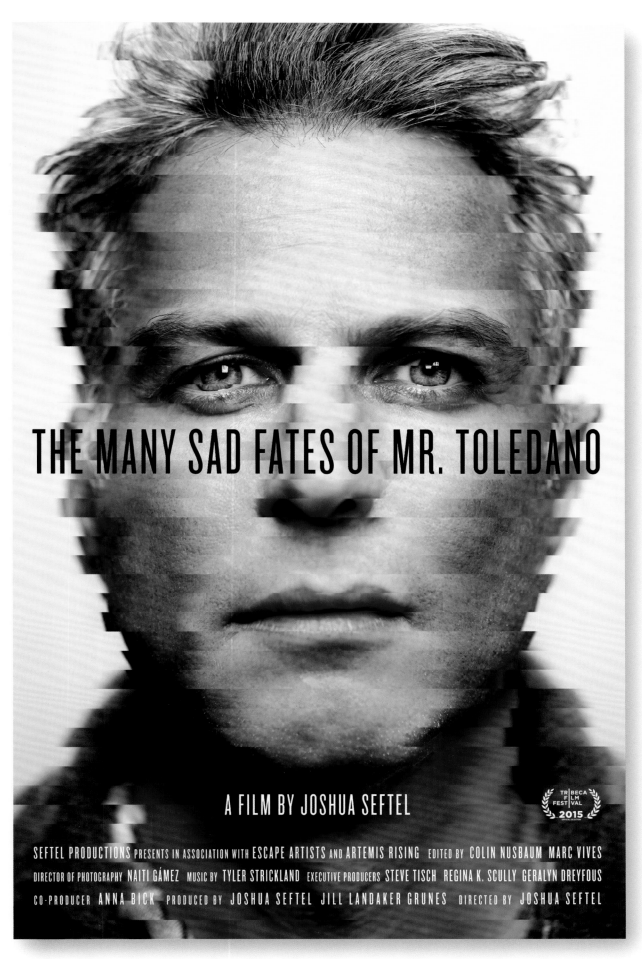

THE MANY SAD FATES OF MR. TOLEDANO

A FILM BY JOSHUA SEFTEL

SEFTEL PRODUCTIONS PRESENTS IN ASSOCIATION WITH ESCAPE ARTISTS AND ARTEMIS RISING EDITED BY COLIN NUSBAUM MARC VIVES
DIRECTOR OF PHOTOGRAPHY NAITI GÁMEZ MUSIC BY TYLER STRICKLAND EXECUTIVE PRODUCERS STEVE TISCH REGINA K. SCULLY GERALYN DREYFOUS
CO-PRODUCER ANNA BICK PRODUCED BY JOSHUA SEFTEL JILL LANDAKER GRUNES DIRECTED BY JOSHUA SEFTEL

Seftel Productions
*The Many Sad Fates
of Mr. Toledano*
Poster

Famed photographer Phil
Toledano tried to imagine
his sad fate if a variety of
misfortunes befell him. He
asked filmmaker Joshua
Seftel and a makeup artist
to "document" his transition
aging, obesity, homeless,
homicidal and suicidal. The
documentary short won an
award at the Tribeca Film
Festival. This distinguishing
portrait symbolized his
uncertain evolution.

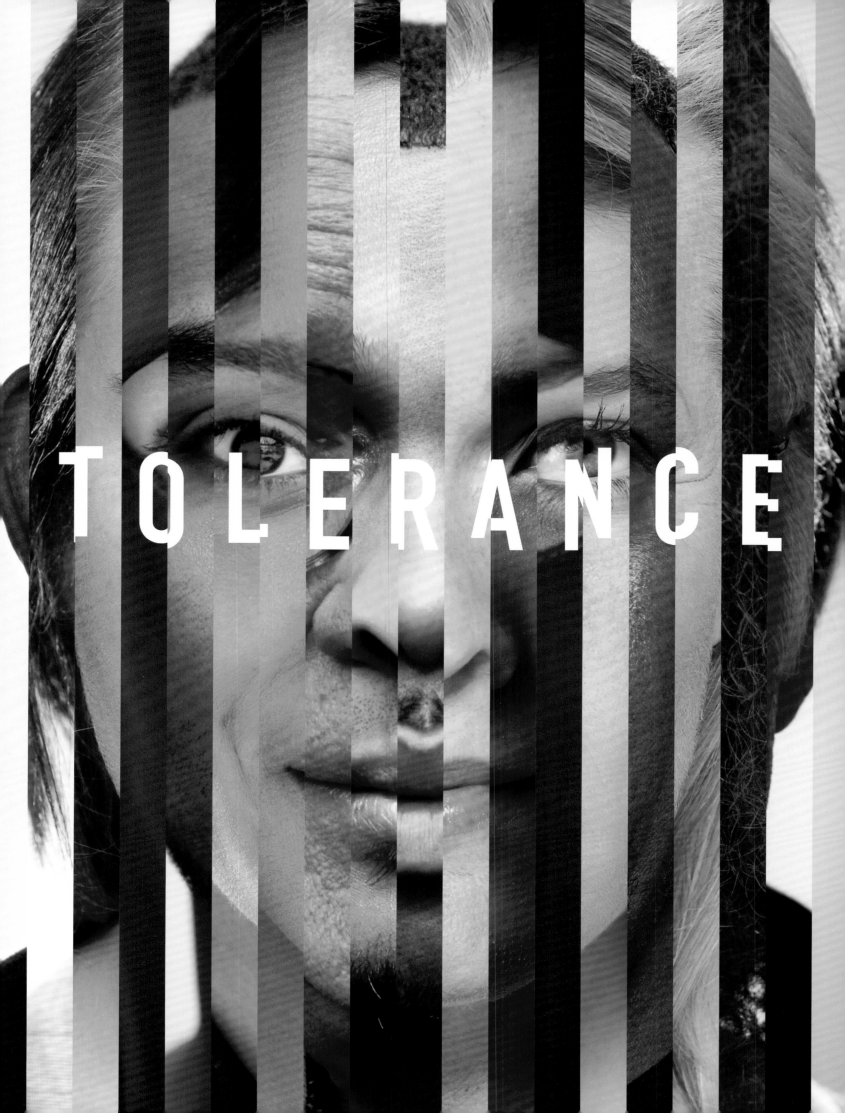

ArtCenter *The Face of 21st Century Design* Poster

ArtCenter wanted to describe the face of design in the 21st century, but no one student or single art medium would do it. By creating a collage portrait of all of the school's majors – illustration, film, product design, digital arts, transportation, photography, advertising, graphic design and environmental design – the poster depicted how future designers could be an amalgam of design disciplines.

International *Tolerance* Poster

New York-based illustrator/ designer Mirko Ilić, a Bosnian national, produced a traveling exhibition around the concept of Tolerance. Over 100 designers worldwide were asked to contribute posters for the show. My aim was to show tolerance and equality by splicing together a portrait from multiple genders and 19 distinct nationalities and ethnic groups.

EAT, DRINK & BE MERRY

Eating and drinking are the most ordinary, yet

essential activities to living. As designers, we interpret

this activity of shopping, preparing and consuming a

meal from many points of view. Building from

the anticipation and visualizing the finished meal, food

or drink is one of life's great pleasures.

**Square One
Restaurant Poster**

When renowned chef

Joyce Goldstein's San

Francisco restaurant, Square

One, celebrated their fifth

anniversary, she asked Terry

Heffernan and me to create

a commemorative poster.

This collage reflects the

Mediterranean ingredients of

the restaurant's cuisine.

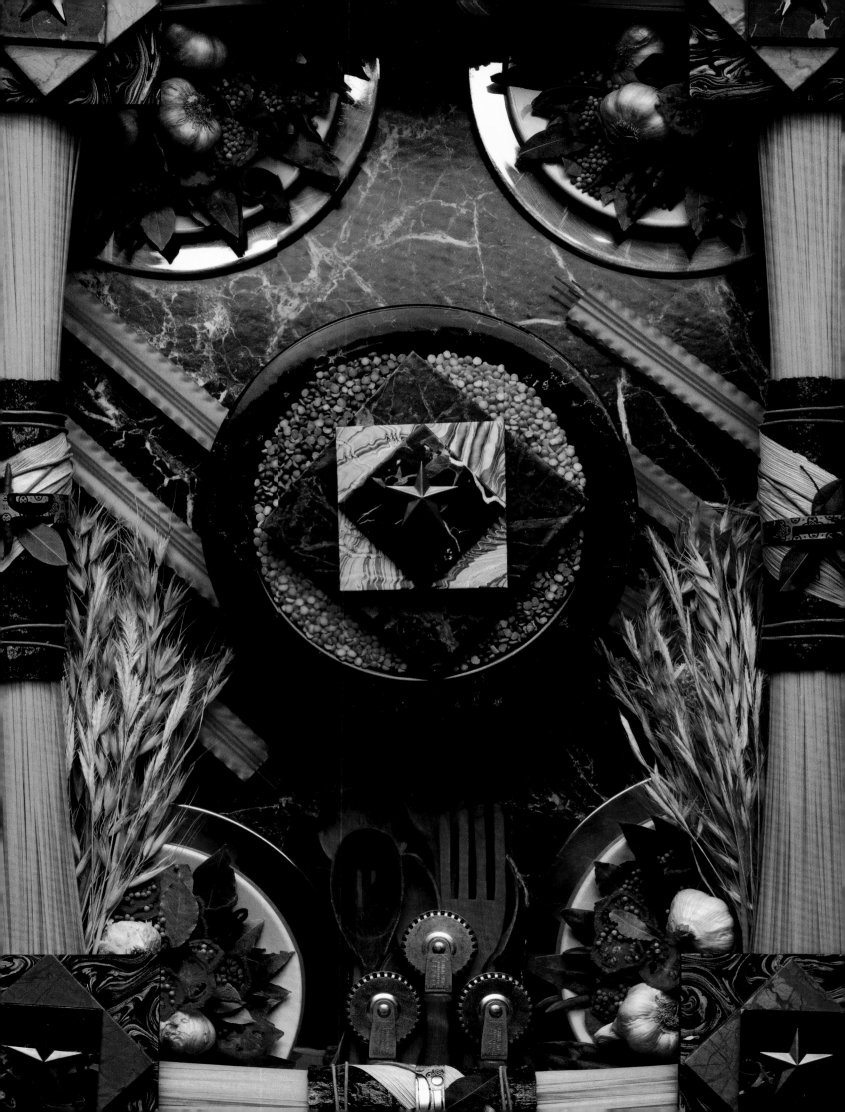

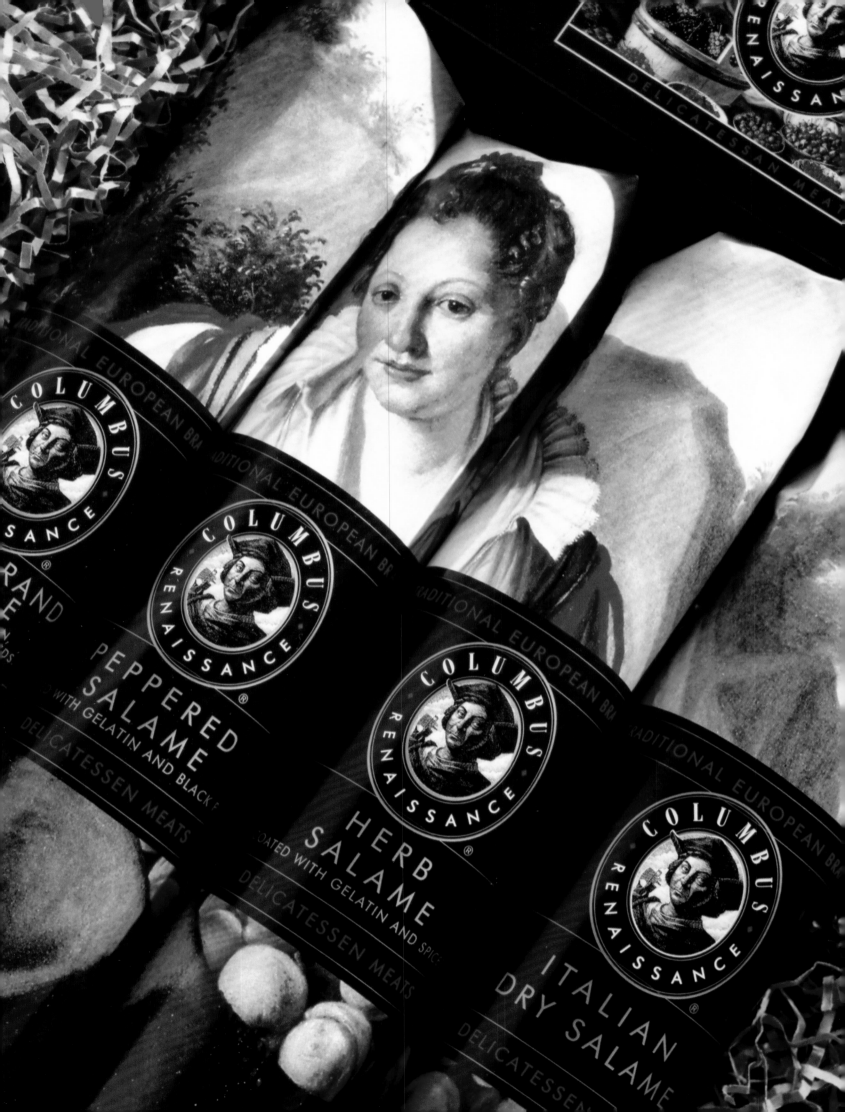

A brand with all organic ingredients, Fork in the Road, wanted their packaging to feel transparent, natural and not obsfucated by fussy design. Our approach was to design packaging that simply revealed the fresh farm-to-fork product and explained and depicted its contents.

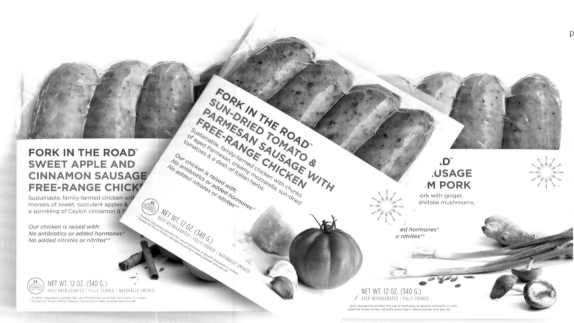

Columbus
Salame Gift
Packaging

The premium look of the new Columbus packaging encouraged Williams Sonoma to add the brand to their stores and online catalog. For a special salame Christmas holiday gift set, we chose a Renaissance painting and extended it over all four salame rolls to create a single image and increase the image's visibility and elegance.

Columbus Salame Branding

Right: Our redesign of the 75-year-old Columbus Salame brand was in response to
their desire to give a more sophisticated look to the packaging and communicate the authentic Italian flavor and
quality of their deli meats. Our approach was to suggest Old World premium standards in
the packaging with an engraved portrait of Christopher Columbus, by Douglas Smith, coupled with Renaissance
paintings, classic typography and a warm, rich color palette.

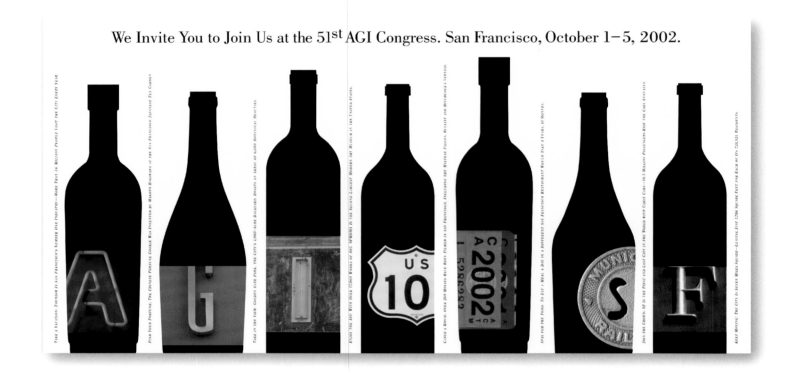

We Invite You to Join Us at the 51st AGI Congress. San Francisco, October 1–5, 2002.

51st Alliance Graphique
Internationale Congress Invitation

Above: As co-chair of the 51st Alliance Graphique Internationale Congress held
in San Francisco in 2002, I was charged with creating an invitational poster. The silhouetted
wine bottles symbolize the Napa Valley wine country, with bottle labels
made of found letters and signs that spell out the date and place of the AGI event.

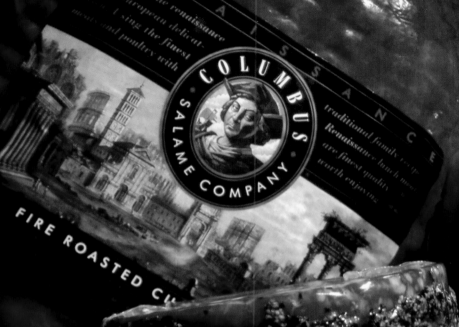

RENAISSANCE

COLUMBUS
SALAME COMPANY

Welcome to the renaissance
of the European delicat-
essen. I sing the finest
meats and poultry with

traditional family recipes.
Renaissance lunch meats
are finest quality
worth enjoying.

FIRE ROASTED C

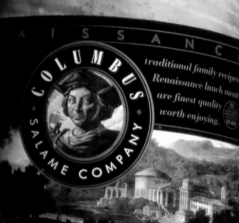

RENAISSANCE

COLUMBUS
SALAME COMPANY

traditional family recipes.
Renaissance lunch meats
are finest quality
worth enjoying.

SOPPRESATA

USDA CHOICE
FIRST CUT

RENAISSANCE

COLUMBUS
SALAME COMPANY

Welcome to the renaissance
of the European delicat-
essen. I sing the finest
meats and poultry with

traditional family recipes.
Renaissance lunch meats
are finest quality
worth enjoying.

PEPPERED SALAME

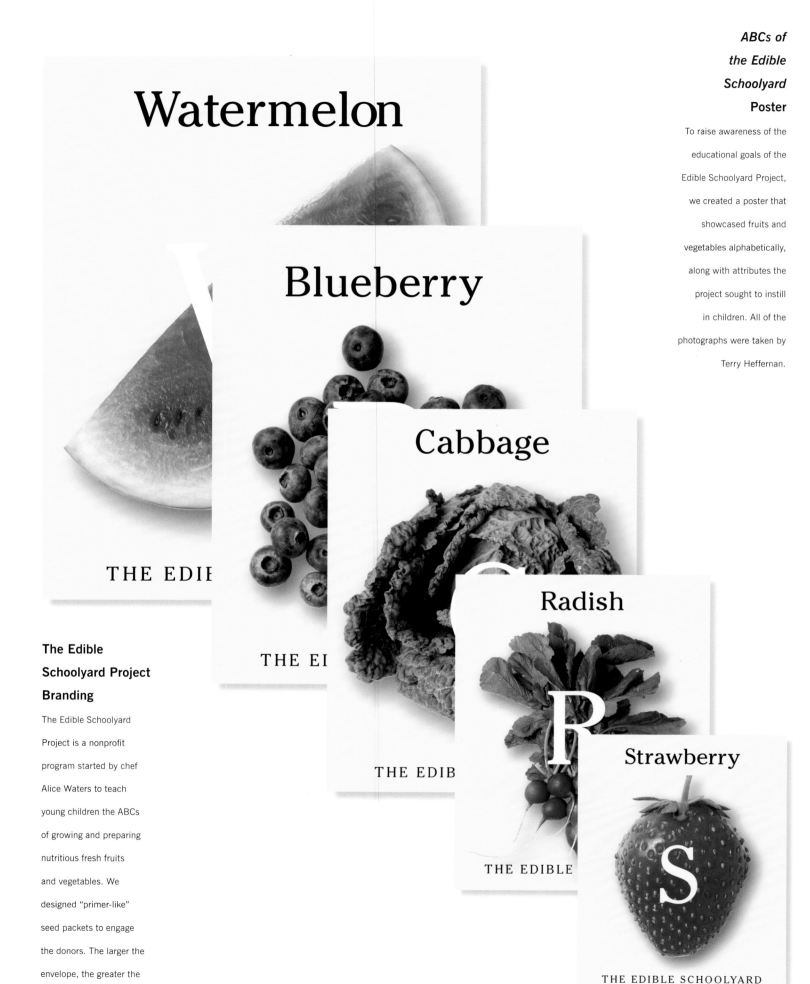

Watermelon

Blueberry

Cabbage

Radish

Strawberry

THE EDIBLE SCHOOLYARD

To raise awareness of the educational goals of the Edible Schoolyard Project, we created a poster that showcased fruits and vegetables alphabetically, along with attributes the project sought to instill in children. All of the photographs were taken by Terry Heffernan.

The Edible Schoolyard Project Branding

The Edible Schoolyard Project is a nonprofit program started by chef Alice Waters to teach young children the ABCs of growing and preparing nutritious fresh fruits and vegetables. We designed "primer-like" seed packets to engage the donors. The larger the envelope, the greater the size of the donation.

Apple

A is for Awareness.

Traditional American curricula, such as math, science and history, take on new meaning as children become aware of the importance of these subjects to mature as children grow and cook their foods.

Blueberry

B is for Beauty.

Children find that if they look closely, beauty is everywhere—in nature's design of a single leaf, in the thoughtful plan of a garden path, and the plants set on a table. Beauty is the language of care.

Cabbage

C is for Collaboration.

In the garden and kitchen, learning becomes a collaborative experience, with children performing garden and kitchen tasks together and sharing the excitement of seeing seeds in the soil turn into shoots and blossoms and grow into foods they can eat.

Date

D is for Delicious.

Children discover the delicious taste of fruits and vegetables grown with care, picked at the prime of ripeness, and prepared so the true natural flavors remain.

Egg

E is for Ecosystem.

Children learn the principals of ecology first-hand by observing how a garden is an ecosystem in which all living things are symbiotic and interdependent and gain sustenance from the soil, sun and rain.

Fig

F is for Fitness.

Kids learn while they workout performing tasks in the schoolyard garden. With childhood obesity rates at an all-time high, physical fitness activities are crucial to overall health.

Garlic

G is for Geography.

Students learn geography as they trace the indigenous source of foods. Peppers, corn, potato, tomato, and vanilla were native to Mexico and Central America; dates and pomegranates to North Africa, and noodles were brought from China by Marco Polo.

Honey

H is for History.

Even making bread offers a chance to talk about how ancient civilizations harvested grains, explorers who sailed the world in search of spices, and how different cultures prepare and eat the food. History can be learned through food.

Indian Coriander

I is for Interdependence.

Children discover the interdependence and importance of all things in nature, from earthworms, to humble bees, to sunshine, wind and rain. They develop a clearer perspective of the world and their place in it.

Jalapeño

J is for Justice.

Social justice begins by assuring every child has equal access to healthy meals daily. Poor eating habits have led in childhood obesity, diminished learning ability, and a plethora of physical ills due to malnourishment and nutritional starvation.

Kale

K is for Kindness.

Kindness begins by caring for gifts from Mother Nature by serving as responsible stewards of the environment. Sharing meals together with classmates is another act of kindness rewarded by friendship and emotional well-being.

Lemon

L is for Local.

Garden-to-table foods from local farms give children the benefit of eating meals harvested within their senses when they are at their most flavorful, abundant and inexpensive, while also supporting the economic well-being of the community.

Okra

O is for Organic.

The Edible Schoolyard's organic gardening practices avoid the use of chemical herbicides and pesticides. Kids learn the role of beneficial bugs in the garden, and create their own compost from garden cuttings and kitchen food scraps to enrich the soil.

ABCs
of the Edible
Schoolyard

Understanding where food comes from and how to prepare it is as basic and fundamental to human well-being as knowing your A-B-Cs.

Mushroom

M is for Mathematics.

Mathematical concepts take on real-life meaning when children are assigned practical tasks such as figuring out how to double the ingredients in a recipe, convert pints to gallons, calculate volume, and work out the ratio of pairing tastes.

Parsley

P is for Pride.

Children take pride in doing for themselves. Tilling the garden beds, picking the vegetables that they have grown, and turning their harvest into healthy meals is an experiential way of learning that calls on all the senses.

Nectarine

N is for Nutrition.

Nutrition is as much a science as biology and anatomy, and teaching children about the nutritional content of different types of foods and what their bodies need to stay healthy and happy is essential.

Quince

Q is for Questions.

Children have an innate curiosity about things they encounter prompting them to continually question why and look more closely. Learning happens spontaneously as questions come to mind.

Radish

R is for Respect.

Children develop greater respect and appreciation for where foods come from and how it gets on their plate. They see that even leafy lettuce requires planting, growing, and preparation just to make a simple salad.

Strawberry

S is for Sharing.

Children work collectively to achieve a common goal. This group learning process encourages kids to share their knowledge, complement each other's skills, and celebrate their combined success.

Tomato

T is for Transformative.

The way students engage with nature and the foods that they eat is a transformative experience that influences their eating choices into adulthood.

Uva

U is for Universal.

Food is the universal need of all living beings, and relates to every subject taught in school. It is the center of every celebration, and essential to achieve social justice.

Valencia Orange

V is for Variety.

Children tend to alter their diet after discovering the vast variety of fruits and vegetables available to them and the many ways they can be prepared.

Watermelon

W is for Wonder.

The love of learning begins by engaging each individual's sense of wonder about the world around them, the rich history of everyday things, and the relevance of academic subjects to their daily life.

Xocolatl

X is for Xenophile.

Learning the origin of plants and how they are used and eaten by people around the world instill appreciation of foreign peoples, manners and cultures.

Yam

Y is for Yummy.

After comparing the taste of ripe and just-picked fruits and vegetables with prepackaged, mass-produced, processed foods, most students rethink what they consider yummy.

Zucchini

Z is for Zest.

Children acquire a zest for learning by viewing education as an exploration of the world around them. Edible Schoolyard tasks engage all of their senses and let them discover on their own.

**Dreyer's
Dreamery
Packaging**

Dreyer's luscious
Dreamery ice creams
lent themselves to
creating fantasy
dreamscapes based on
each flavor's name.
We invited 18 illustrators
to let their imaginations
soar in depicting
the imaginary origin
and ingredients of
each flavor that varied
from "Chilly Chili"
to "Grandma's Cookie
Jar" and "Galactic
Chocolate Swirl."

DEAN & DELUCA

PURVEYORS OF FINE FOOD, WINE AND KITCHENWARE

Autumn 2000

WWW.DEANDELUCA.COM

**Dean & DeLuca
Catalog**

As the renowned New
York food chain sought
to expand to West Coast
locations, Dean & DeLuca
engaged us to evolve their
catalog to reflect a West
Coast attitude coupled
with a New York City vibe.

**BLACK RASPBERRY
AVALANCHE**
All Natural Flavors

**GRANDMA'S
COOKIE JAR**

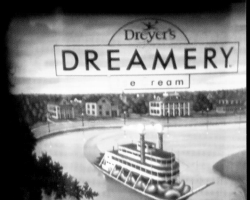

**CASHEW
PRALINE PARFAIT**
All Natural Flavors

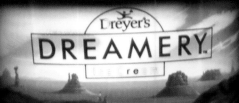

**...ACTIC
...ATE SWIRL**
...ural Flavors

**CARAMEL
TOFFEE BAR HEAVEN**
Natural and Artificial Flavors Added

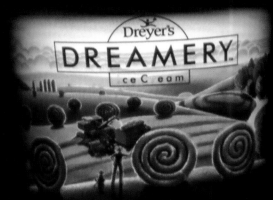

STICKY BUN
Natural and Artificial Flavors Added

**BLUE RIBBON
BERRY PIE**
All Natural Flavors

HARVEST PEACH
All Natural Flavors

COOL MINT

FRESH
HARVEST
2000

GRAPE
JUICE

Chardonnay

750 ML (25.3 FL OZ)

ÑAPA
STYLE

FRESH
HARVEST
2000

GRAPE
JUICE

Cabernet

750 ML (25.3 FL OZ)

ÑAPA
STYLE

Olive Oil

500 ML (16.9 FL OZ)

NapaStyle
Packaging

Renowned chef and
vintner Michael Chiarello
asked us to design a brand
identity for his new specialty
food line. The product
categories ran the gamut from
olive oil, grape juices, spice
rubs, salts and Italian sauces.
We devised a graphic branding
system of typography and
a distinct color palette that
evoked Napa Valley's love of
the culinary arts, fine food and
casual elegance.

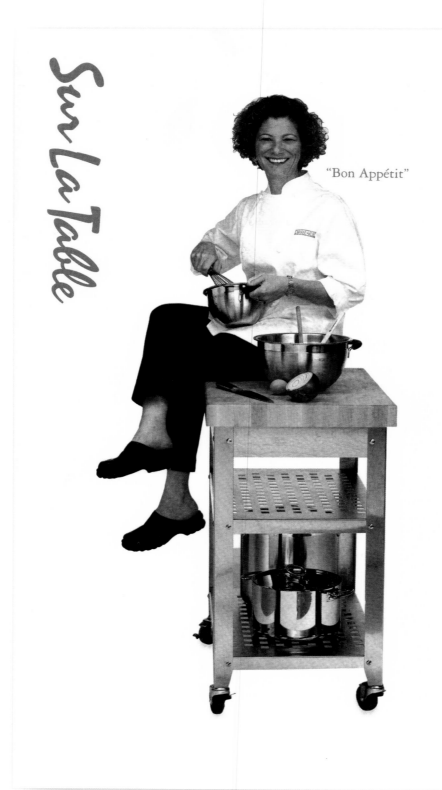

Sur La Table

"Bon Appétit"

Holiday 2004

Sur La Table Catalog

Sur La Table has earned a reputation as being the culinary store appealing to serious gourmet home

cooks. This catalog was curated with kitchen tools that even professional chefs would covet. The design steered away from

homey mood shots and spoke directly to knowledgeable cooks with clean silhouetted product shots

and simple graphic food photography. Understanding that a great meal contains two halves of a whole, *preparation*

and *presentation*, the catalog was divided into two sections.

Cooking tips from well-known chefs were translated throughout the catalogs.

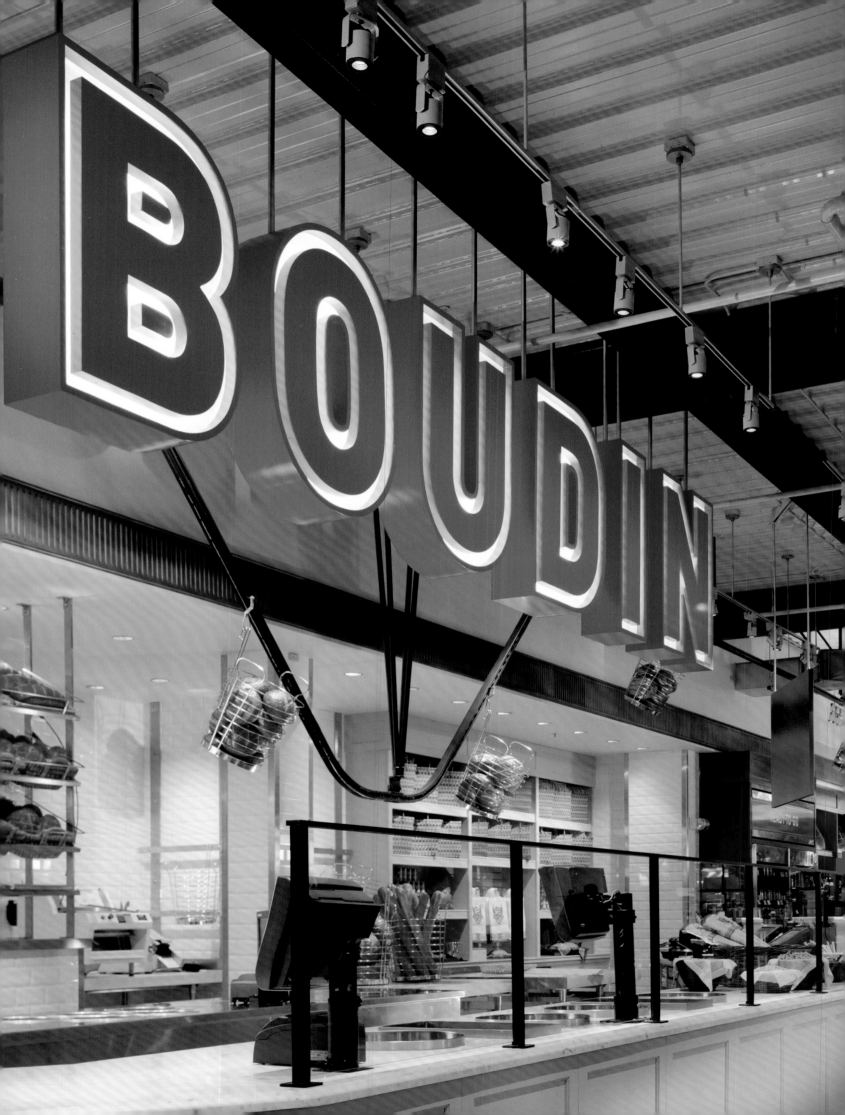

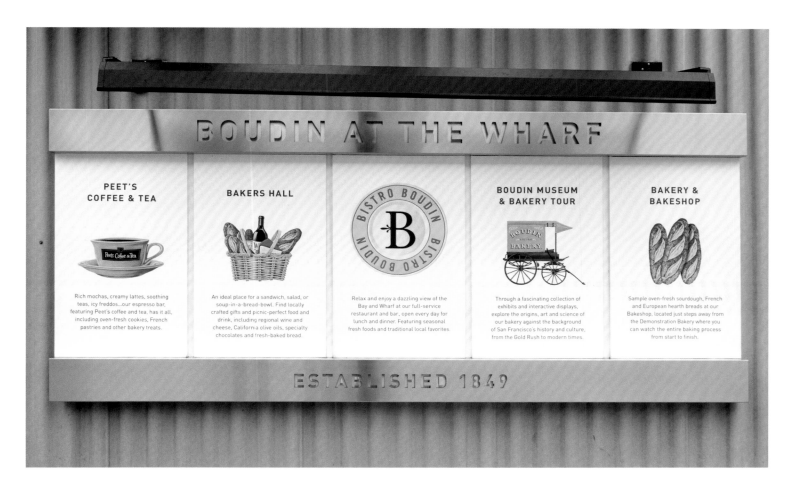

Boudin Bakery Flagship Store

Founded in 1849 at the start of the Gold Rush, Boudin is the oldest continuously operated business in

San Francisco and the original home of San Francisco's sourdough French bread. Even today the bakery's original sourdough

starter goes into every loaf. In 2005, Boudin announced they would establish a flagship bakery, retail store,

bistro and museum on San Francisco's Fisherman's Wharf, and asked us to create the exterior and interior signage system,

to design interior graphics and to develop the museum displays.

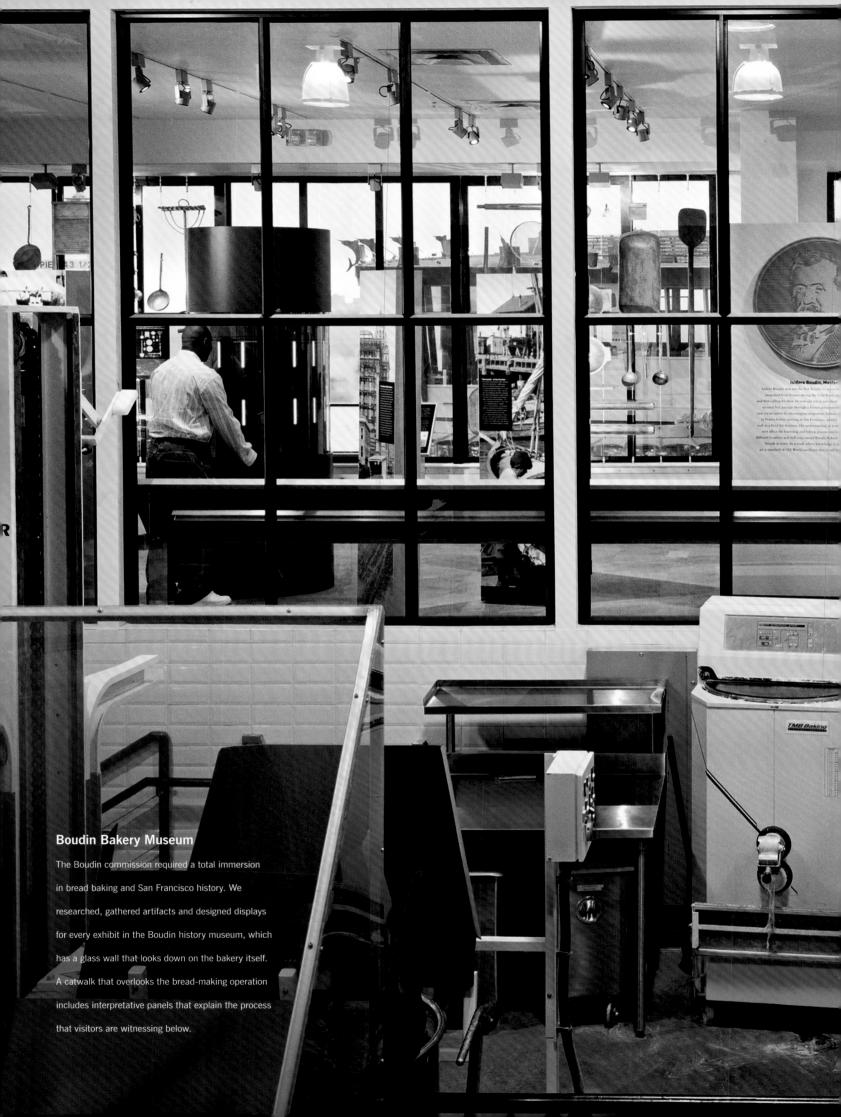

Boudin Bakery Museum

The Boudin commission required a total immersion in bread baking and San Francisco history. We researched, gathered artifacts and designed displays for every exhibit in the Boudin history museum, which has a glass wall that looks down on the bakery itself. A catwalk that overlooks the bread-making operation includes interpretative panels that explain the process that visitors are witnessing below.

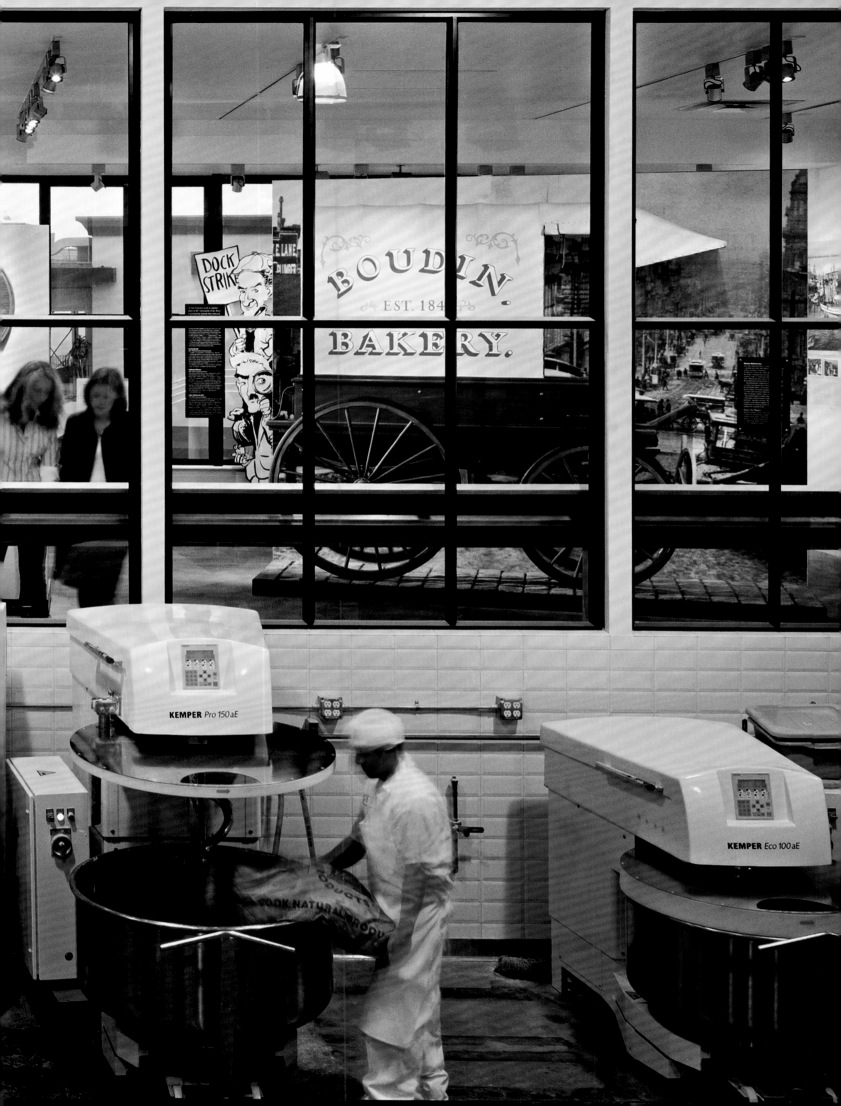

**Alliance Graphique
Internationale
London Congress
Teacup**

AGI asked their members
to design an object symbolic
of the city where the annual
Congress is being held.
A teacup was picked to
be representative of London
and its traditional "cuppa"
tea, and this was my offering
from the colonies.

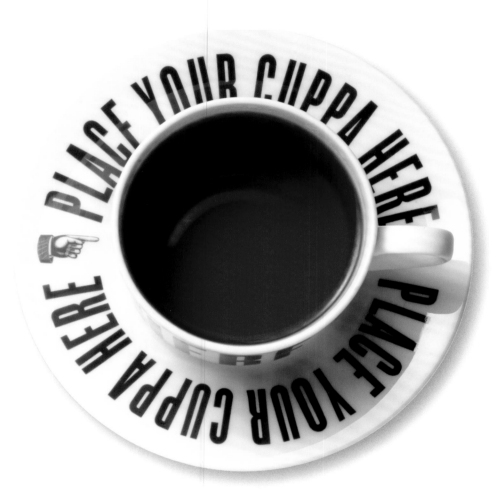

**Timeframe
Wine Labels**

River Lane Vineyard
wanted a wine label that
was distinctive yet
offered a link to the natural
process of growing wine
grapes. Our solution was to
show the passage of time,
from the season of growing
to harvesting grapes,
in four single grape leaves
printed in colors that
reflected the brand's
time frame.

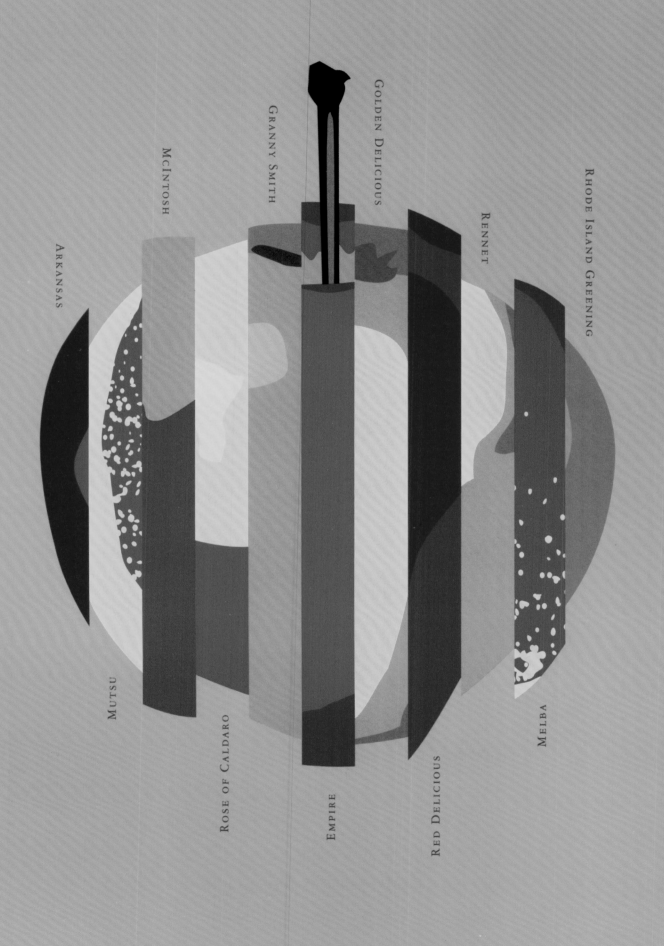

ARKANSAS

McINTOSH

GRANNY SMITH

GOLDEN DELICIOUS

RENNET

RHODE ISLAND GREENING

MUTSU

ROSE OF CALDARO

EMPIRE

RED DELICIOUS

MELBA

Potlatch
Pasta Chart

As a part of the Potlatch *Field Studies* series on food, we developed a diagrammatic chart identifying pasta types and displayed them according to relative size, color and texture.

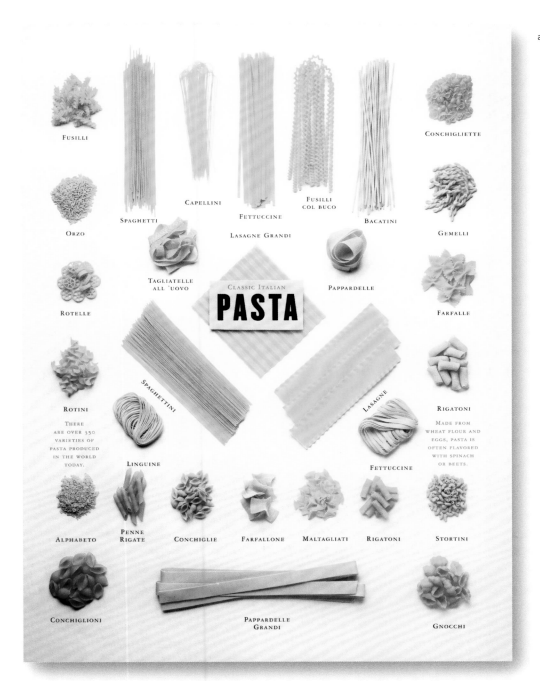

FUSILLI

CONCHIGLIETTE

CAPELLINI

FUSILLI COL BUCO

SPAGHETTI

FETTUCCINE

BACATINI

ORZO

LASAGNE GRANDI

GEMELLI

TAGLIATELLE ALL 'UOVO

PAPPARDELLE

CLASSIC ITALIAN
PASTA

ROTELLE

FARFALLE

SPAGHETTINI

LASAGNE

RIGATONI

ROTINI

THERE ARE OVER 350 VARIETIES OF PASTA PRODUCED IN THE WORLD TODAY.

LINGUINE

FETTUCCINE

MADE FROM WHEAT FLOUR AND EGGS, PASTA IS OFTEN FLAVORED WITH SPINACH OR BEETS.

ALPHABETO

PENNE RIGATE

CONCHIGLIE

FARFALLONE

MALTAGLIATI

RIGATONI

STORTINI

CONCHIGLIONI

PAPPARDELLE GRANDI

GNOCCHI

Potlatch
Field Studies

We designed a series of promotional brochures for Potlatch called *Field Studies*. This one was on food design. The sliced apple illustration, created by Ward Schumaker, was intended to chart the 11 most common apple varieties grown in the United States.

82

LIVING WITH NATURE

Presenting the natural world can

be as traditional as a scenic landscape and

as abstract as a lyrical interpretation of

a chambered nautilus. Running through design

approaches that would work best for

the objectives of the assignment takes me from

the scientific to the allegorical.

**NatureBridge
Poster Campaign**

First in a series of posters

created for NatureBridge,

a nonprofit organization

whose mission is to introduce

and connect young people

to America's national parks.

Six international artists were

selected to create these

distinctive limited edition

prints to auction at a

fundraiser. Artist: Martin

Haake, Berlin, Germany.

YOSEMITE
National Park

Great Grey Owl

American black bear

Virginia Canyon

Coyote

Grand Canyon of the Tuolumne River

Tuolumne Meadows

Yosemite Falls

Mount Hoffmann

El Capitan

N
W E
S

Half Dome

Glacier Point

Henness Ridge Eco Center

Mount Starr King

Little Elephant Heads

Stellar Jay

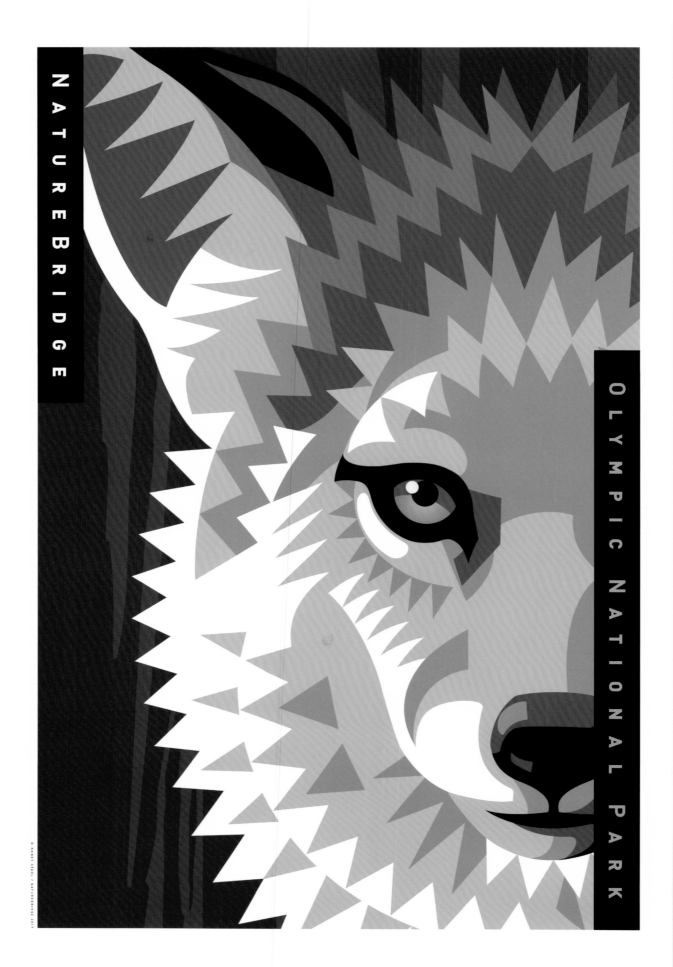

NATUREBRIDGE

OLYMPIC NATIONAL PARK

Nancy Stahl
New York City, New York

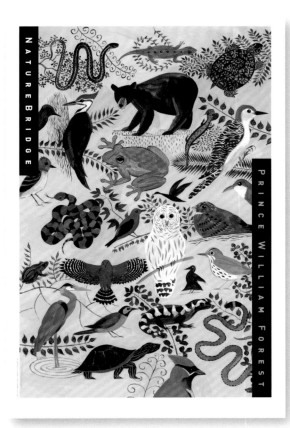

John Mattos
San Francisco, California

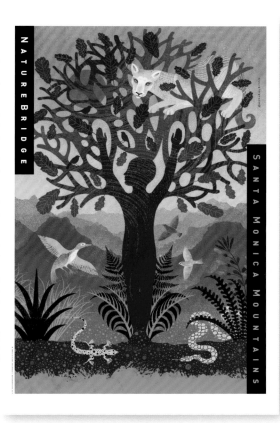

Anna and Elena Balbusso
Milan, Italy

NatureBridge Fundraiser Posters

We worked with six different artists who were each assigned a specific national park site to interpret. Limited edition copies were printed at 40 inches by 68 inches, signed by each artist and then auctioned off at their annual meeting. In addition to these large scale prints, a smaller set of six was housed in a black portfolio and auctioned off separately.

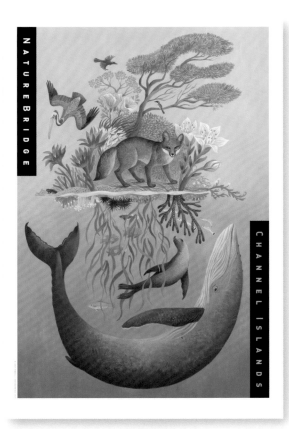

Jeffrey Fisher
London, United Kingdom

Jody Hewgill
Toronto, Canada

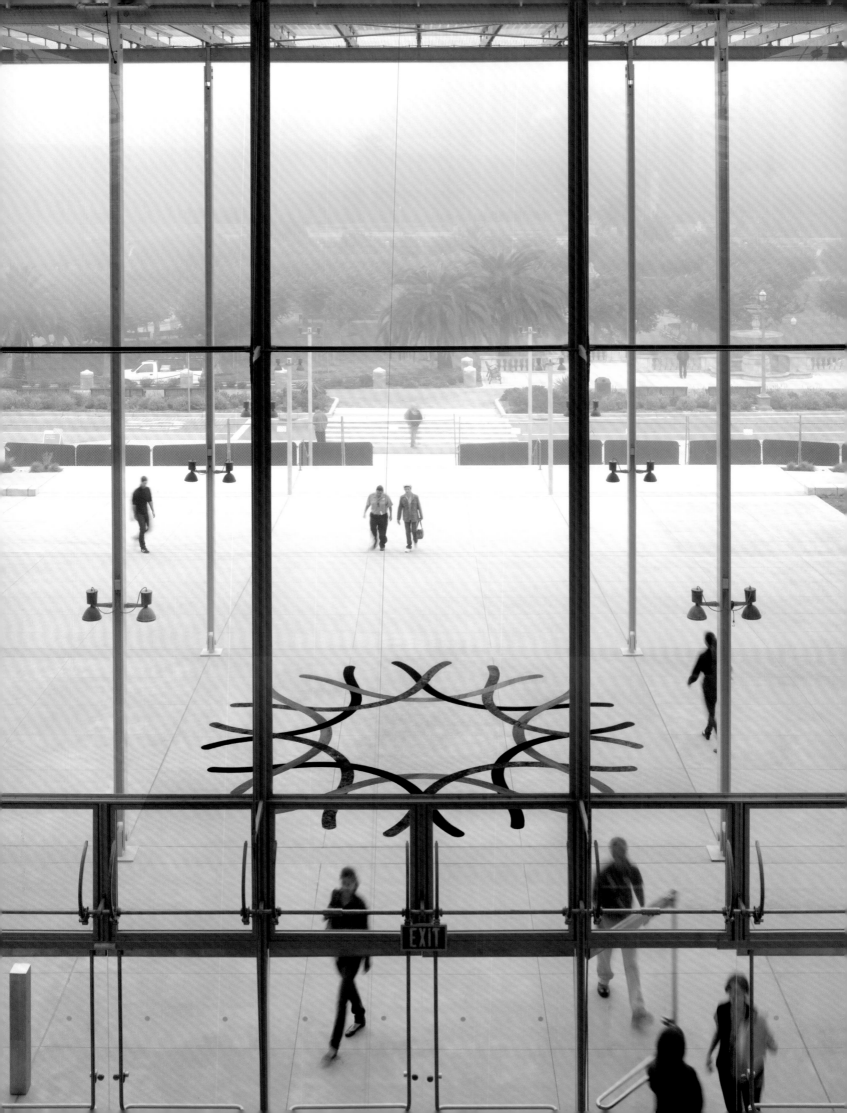

CALIFORNIA ACADEMY OF SCIENCES

California Academy of Sciences Environmental Design

The world's only institution
to house a natural sciences
museum, aquarium,
planetarium and scientific
research program under
one roof, the California
Academy of Sciences in
San Francisco sought to
establish a unique brand
for the new combined
museum.

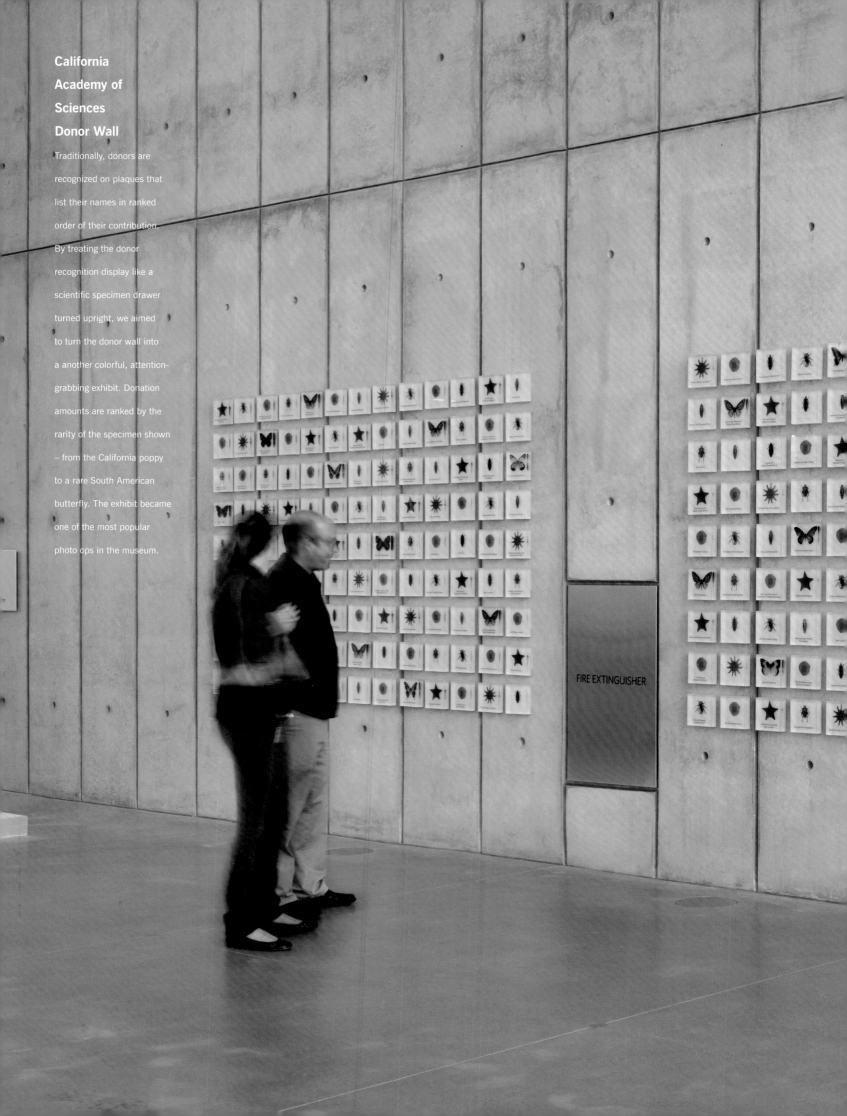

California Academy of Sciences Donor Wall

Traditionally, donors are recognized on plaques that list their names in ranked order of their contribution. By treating the donor recognition display like a scientific specimen drawer turned upright, we aimed to turn the donor wall into a another colorful, attention-grabbing exhibit. Donation amounts are ranked by the rarity of the specimen shown – from the California poppy to a rare South American butterfly. The exhibit became one of the most popular photo ops in the museum.

FIRE EXTINGUISHER

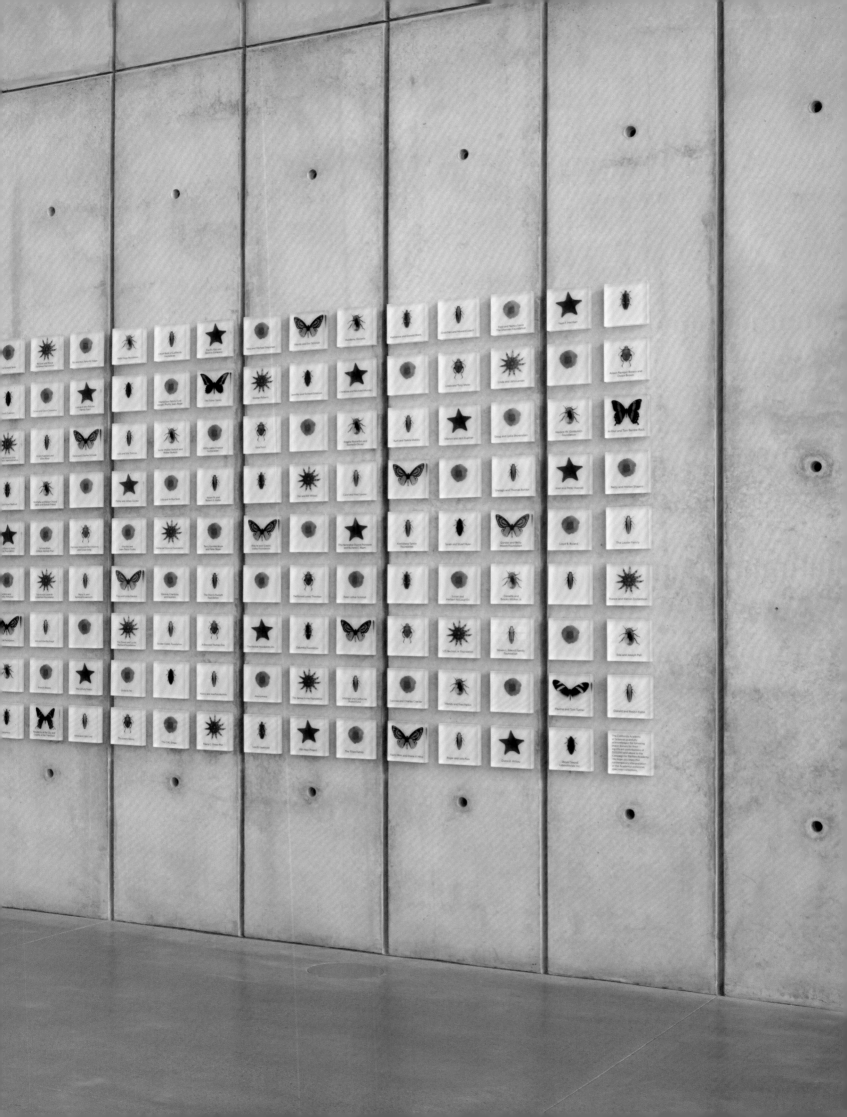

California Academy of Sciences Membership Program

One of the strategic goals developed by the museum staff was to keep the museum "alive" during their year-long hiatus for reconstruction in Golden Gate Park. During the closure, the museum held the public's attention with an active print program.

November 2007

CALIFORNIA ACADEMY OF SCIENCES

LifeStories

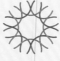

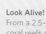

Look Alive!
From a 2.5-acre living roof to coral reefs and rainforests within, the new California Academy of Sciences will be, quite literally, life-supporting. Here's an advance look at our new home and our continuing mission of discovery, sustainability, education, and learning to preserve life on Planet Earth. Things are growing in here, and we want you to grow with us!

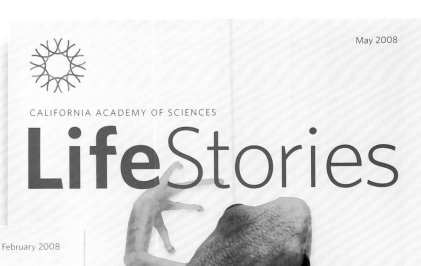

May 2008

CALIFORNIA ACADEMY OF SCIENCES

LifeStories

February 2008

ories

Early Warning System!
The bright amber color of
Madagascar's golden mantella
frog is a warning sign to predators:
"Don't eat me, I'm toxic!" But the
tiny creature also has an urgent
alert for the rest of us. Like all
amphibians, it's racing toward
extinction at alarming speed. To
increase the population, Academy
biologists are breeding and
raising the frogs that will make
their home in the new rainforest.

Reef Encounter
No, the moorish idol isn't a
piece of statuary. It's a common
inhabitant of shallow tropical reefs
and lagoons that mates for life.
The moorish idol is said to have
gotten its name from the Moors
of Africa, who believed the fish to
be a "bringer of happiness." It will
be just one of thousands of colorful
inhabitants that will flourish in the
Academy's new coral reef.

**California Academy
of Sciences
Communication
Program**

California Academy asked
us to develop a complete
communications program
for the public. We designed
multilingual maps, a quarterly
newsletter and a monthly
magazine, along with sub-
branding for special adjunct
groups and membership
materials. We also developed
complete typographic
wayfinding signage in the
museums and for citywide
banners and printed
materials generated by the
museum's staff.

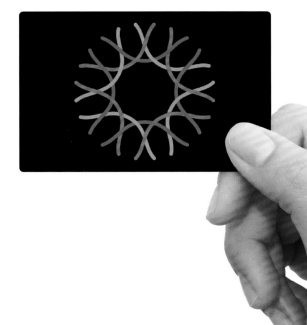

San Francisco Zoo Branding and Signage

During a major modernization of the San Francisco Zoo, we were hired to revitalize their visual identity. Continuing the zoo's tradition of using wrought-iron for signage, we made cut silhouettes of wild animal figures and integrated them into the brand and wayfinding system throughout the zoo, from parking lot to animal enclosures.

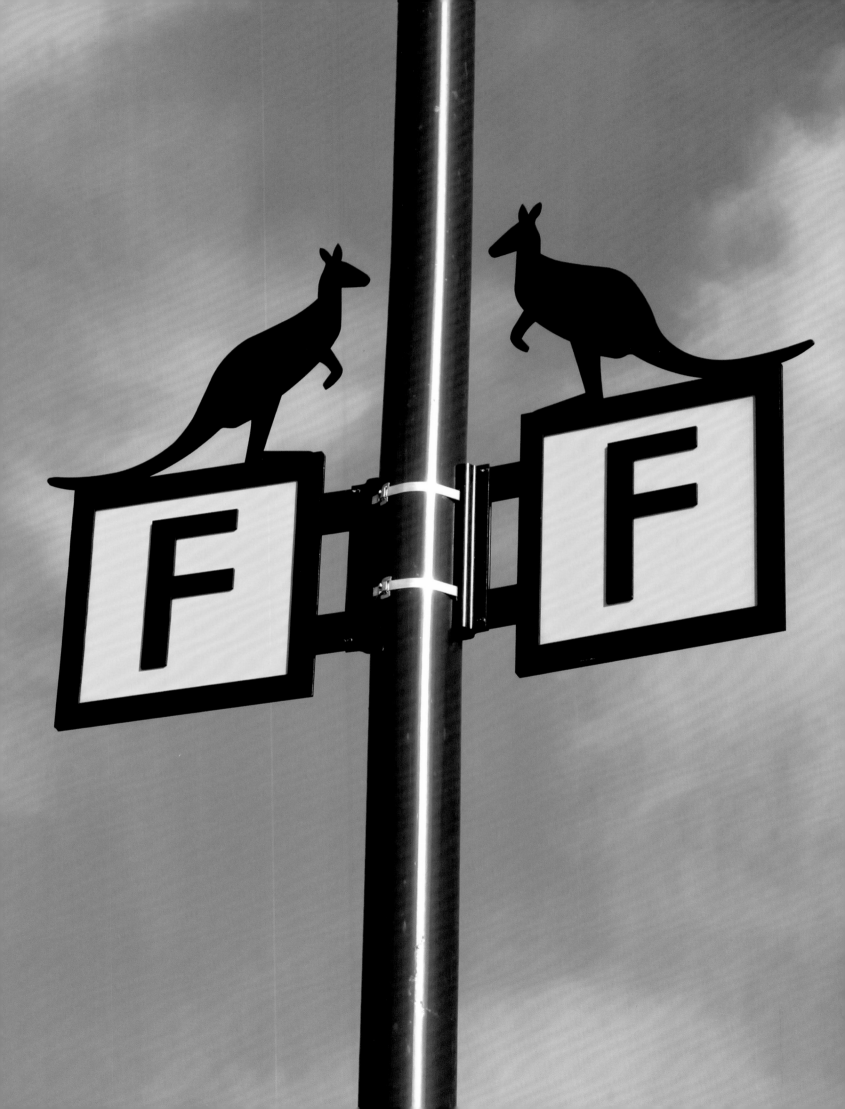

FRIENDS OF MADAGASCAR

ZOO

MEMBERSHIP CARD

COMMEMORATIVE MEMBERSHIP CARD

NEW YORK CITY

Sappi *The Standard 7 Fanciful Jungle*

As part of *The Standard 7 Packaging Perceptions*, this fanciful botanical scene allowed us to demonstrate

the variety of ways flora and fauna can enliven promotional concepts. Based on Henri Rousseau's *The Equatorial Jungle* (1909),

Nancy Stahl's contemporary interpretation brings a fresh look to Rousseau's classic painting.

California Calls You

Four Views of the California State Park System

California's state parks are precious and priceless places. And they beckon to us in unforgettable ways — the breeze through the wildflowers at Montaña de Oro, the echoes of history on Angel Island, the cry of the elephant seals at Año Nuevo. But this collection of wild and historic settings — the state parks that belong to all of us — is in unprecedented peril. California's budget crisis threatens many parks with closure. And we lack a long-term plan for stewarding nearly 100 years of investment. Today, California reaches out to us with an urgent SOS: "Save Our State Parks." And the California State Parks Foundation — for more than 40 years, our parks' trusted steward and protector — is rising to the challenge. Our $68 million fundraising campaign combines immediate steps to address park closures with an overarching strategy to safeguard state parks, realize their potential, and steward them over time. Read on to learn more about the wonders and treasures whose future is at stake — and the bold campaign that rallies us to answer the call.

CALIFORNIA STATE PARKS

DID YOU KNOW?

A Sense of Place

ORNIA'S
PARKS,
MITTED
M, AND
S YOUR
CT THEM,
FUTURE

What Can You Do?

At peak bloom, the iconic orange petals of *Eschscholzia californica* cover all 1,745 acres of Antelope Valley California Poppy Reserve. This stunning display is just one of the wonders, both natural and historic, that make California state parks unforgettable places, unique in the world.

California State Parks Foundation *Answer the Call*

Our assignment was to create a development campaign for the cash-strapped California

State Parks Foundation. The program was to include a campaign identity, a newsletter, a website and a case statement.

The case statement took the form of an oversized Wire-O brochure with four distinct mini-books bound in.

Lushly illustrated with imagery from their historical archives, along with little known facts about the parks' plans and

beautiful photos taken by amateur photographers of the parks. We also created a website

where the public could find more detailed information about the parks and how one could volunteer.

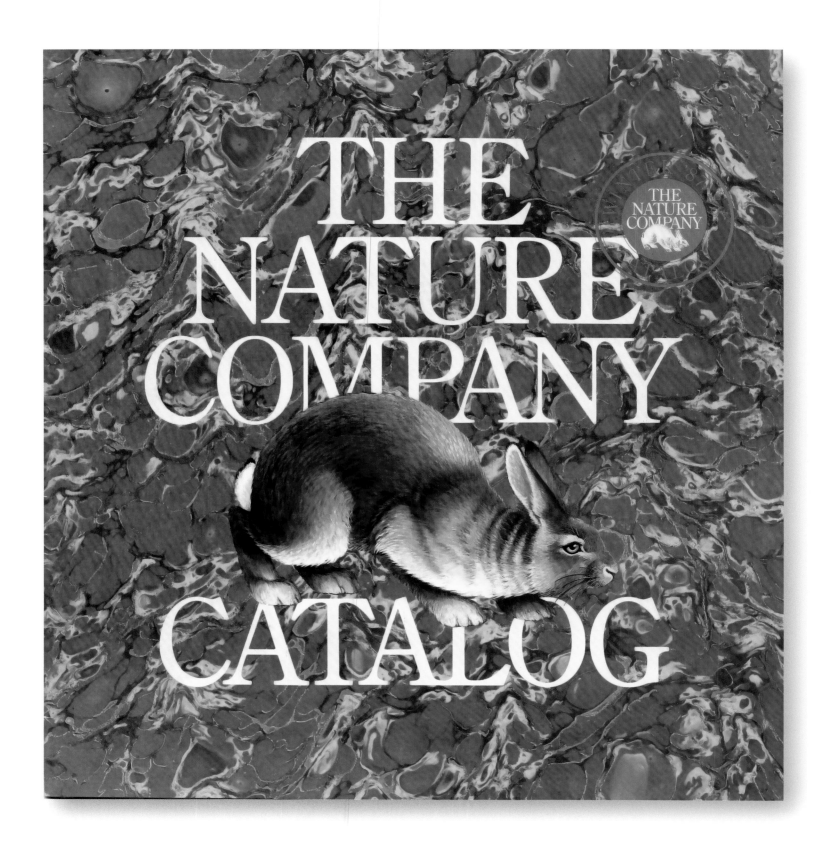

THE NATURE COMPANY CATALOG

The Nature Company Branding and Catalogs

One of California's first retail experiments, The Nature Company was founded in the early 1980s to promote merchandise that celebrated the natural world. As this cover demonstrates, an important part of the branding system was the interchangeability of an object in the brand. The European hare could be substituted with a fish, a shell, a dinosaur or other creature, either contemporary or historical.

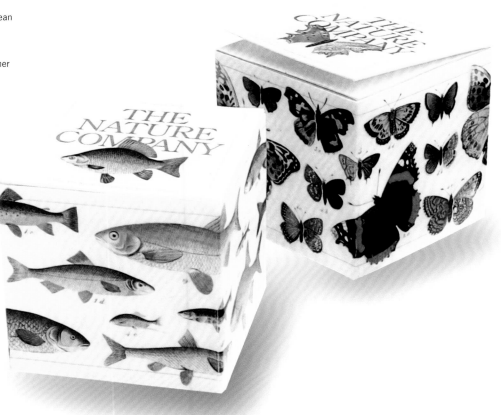

The Nature Company Packaging

We were originally commissioned to design the identity and catalog for the company. As The Nature Company expanded from six stores in the San Francisco Bay Area to over 300 nationwide, we were engaged to create a wide variety of products, signage and specialty packaging. These note blocks were an example of how to keep the brand alive through constantly changing brand extensions.

THE NATURE COMPANY

The Nature Company Brand

We paired Century Schoolbook, a typeface often associated with children's books, for the brand logotype and a European hare as the logo to give The Nature Company an approachable, slightly educational, friendly feel. Like the stores, the retail catalog featured an abundant array of nature merchandise.

There's always a surprise in store at the Nature Company—a special magic that mixes dinosaurs and dolphins, crystal kits and telescopes, fine art prints and discovery tools that kids can use. There are maps to hang on your walls, and maps to put in your pocket; intriguing objects to display as well as experiments to do. At the Nature Company, there's always more to discover!

Call Toll Free 800 227-1114
in California: 800-782-0033

11 Who's Who in The World of Animals.
Without a doubt the most readable, best illustrated survey of the world of animals available today, The new Macmillan Illustrated Animal Encyclopedia contains more than 1900 full color illustrations by renowned wildlife artists and concise biographies of the animals by leading authorities. All major families of birds, fish, reptiles and mammals covered. An invaluable reference tool and beautiful artwork in its own right. 9¼" × 11½." hardbound. #3121A $35.00

12 Inflatable Globes Great for Any Age.
These brightly colored and fully detailed vinyl Earth globes are just as accurate as any formal table model, but they can also be dropped, squeezed, kicked or carried in a pocket to school. Just blow them up and they'll stay full for months! 10½" diameter. Sold as a set of two. #1151A Pair of Globes $10.00

13 "Flying Puffins" for Jugglers or Puffin Lovers.
This happy set of bean-bag puffins is actually designed for juggling. Their great popularity makes us feel, however, that lots of people are taking them home for personal puffin pets. 3¾" high. #1115A Set of three $10.75

18 Dolphin Trifold Notecards From The California Academy of Sciences.
The playful, popular Pacific-White-Sided Dolphins from the California Academy of Sciences Museum are the subject of The Nature Company's newest note cards. Each trifold card is packaged with a blank sheet of fine notepaper to provide additional writing space. You'll have trouble deciding whether to send these off in the mail or to keep them as desktop sculptures for yourself! 4½" × 7½." Set of eight cards and envelopes. #4343A $8.95

AUDUBON ZOOLOGICAL GARD

20 This Monkey Climbs Up The Back and Over!
Each of these shoulder-clinging monkeys is an original airbrush T-shirt design by Ken Holly (creator of our last season's hit Venus Flytrap shirt), and features printing both on the back and over the shoulder onto the front. They're highly unusual and original, and a lot of fun to wear. 100% cotton, in adult sizes S (34–6), M (38–40), L (42–44) and ExL (46). Be sure to specify size. #5133A $16.95

21 Our Favorite Sea-Otter Poster.
One of the finest contemporary animal photographers, Jeff Foott always captures the spirit of his subject perfectly. His California Sea Otter—the latest in the Nature Company's Wildlife Series—is a fine example, with its irresistably lifelike detail. Available unframed or framed (as shown) in metal sectional frames with acrylic pane. 25" × 27." #9165A Unframed $20.00 #9166A Framed $90.00

THE NATURE COMPANY

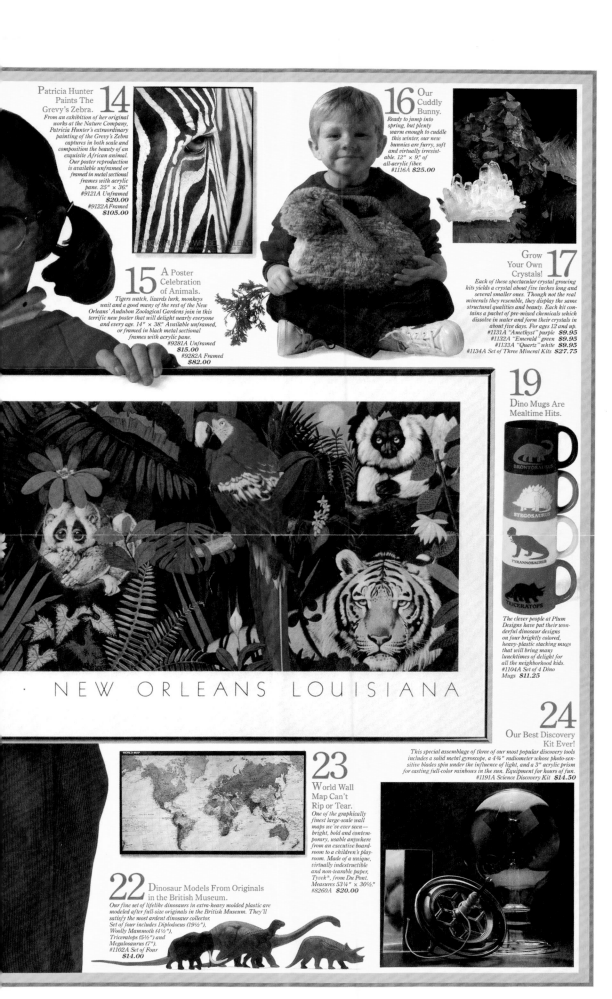

Patricia Hunter Paints The Grevy's Zebra. **14**
From an exhibition of her original works at the Nature Company, Patricia Hunter's extraordinary painting of the Grevy's Zebra captures in both scale and composition the beauty of an exquisite African animal. Our poster reproduction is available unframed or framed in metal sectional frames with acrylic pane. 25" × 36".
#9121A Unframed
$20.00
#9122A Framed
$105.00

16 **Our Cuddly Bunny.**
Ready to jump into spring, but plenty warm enough to cuddle this winter, our new bunnies are furry, soft and virtually irresistible. 12" × 9" of all-acrylic fiber.
#1116A $25.00

15 **A Poster Celebration of Animals.**
Tigers watch, lizards lurk, monkeys wait and a good many of the rest of the New Orleans' Audubon Zoological Gardens join in this terrific new poster that will delight nearly everyone and every age. 14" × 38". Available unframed, or framed in black metal sectional frames with acrylic pane.
#9281A Unframed
$15.00
#9282A Framed
$82.00

Grow Your Own Crystals! **17**
Each of these spectacular crystal growing kits yields a crystal about five inches long and several smaller ones. Though not the real minerals they resemble, they display the same structural qualities and beauty. Each kit contains a packet of pre-mixed chemicals which dissolve in water and form their crystals in about five days. For ages 12 and up.
#1131A "Amethyst" purple $9.95
#1132A "Emerald" green $9.95
#1133A "Quartz" white $9.95
#1134A Set of Three Mineral Kits $27.75

19 **Dino Mugs Are Mealtime Hits.**
The clever people at Plum Designs have put their wonderful dinosaur designs on four brightly colored, heavy-plastic stacking mugs that will bring many lunchtimes of delight for all the neighborhood kids.
#1104A Set of 4 Dino Mugs $11.25

· NEW ORLEANS LOUISIANA

24 **Our Best Discovery Kit Ever!**
This special assemblage of three of our most popular discovery tools includes a solid metal gyroscope, a 4¾" radiometer whose photo-sensitive blades spin under the influence of light, and a 3" acrylic prism for casting full-color rainbows in the sun. Equipment for hours of fun.
#1191A Science Discovery Kit $14.50

23 **World Wall Map Can't Rip or Tear.**
One of the graphically finest large-scale wall maps we've ever seen— bright, bold and contemporary, usable anywhere from an executive boardroom to a children's playroom. Made of a unique, virtually indestructible and non-tearable paper, Tyvek®, from Du Pont. Measures 53¼" × 30½".
#8260A $20.00

22 **Dinosaur Models From Originals in the British Museum.**
Our fine set of lifelike dinosaurs in extra-heavy molded plastic are modeled after full-size originals in the British Museum. They'll satisfy the most ardent dinosaur collector. Set of four includes Diplodocus (19½"), Woolly Mammoth (4½"), Triceratops (5½") and Megalosaurus (7").
#1102A Set of Four
$14.00

The Nature Company Packaging

The Nature Company developed a line of unique products sold exclusively by the brand and asked us to design packaging in keeping with the brand's color system, typography and playful spirit. The packaging above was for a selection of inflatable dinosaurs and reptiles.

Sappi

The Standard 5

Hip-Hop Beetle

A print education piece
for Sappi, *The Standard*
demonstrated how well
Sappi papers could handle
any kind of printing process.
For *The Standard 5* on
special printing techniques,
we chose to team with
826 Valencia, a nonprofit
after-school tutoring
program that held sessions
in imaginary stores –
such as the Pirate Supply
Store, the Museum of
Unnatural History and
Robot Supply and Repair.
The theme let us create
all kinds of fanciful
characters such as the
hip-hop beetle.

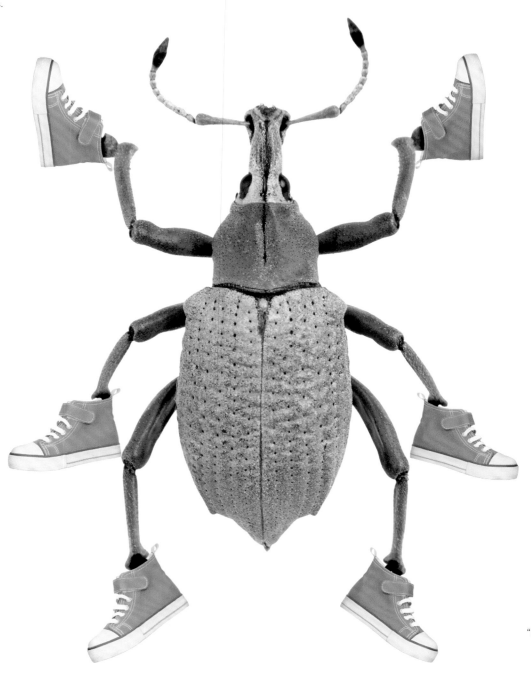

Sappi

The Standard 5

Alien

To extend the theme of
"nature" to other planetary
realms, we asked Italian
artisit Beppe Giacobbe
to create an alien with
360-degree eye view, in
an interstellar landscape
for the Space Travel
Supply store.

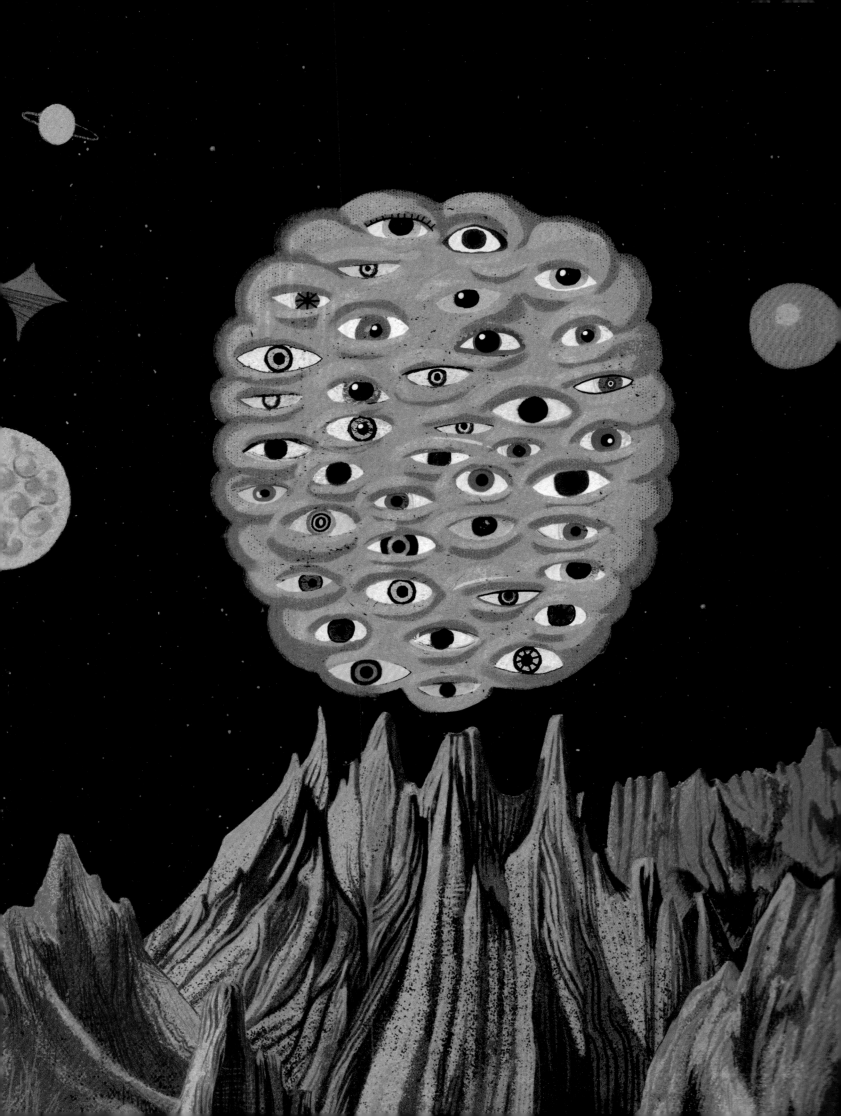

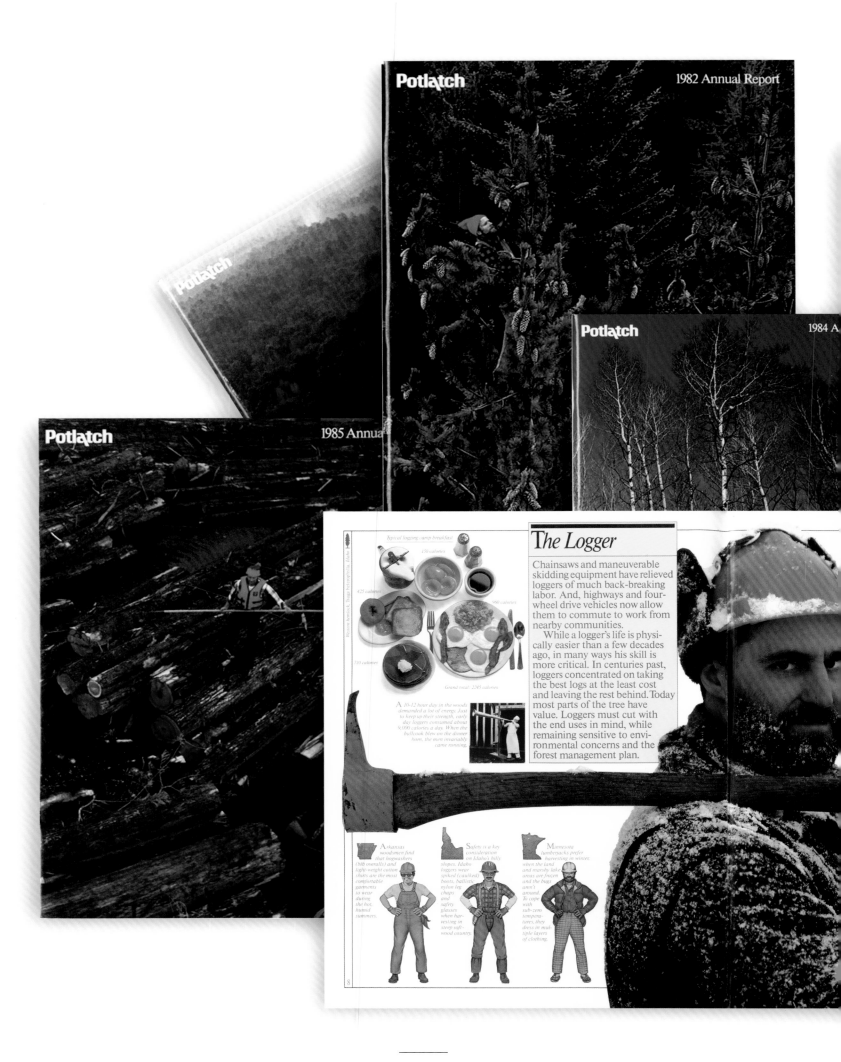

Potlatch 1982 Annual Report

Potlatch 1984 A...

Potlatch 1985 Annua...

Typical logging camp breakfast

150 calories

425 calories

660 calories

710 calories

Grand total: 2345 calories

A 10-12 hour day in the woods demanded a lot of energy. Just to keep up their strength, early day loggers consumed about 9,000 calories a day. When the bullcook blew on the dinner horn, the men invariably came running.

The Logger

Chainsaws and maneuverable skidding equipment have relieved loggers of much back-breaking labor. And, highways and four-wheel drive vehicles now allow them to commute to work from nearby communities.

While a logger's life is physically easier than a few decades ago, in many ways his skill is more critical. In centuries past, loggers concentrated on taking the best logs at the least cost and leaving the rest behind. Today most parts of the tree have value. Loggers must cut with the end uses in mind, while remaining sensitive to environmental concerns and the forest management plan.

Arkansas woodsmen find that hogwashers (bib overalls) and light-weight cotton shirts are the most comfortable garments to wear during the hot, humid summers.

Safety is a key consideration on Idaho's hilly slopes. Idaho loggers wear spiked (caulked) boots, ballistic nylon leg chaps and safety glasses when harvesting in steep softwood country.

Minnesota lumberjacks prefer harvesting in winter, when the land and marshy lake areas are frozen and the bugs aren't around. To cope with sub-zero temperatures, they dress in multiple layers of clothing.

8

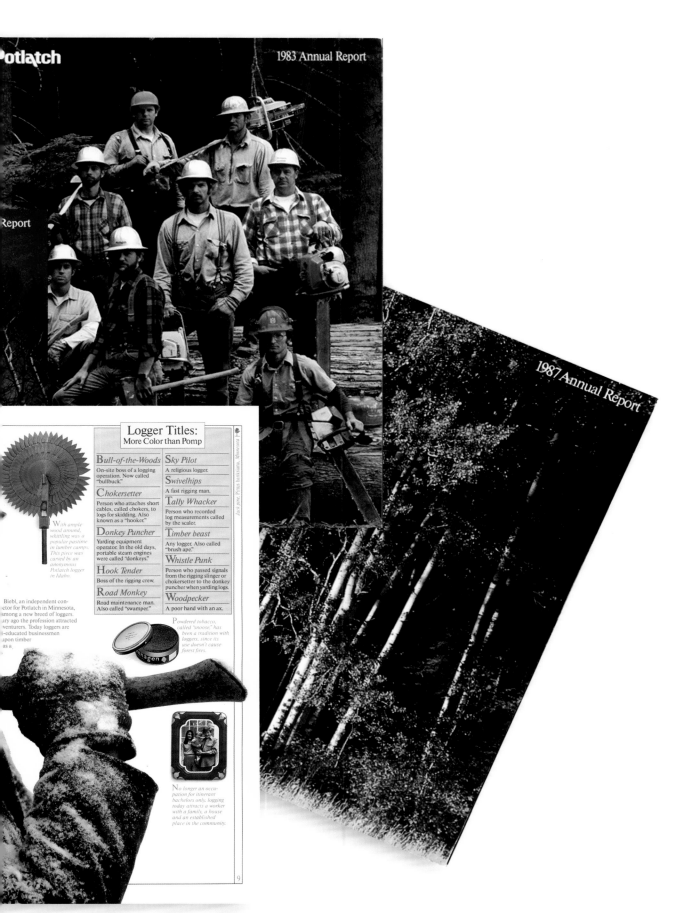

Potlatch
Annual Reports

We designed the annual report for Potlatch Corporation for more than 20 years. A forest products company that sustainably harvested timber and manufactured it into lumber and paper products, Potlatch had a rich, exciting and colorful history – too much to cover in a single book. We suggested it be presented over a six-year period. Each annual report took an encyclopedic look at part of the business. The series was unprecedented in the industry and became a teaching tool in Idaho's educational institutions.

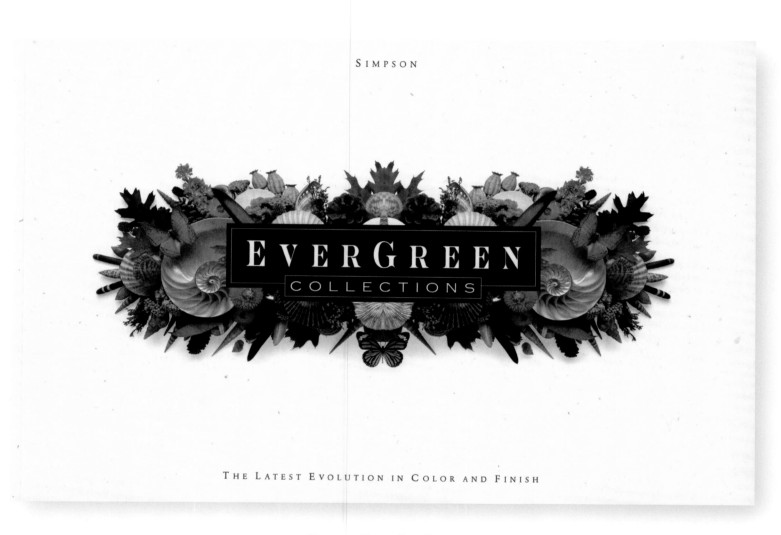

Simpson Paper EverGreen

Simpson Paper engaged us from the start of product development of a new line of uncoated recycled papers.

We were asked to create the name, review the color palette and develop a complete launch campaign, including brochures,

swatch books, ads and other materials. From the name EverGreen, we created a brand persona that aligned their identity with the natural world.

The brochure was illustrated with original photographs, historic paintings, prints and commissioned drawings

that added an authenticity to the entire campaign.

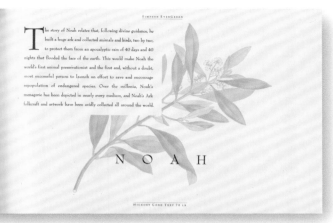

The story of Noah relates that, following divine guidance, he built a huge ark and collected animals and birds, two by two, to protect them from an apocalyptic rain of 40 days and 40 nights that flooded the face of the earth. This would make Noah the world's first animal preservationist and the first and, without a doubt, most successful person to launch an effort to save and encourage repopulation of endangered species. Over the millenia, Noah's menagerie has been depicted in nearly every medium, and Noah's Ark folkcraft and artwork have been avidly collected all around the world.

N O A H

THE HISTORIC APOLLO 11 LUNAR-LANDING MISSION IN 1969 AIMED NOT ONLY TO PUT THE FIRST MAN ON THE MOON BUT TO BRING HOME SAMPLES OF MOON ROCK SO SCIENTISTS COULD SEARCH FOR CLUES TO THE ORIGIN OF THE SOLAR SYSTEM. AS MORE THAN 600 MILLION PEOPLE WATCHED FROM EARTH 240,000 MILES AWAY, ASTRONAUT

NEIL ARMSTRONG {1930-} TOOK "ONE GIANT LEAP FOR MANKIND." IN ADDITION TO PERFORMING SCIENTIFIC EXPERIMENTS, ARMSTRONG COLLECTED ABOUT 46 POUNDS OF LUNAR TOPSOIL AND ROCKS AND GATHERED SOLAR PARTICLES ON A STRIP OF ALUMINUM FOIL. A MOON ROCK SPECIMEN IS ON EXHIBIT AT THE SMITHSONIAN'S AIR AND SPACE MUSEUM.

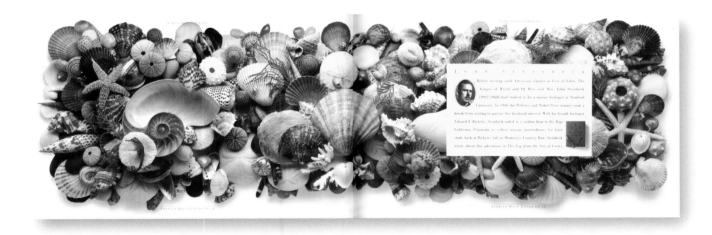

JOHN STEINBECK

Before writing such American classics as East of Eden, The Grapes of Wrath and Of Mice and Men, John Steinbeck (1902-1968) had studied to be a marine biologist at Stanford University. In 1940 the Pulitzer and Nobel Prize winner took a break from writing to pursue this boyhood interest. With his friend, biologist Edward F. Ricketts, Steinbeck sailed in a sardine boat to the Baja California Peninsula to collect marine invertebrates for later study back at Ricketts' lab on Monterey's Cannery Row. Steinbeck wrote about this adventure in The Log from the Sea of Cortez.

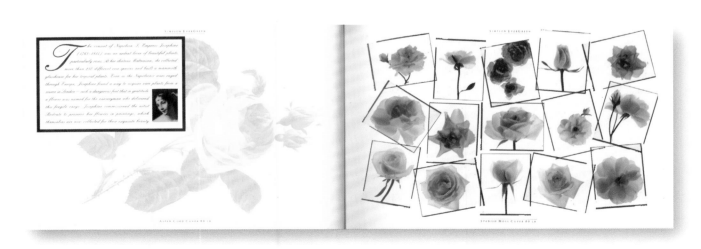

The consort of Napoleon I, Empress Josephine (1763-1814) was an ardent lover of beautiful plants, particularly roses. At her chateau Malmaison, she cultivated more than 250 different rose species and built a mammoth glasshouse for her tropical plants. Even in the Napoleonic wars raged through Europe, Josephine found a way to acquire rare plants from a center in London — such a dangerous feat that a gunboat's officers was named for the courageous who delivered this fragile cargo. Josephine commissioned the artist Redouté to preserve her flowers in paintings, which themselves are now collected for their exquisite beauty.

MOMENTS IN TIME

Designers are frequently asked to create

an emblem, logo, image or object to commemorate

noteworthy events and anniversaries.

Such assignments demand understanding the significance

of the moment and embodying it in the design.

**First
Responder
Poster**

This somber flag with
the vibrantly contrasting
colors of the Stars & Stripes
in "9-11" was created as
a remembrance to those
who perished in the
collapse of New York's
World Trade Centers and to
honor the first responders
after the attack.

9.11

Golden Gate Bridge 75th Anniversary Seal

The Golden Gate National Parks Conservancy asked us to create a commemorative symbol marking the 75th anniversary of the building of San Francisco's beloved bridge. Of course, the iconic international orange color of the bridge and the Art Deco style of the towers made an ideal medallion.

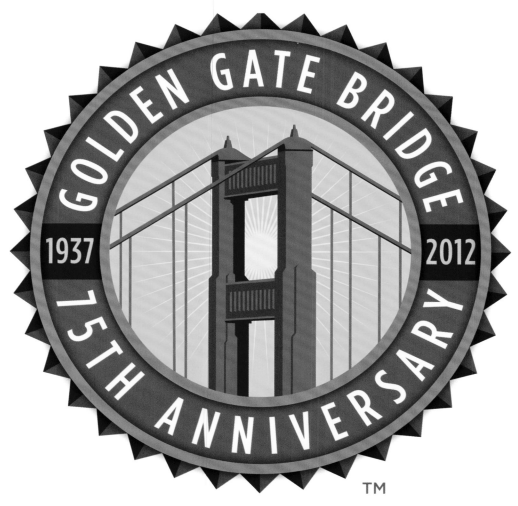

GOLDEN GATE BRIDGE

1937 2012

75TH ANNIVERSARY

TM

Golden Gate Bridge 75th Anniversary Promotions

In addition to displaying the logo on all 75th anniversary promotional materials citywide with banners and souvenir items, it was etched into the glass at the bridge's Welcome Center.

GOLDEN GATE BRIDGE · OPENED MAY 27, 1937 ·

BRIDGE
PAVILION
INFORMATION & STORE

A HISTORY OF ART CENTER COLLEGE OF DESIGN

AND THE MYRIAD WAYS ITS ALUMNI SHAPE AND

INFORM THE VISION OF OUR GLOBAL CULTURE

ArtCenter *Design Impact* Boxed Set

When ArtCenter, my alma mater, celebrated their 75th anniversary, I was asked to produce

a commemorative book that showcased the contributions that graduates made to contemporary visual culture.

Alumni who rose to the top of their field were too numerous to feature only a few. That led to creating a boxed set.

One hard-bound book provided an overview of ArtCenter's 75-year history, and a second part

was an 80-foot-long "exhibit in a box" made up of eight 10-foot-long sections showing the seminal

work created by alumni over the past 75 years.

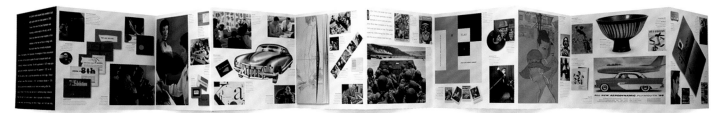

The renowned achievements of alumni were presented by decade

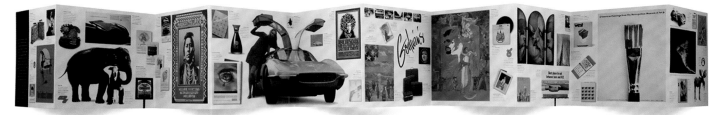

in 10-foot-long accordion-fold panels.

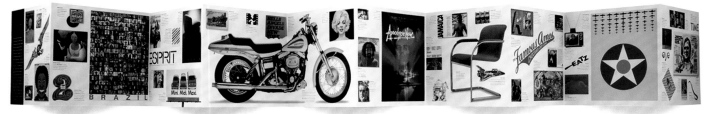

A monumental undertaking, we teamed with

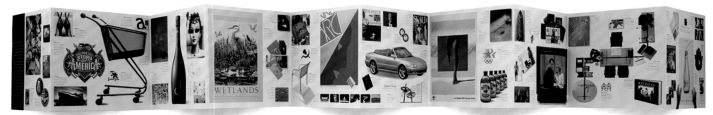

ArtCenter to showcase famous works generated by graduates in

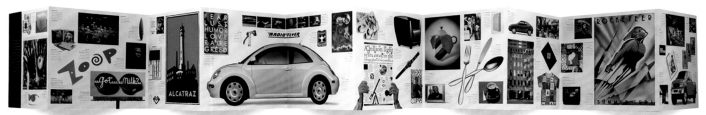

graphic design, transportation and product design, illustration, photography, environmental design,

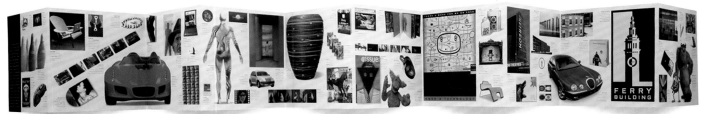

filmmaking, photography and art direction.

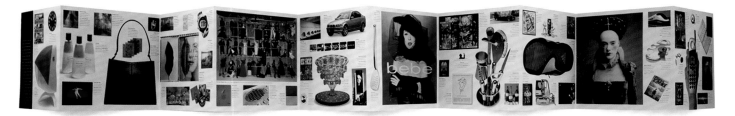

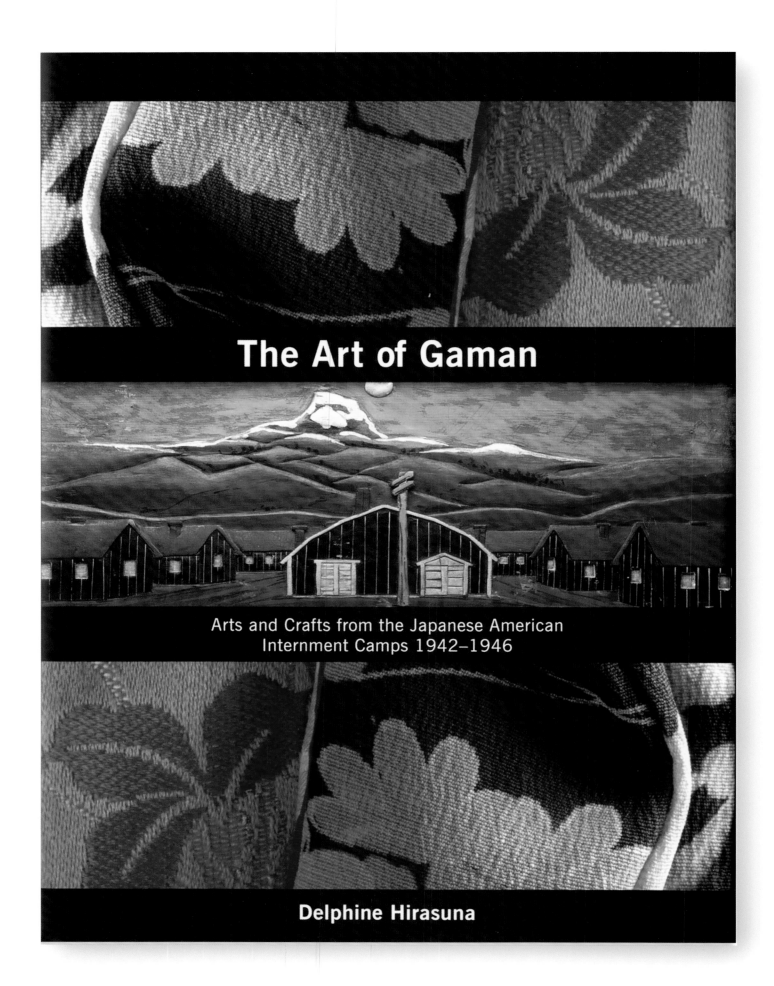

The Art of Gaman

Arts and Crafts from the Japanese American
Internment Camps 1942–1946

Delphine Hirasuna

Searching for an unusual

approach to demonstrate

the variety of images,

both contemporary and

historical, encompassed

in the Corbis Collection

was an exciting challenge.

A 24/7, 365 day-at-a-

glance calendar format

showcased the vast range

of the Corbis Collection.

In addition to the print

calendar, a digital version

was also developed.

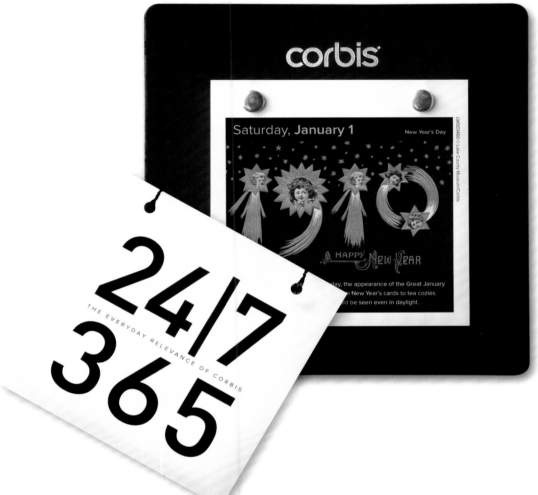

The Art
of Gaman Book

This 124-page book is

a celebration of the art

created in the Japanese

American internment

camps from 1942–1946.

Written by Delphine

Hirasuna and photographed

by Terry Heffernan, it

shows a unique look inside

this American tragedy.

1983 S S M T W T F S S M T W T F S S M T W T F S
Jan. 1 2 3 4 5 6 7 8 9 10 11 12 13 14 15 16 17 18 19 20 21 22

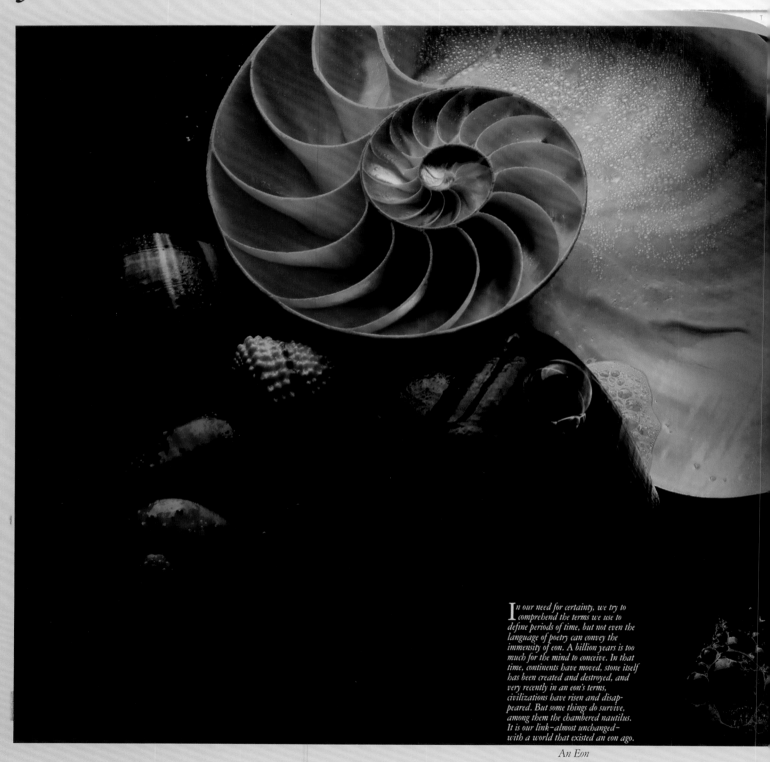

I n our need for certainty, we try to comprehend the terms we use to define periods of time, but not even the language of poetry can convey the immensity of eon. A billion years is too much for the mind to conceive. In that time, continents have moved, stone itself has been created and destroyed, and very recently in an eon's terms, civilizations have risen and disappeared. But some things do survive, among them the chambered nautilus. It is our link–almost unchanged– with a world that existed an eon ago.

An Eon

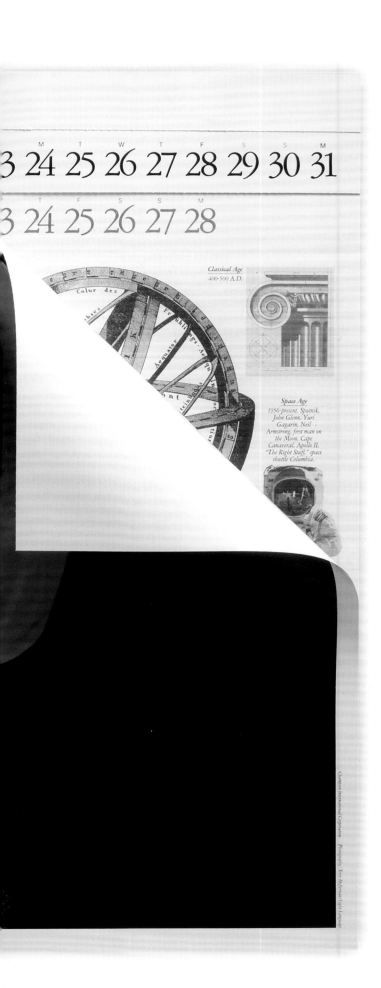

Classical Age
400-500 A.D.

Space Age
1956-present, Sputnik,
John Glenn, Yuri
Gagarin, Neil
Armstrong, first man on
the Moon, Cape
Canaveral, Apollo II,
"The Right Stuff," space
shuttle Columbia.

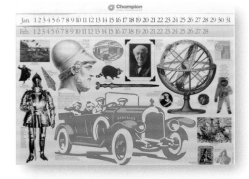

Champion
Calendar

To promote Champion
papers, we designed a wall
calendar to show the
colors and finishes of the
papers they make. Each
successive month on
the calendar showed
contemporary and historic
images that represented
periods of time, from an
eon, an age, a generation,
a score, a year, a season,
a month, a day, an hour, a
minute and a second.
We designed each sheet
so the image got
progressively shorter
as the page of the previous
month was torn away. By
year-end, only the days of
the year remained, creating
a "swatchbook" of sorts
showing the entire
Champion paper palette.

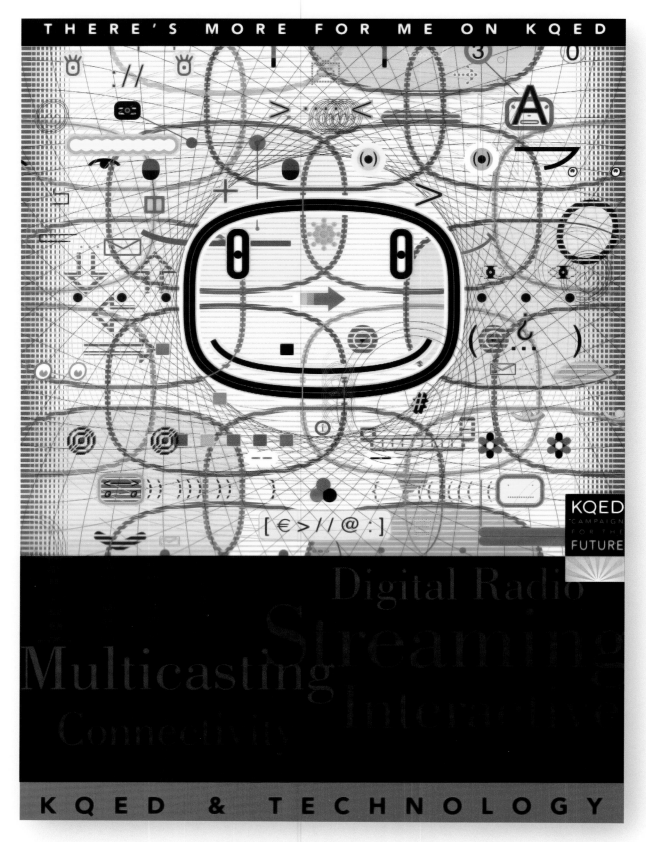

KQED *Campaign for the Future* Posters

KQED, the Bay Area's public television station, commissioned us to develop a publicity campaign to raise funds

for much needed technological upgrades. Through informational interviews with KQED management, we identified target audiences for

the fundraising appeal, and engaged well-known artists to create posters related to the subjects of education,

the arts, children, technology, ethnicity and culture. The art was used in an advertising campaign, in direct mail marketing and in

bus shelters around the Bay Area. Illustration by John Hersey.

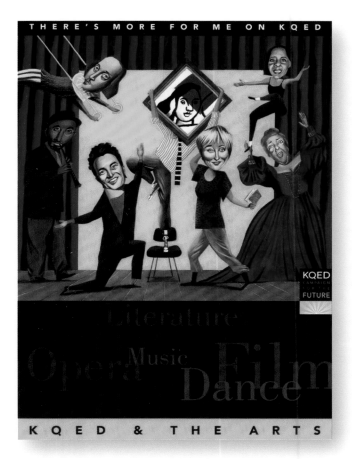

Artist: Mark Ulriksen

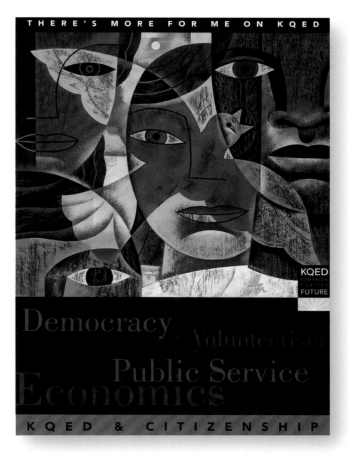

Artist: Rafael López

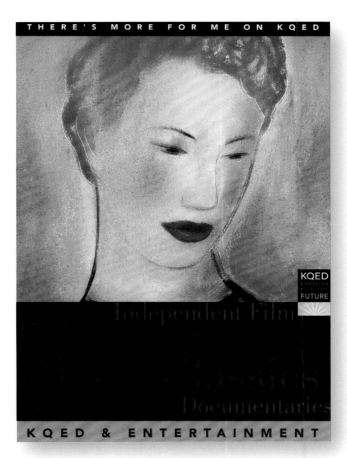

Artist: Vivienne Flesher

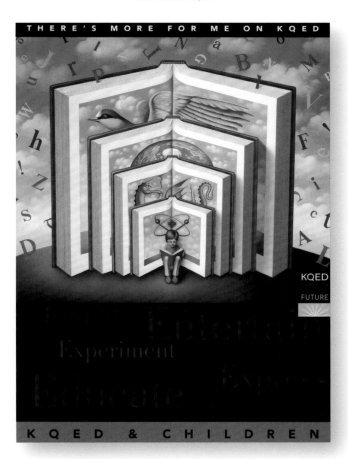

Artist: Gary Overacre

THE ONE SHOW | VOLUME 33

ONE SHOW INTERACTIVE | VOLUME 14

ONE SHOW DESIGN | VOLUME 5

ONE SHOW ANNUALS

THE ONE SHOW | VOLUME

ONE SHOW INTERACTIVE |

ONE SHOW DESIGN | VOL

**One Show
Annual Books**

The prestigious One Show is one of the most coveted awards for creativity in the United States. Each year they publish a set of annuals featuring design, advertising and interactive winners. We were asked to design the books in 2011. The annuals were meant to be sold as a boxed set or individually. We designed the box and volumes with gradated stripes so they could be identified as a matched set, yet still look good as a single book.

VOLUME 14

5

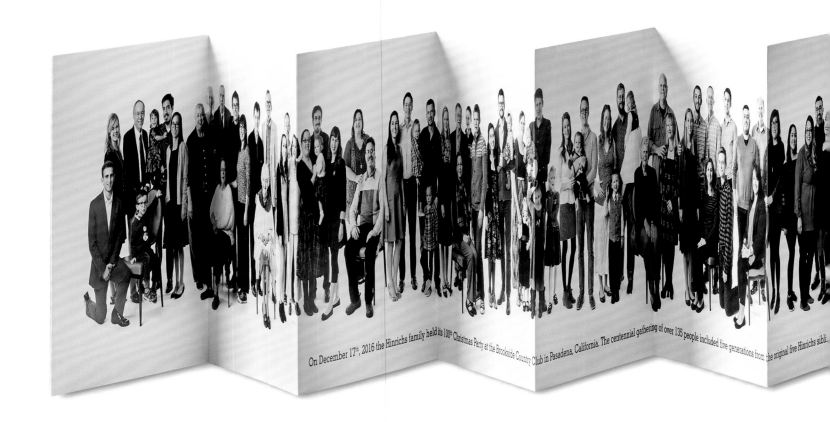

Hinrichs Centennial Family Gathering

For nearly a century, the original five Hinrichs siblings gathered each year for a Christmas Party, and the event has been carried on ever since by their offspring and descendants.

To celebrate the 100th anniversary, we asked a photographer to set up a "studio" and photograph family groups, which we photoshopped together to create one large family portrait.

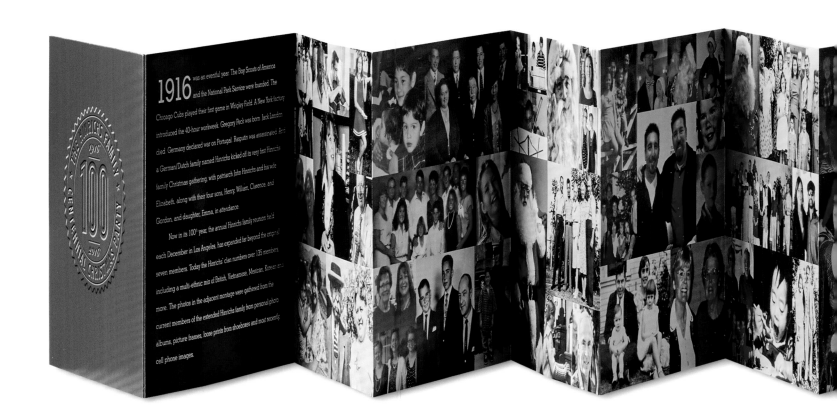

122

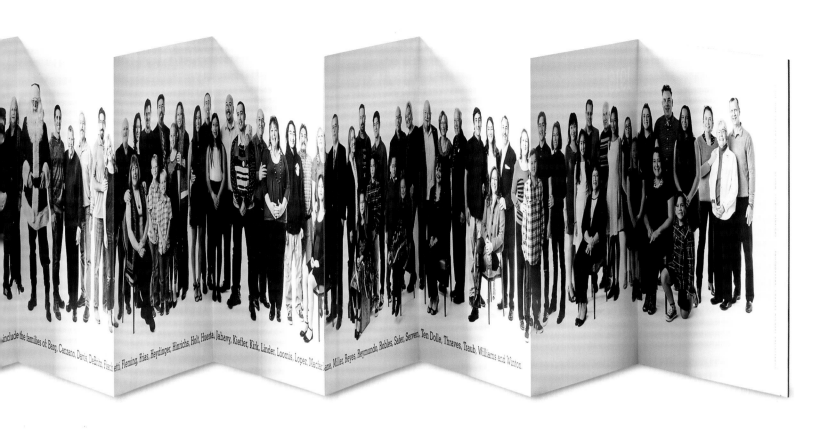

The photo was scanned, printed and bound as an accordion-fold memento. The reverse side of the family

picture featured a montage of photos taken over the past 99 years. The unfolded piece measured 8 inches high by 98 inches wide.

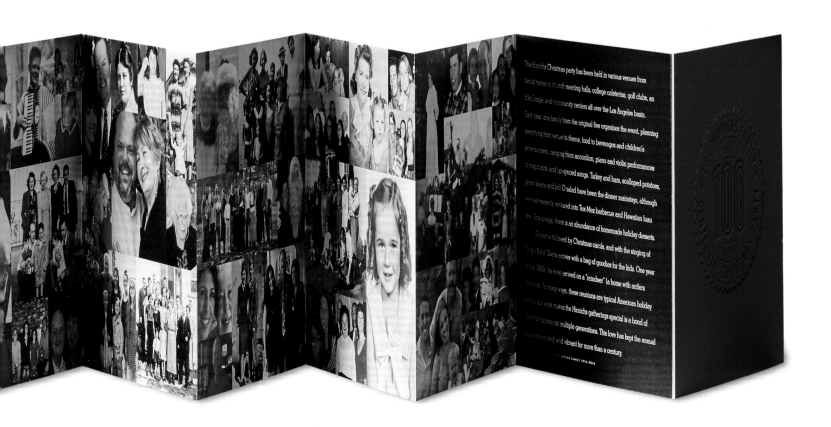

Long May She Wave **Book**

Featuring a large portion of my Stars & Stripes memorabilia collection, *Long May She Wave* takes a graphic look at the role the flag played throughout American history. The book examines the changing symbolism of the flag in times of war, celebration, tragedy, commerce, politics, etc. Its meaning changes, even as the flag remains a constant.

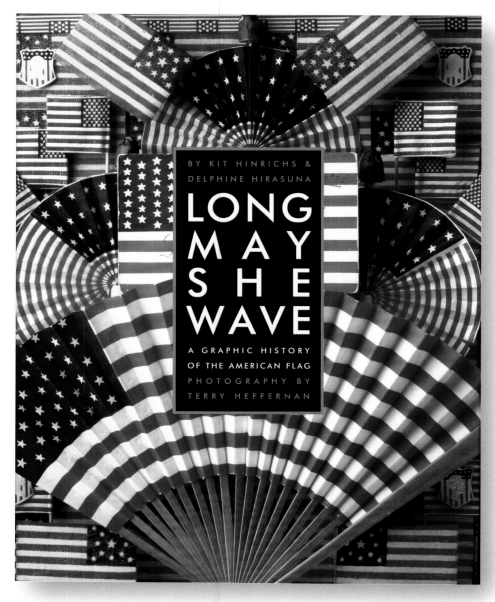

BY KIT HINRICHS &
DELPHINE HIRASUNA

LONG
MAY
SHE
WAVE

A GRAPHIC HISTORY
OF THE AMERICAN FLAG
PHOTOGRAPHY BY
TERRY HEFFERNAN

Long May She Wave **Museum Exhibition**

The Nevada Museum of Art, asked us to host an exhibition of my flag collection and designated 8,500-square-feet of space for the show. Together with the museums's curator, we designed and organized artifacts with vitrines filled with small Stars & Stripes objects, contrasted against large-scale wall panels, including this three-story long banner to introduce the exhibition.

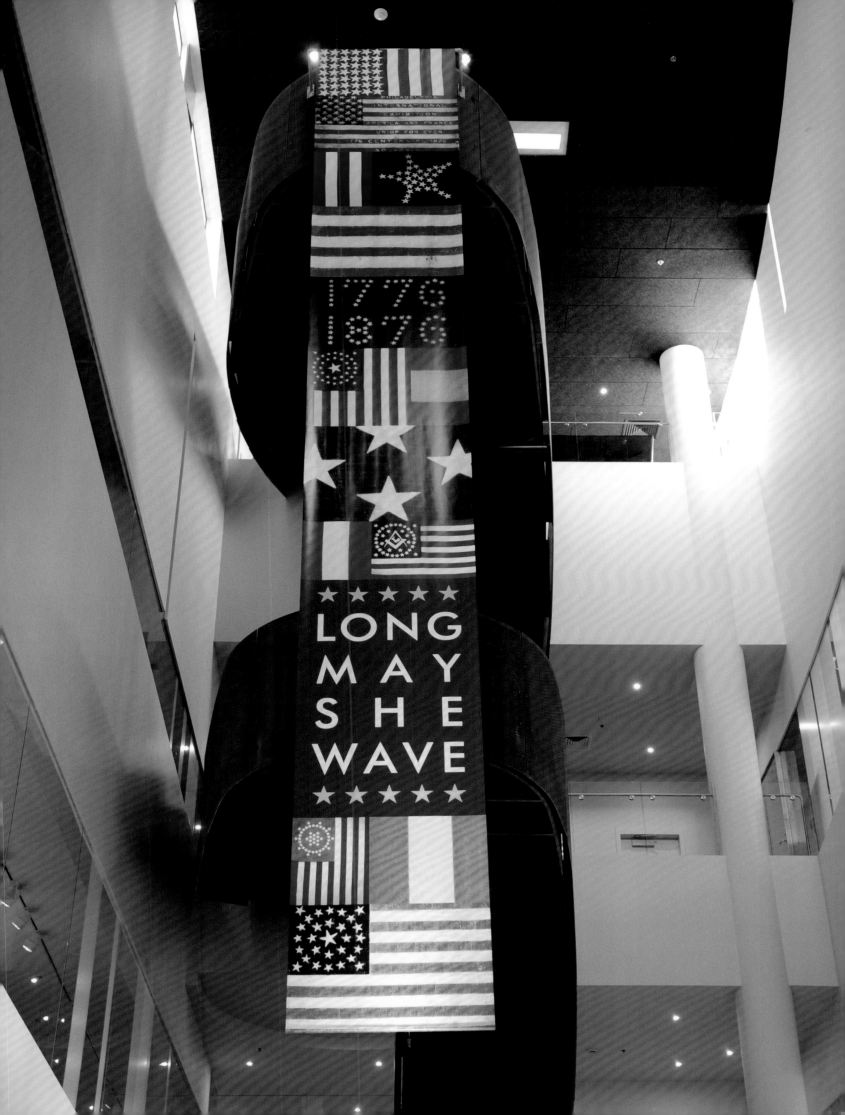

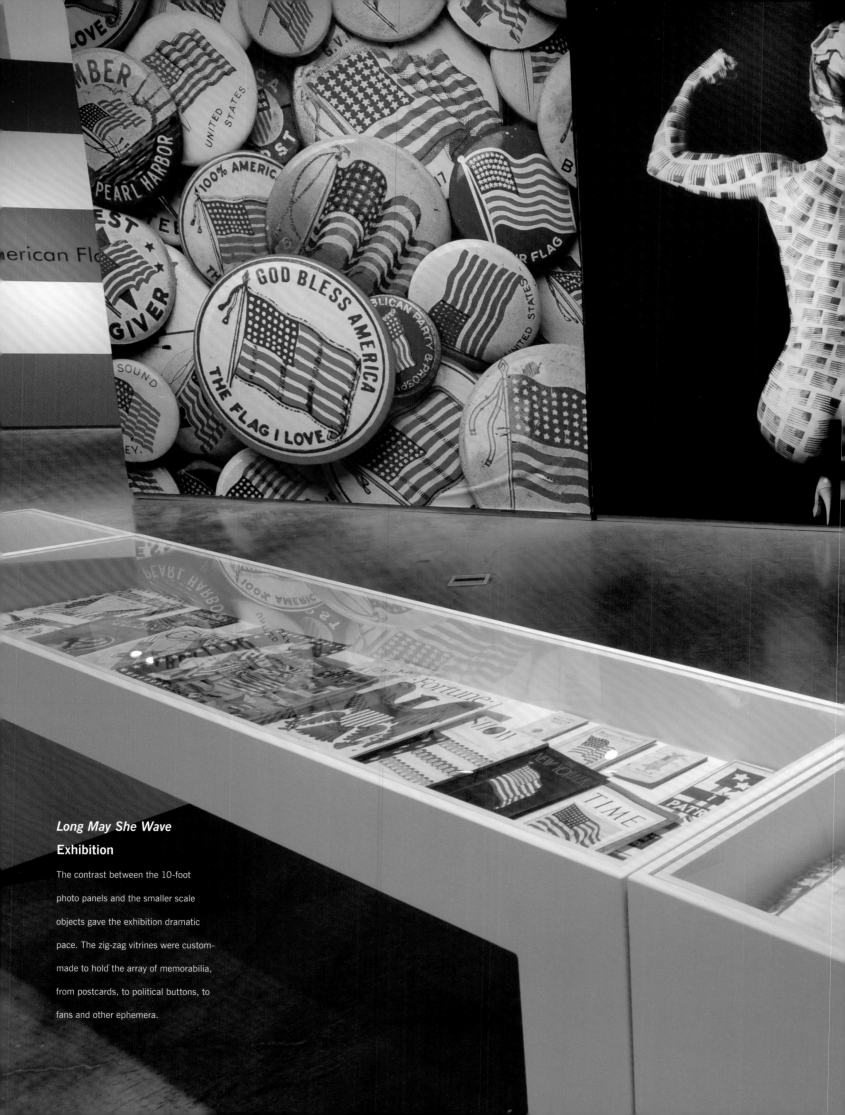

Long May She Wave
Exhibition

The contrast between the 10-foot
photo panels and the smaller scale
objects gave the exhibition dramatic
pace. The zig-zag vitrines were custom-
made to hold the array of memorabilia,
from postcards, to political buttons, to
fans and other ephemera.

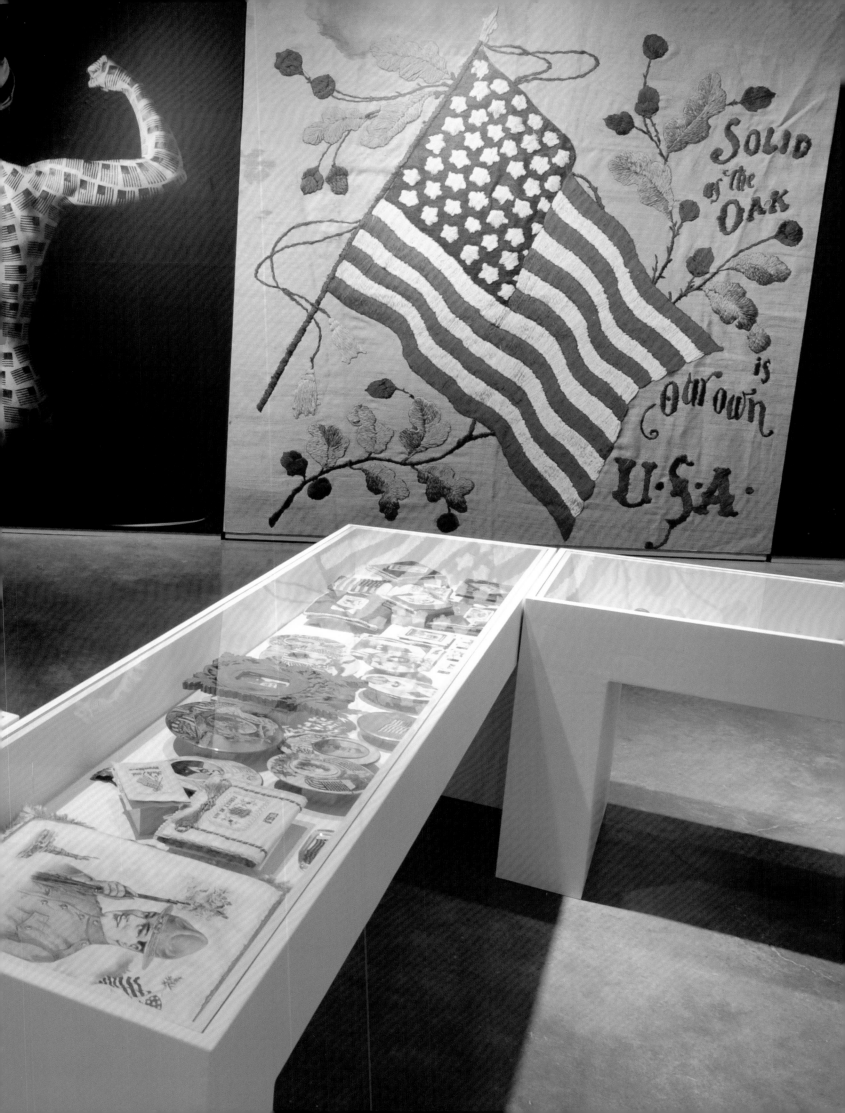

Delphine Hirasuna's *The Art of Gaman* book was turned into a traveling exhibition shown in 15 museums, including the Smithsonian's Renwick Gallery. For the entry to the galleries, we expressed the irony of putting Americans of Japanese descent in World War II internment camps, by constructing an American flag out of origami cranes and displaying it in front of the order instructing all people of Japanese ancestry to report to a concentration camp.

USPS *Bicentennial Flag Act* Stamp and 1st Day Cover

Being asked to design a commemorative postage stamp for the Bicentennial of the Flag Act aligned perfectly with my passion for collecting Stars & Stripes memorabilia. In addition to designing the stamp, we created a limited edition envelope for the "First Day of Issue." It was the first of four flag stamps we designed for the USPS.

The Art of Gaman

Arts and Crafts from the Japanese American Internment Camps

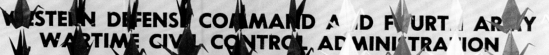

WESTERN DEFENSE COMMAND AND FOURTH ARMY
WARTIME CIVIL CONTROL ADMINISTRATION
Presidio of San Francisco, California
May 3, 1942

INSTRUCTIONS
TO ALL PERSONS OF
JAPANESE
ANCESTRY

Living in the Following Area:

All of that portion of the County of Alameda, State of California, within the boundary beginning at the point where the southerly limits of the City of Oakland meet San Francisco Bay; thence easterly and following the southerly limits of said city to U.S. Highway No. 50; thence southerly and easterly along said Highway No. 50 to its intersection with California State Highway No. 21; thence southerly on said Highway No. 21 to its intersection, at or near Warm Springs, with California State Highway No. 17; thence southerly on said Highway No. 17 to the Alameda-Santa Clara County line; thence westerly and following said county line to San Francisco Bay; thence northerly and following the shoreline of San Francisco Bay to the point of beginning.

Pursuant to the provisions of Civilian Exclusion Order No. 34, this Headquarters, dated May 3, 1942, all persons of Japanese ancestry, both alien and non-alien, will be evacuated from the above area by 12 o'clock noon, P. W. T., Saturday, May 9, 1942.

No Japanese person living in the above area will be permitted to change residence after 12 o'clock noon, P. W. T., Sunday, May 3, 1942, without obtaining special permission from the representative of the Commanding General, Northern California Sector, at the Civil Control Station located at:

920 - "C" Street,
Hayward, California.

Such permits will only be granted for the purpose of uniting members of a family, or in cases of grave emergency.

The Civil Control Station is equipped to assist the Japanese population affected by this evacuation in the following ways:

1. Give advice and instructions on the evacuation.
2. Provide services with respect to the management, leasing, sale, storage or other disposition of most kinds of property, such as real estate, business and professional equipment, household goods, boats, automobiles and livestock.
3. Provide temporary residence elsewhere for all Japanese in family groups.
4. Transport persons and a limited amount of clothing and equipment to their new residence.

The Following Instructions Must Be Observed:

1. A responsible member of each family, preferably the head of the family, or the person in whose name most of the property is held, and each individual living alone, will report to the Civil Control Station to receive further instructions. This must be done between 8:00 A. M. and 5:00 P. M. on Monday, May 4, 1942, or between 8:00 A. M. and 5:00 P. M. on Tuesday, May 5, 1942.

2. Evacuees must carry with them on departure for the Assembly Center, the following property:
 (a) Bedding and linens (no mattress) for each member of the family;
 (b) Toilet articles for each member of the family;
 (c) Extra clothing for each member of the family;
 (d) Sufficient knives, forks, spoons, plates, bowls and cups for each member of the family;
 (e) Essential personal effects for each member of the family.

All items carried will be securely packaged, tied and plainly marked with the name of the owner and numbered in accordance with instructions obtained at the Civil Control Station. The size and number of packages is limited to that which can be carried by the individual or family group.

3. No pets of any kind will be permitted.

4. No personal items and no household goods will be shipped to the Assembly Center.

5. The United States Government through its agencies will provide for the storage, at the sole risk of the owner, of the more substantial household items, such as iceboxes, washing machines, pianos and other heavy furniture. Cooking utensils and other small items will be accepted for storage if crated, packed and plainly marked with the name and address of the owner. Only one name and address will be used by a given family.

6. Each family, and individual living alone, will be furnished transportation to the Assembly Center or will be authorized to travel by private automobile in a supervised group. All instructions pertaining to the movement will be obtained at the Civil Control Station.

Go to the Civil Control Station between the hours 8:00 A. M. and 5:00 P. M.,
Monday, May 4, 1942, or between the hours of 8:00 A. M. and 5:00 P. M.,
Tuesday, May 5, 1942, to receive further instructions.

J. L. DEWITT
Lieutenant General, U. S. Army
Commanding

SEE CIVILIAN EXCLUSION ORDER NO. 34.

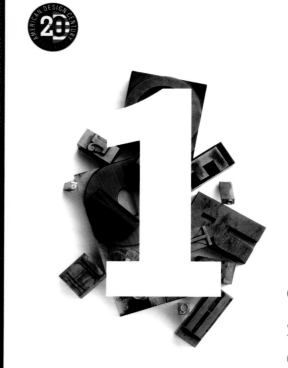

Vintage: Typography

Potlatch McCoy: Posters

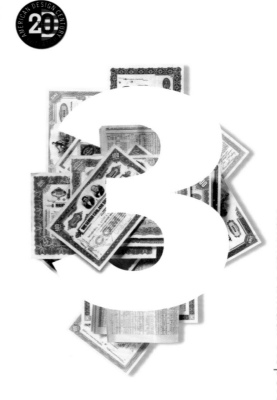

Karma: Annual Reports

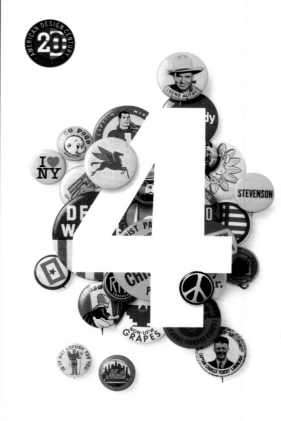

Potlatch Premium Papers: Icons

Potlatch
American
Design Century
Covers

Each cover of the four
books had an integration
of type and imagery that
defined the content of each
book and the orders of the
series sequences.

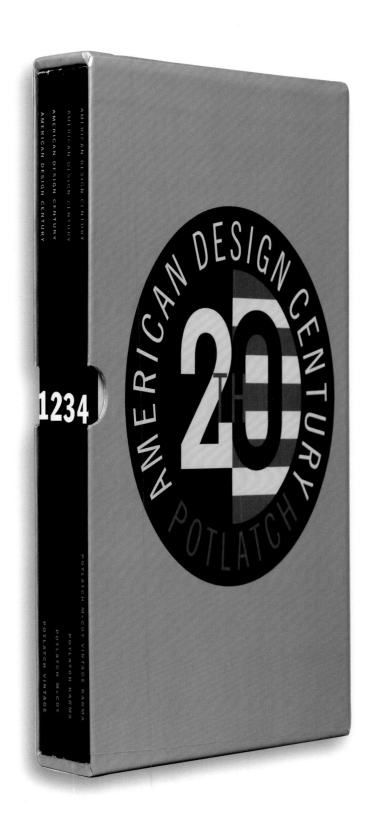

Potlatch
American Design
Century **Series**
Slipcase

Asked to produce another
promotional brochure for
Potlatch papers, it occurred
to us that while every industry
was doing a retrospective of
work produced in the 20th
century, no one had focused
exclusively on the importance
of graphic design. We
proposed creating four books –
on typography, posters, annual
reports and cultural icons
– each printed on a different
Potlatch paper grade. As the
20th century came to a close,
we sent customers a slipcase
box to hold all four volumes.

CULTURAL PHENOMENA

PERSONAL PASSIONS

COLLECTIONS

RETROSPECTION

THE PENTAGRAM PAPERS

A collection of 36 papers
containing curious, entertaining,
stimulating, provocative,
and occasionally controversial
points of view that have
come to the attention of, or in
some cases are actually
originated by, the partners
of Pentagram Design

CREATED BY THE PENTAGRAM PARTNERS

EDITED BY DELPHINE HIRASUNA

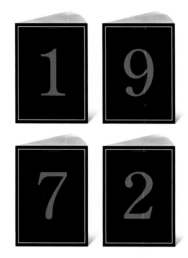

The Pentagram
Papers Book

The Pentagram Papers, aka "little black books," produced occasionally by the Pentagram partners since 1972, originally began with London partner John McConnell. The series had become highly collectible in the design community. While still a partner of Pentagram, Chronicle Books asked us to produce a compendium of these little books, which I did with the help of writer and editor Delphine Hirasuna, and my international partners.

The Pentagram Partnership

In the world of design, Pentagram has long had a special cachet. Not a partnership in the traditional sense, it is more a consortium of creative minds that have joined together for the opportunity to explore ideas outside the bounds of their specialties. Multidisciplinary, multinational, and multifaceted, Pentagram is not known for any single specific style—save for a concept-driven approach that spurns the decorative or trendy. Yet over the last three decades, perhaps no other design firm in the world has had such a sweeping and powerful impact on the visual presentation of business and culture as Pentagram. Its design influence is visible worldwide in corporate brands and communications, exhibitions and interiors, national magazines and catalogs, packaging and consumer products, interactive media and

Chapter Divider

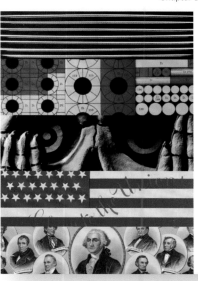

Collections

Collectors can be divided into two categories: Those who seek out beautiful objects like Monet paintings and Ming vases that are precious, rare, and monetarily valuable, and those who are drawn to collecting everyday things that individually may be worth little but are fascinating for their diversity within a given category. A single broom is merely a commonplace tool, but five hundred different brooms allow intriguing comparisons of materials, size, shape, purpose, cultural habits, historical changes, and the like. This latter kind of collecting is a study in form and function, graphic solutions, and cultural expression that many designers find compelling because it hones their ability to note the variations and distinctiveness of like objects.

Example of Opening Spread

No. 17: The Many Faces of Mao

Back Story
While partner Kit Hinrichs was teaching a design class at the California College of Arts and Crafts in San Francisco, a student named Jenny Wong told him she was going to Shanghai to visit her parents and asked if she could bring him a souvenir. "Maybe a Mao button," he said. To his surprise, Jenny returned with a hand-crafted bamboo case filled with Mao buttons made by her father, Tao-shi Shen, a designer of Mao buttons during the Cultural Revolution. For nearly a year, Shen had been held under "house arrest" in the button factory after officials accused him of desecrating Mao's image by leaving a paintbrush on a button. Jenny's gift prompted partner Linda Hinrichs to challenge her brother, Dr. Larry Davis, and his two kids to find more buttons while on his 1990 medical sabbatical in Shanghai. They returned with so many Mao objects that Linda turned them into a Pentagram Paper.

During China's Cultural Revolution (1966–76), Chairman Mao Zedong attained a godlike stature that saw his portrait displayed on billboards, posters, statues, busts, in homes at the family altar, and on buttons that followers pinned to their jackets. A daily ritual for the masses was bowing three times before Chairman Mao's portrait or bust, singing the national anthem, reading passages from Mao's *The Little Red Book*, and wishing him "ten thousand years." More than a fad, the Mao buttons were a show of patriotic fervor and an ever-present reminder of living the ideals of the Cultural Revolution. When the Mao cult was at its peak around 1967, factories in Beijing, Shanghai, and Canton (Guangzhou) turned out more than six million Chairman Mao buttons a month in about twenty different variations. Desecration of Mao's likeness was viewed as cause for imprisonment. By the early 1970s, the extreme aspects of Mao as a divine presence were discouraged, and Mao buttons disappeared from public view.

ONCE UPON A TIME

In all compelling work, there's a story driving

its success. Stories are a universal language that designers

have used to engage global audiences for generations.

But stories are more than words or images alone,

they are a unique interlacing of both. The best stories are

invariably memorable, entertaining, challenging,

enlightening and hopefully, inspiring.

AGI
Coexistence
Poster

Every year at our
congress, the AGI
committee chooses a
theme to illustrate.
In 2015, *Coexistence*
was chosen due to
the international conflict
going on during
the time. The idea of
different imaginary
species getting along
seemed appropriate.

ALLIANCE GRAPHIQUE INTERNATIONALE 2015 CONGRESS

COEXISTENCE

CAN'T WE JUST BE FRIENDS?

DESIGN: KIT HINRICHS, STUDIO HINRICHS ©2015

Sappi Paper
Choices
Promotion

This promotional brochure looked at the choices that every designer makes when designing a piece that is lively and interesting. Design is all about choices: Should it be photographed or illustrated? Which typefaces reinforce or contradict the perception of the message? How should the photographs be styled? Should historical images be used? These are just a few of the choices available to designers, ending, of course, with which choice of Sappi paper to specify.

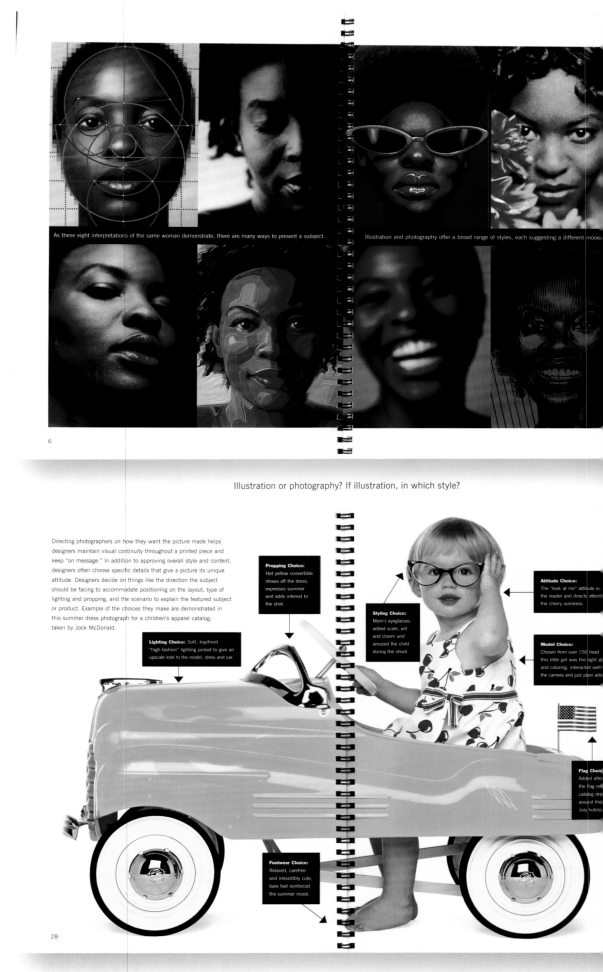

As these eight interpretations of the same woman demonstrate, there are many ways to present a subject.

Illustration and photography offer a broad range of styles, each suggesting a different mood.

6

Illustration or photography? If illustration, in which style?

Directing photographers on how they want the picture made helps designers maintain visual continuity throughout a printed piece and keep "on message." In addition to approving overall style and content, designers often choose specific details that give a picture its unique attitude. Designers decide on things like the direction the subject should be facing to accommodate positioning on the layout, type of lighting and propping, and the scenario to explain the featured subject or product. Example of the choices they make are demonstrated in this summer dress photograph for a children's apparel catalog, taken by Jock McDonald.

Propping Choice: Hot yellow convertible shows off the dress, expresses summer and adds interest to the shot.

Styling Choice: Mom's eyeglasses added scale, wit and charm and amused the child during the shoot.

Attitude Choice: The "look at me" attitude e... the reader and directs atten... the cherry sundress.

Model Choice: Chosen from over 150 head... this little girl was the right a... and coloring, interacted well... the camera and just plain ade...

Lighting Choice: Soft, top/front "high-fashion" lighting picked to give an upscale look to the model, dress and car.

Flag Choi... Added afte... the flag ret... catalog dre... around the... July holida...

Footwear Choice: Relaxed, carefree and irresistibly cute, bare feet reinforced the summer mood.

28

What color car? What color is the model's hair? Glasses or no glasses?

Of hundreds of typefaces, which one has the right voice?

Pick a famous historical photo or shoot a contemporary photo?

American President Lines
1988 Calendar

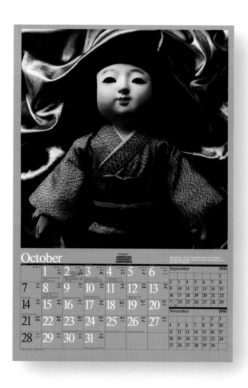
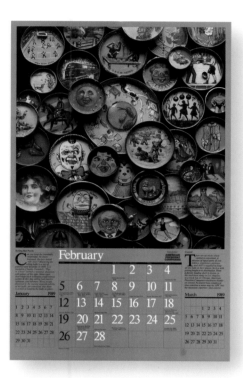
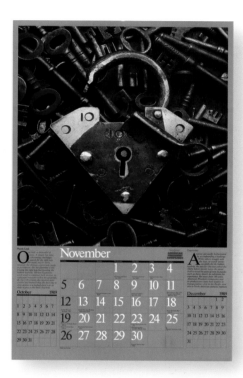

American President Lines Calendar

For APL, an international container shipping giant, we produced large wall calendars to promote their services to clients

across the Pacific. Each year, we researched and created photographic themes related to APL's history and the industries they serve.

All the shots were taken by Terry Heffernan on a large 8 inch by 10 inch camera. We then packaged the calendars in

giant "shipping container" envelopes, which APL hand-delivered to clients in Hong Kong, Tokyo, Singapore, Los Angeles and San Francisco.

The photos were also used for desk diaries given to client executives.

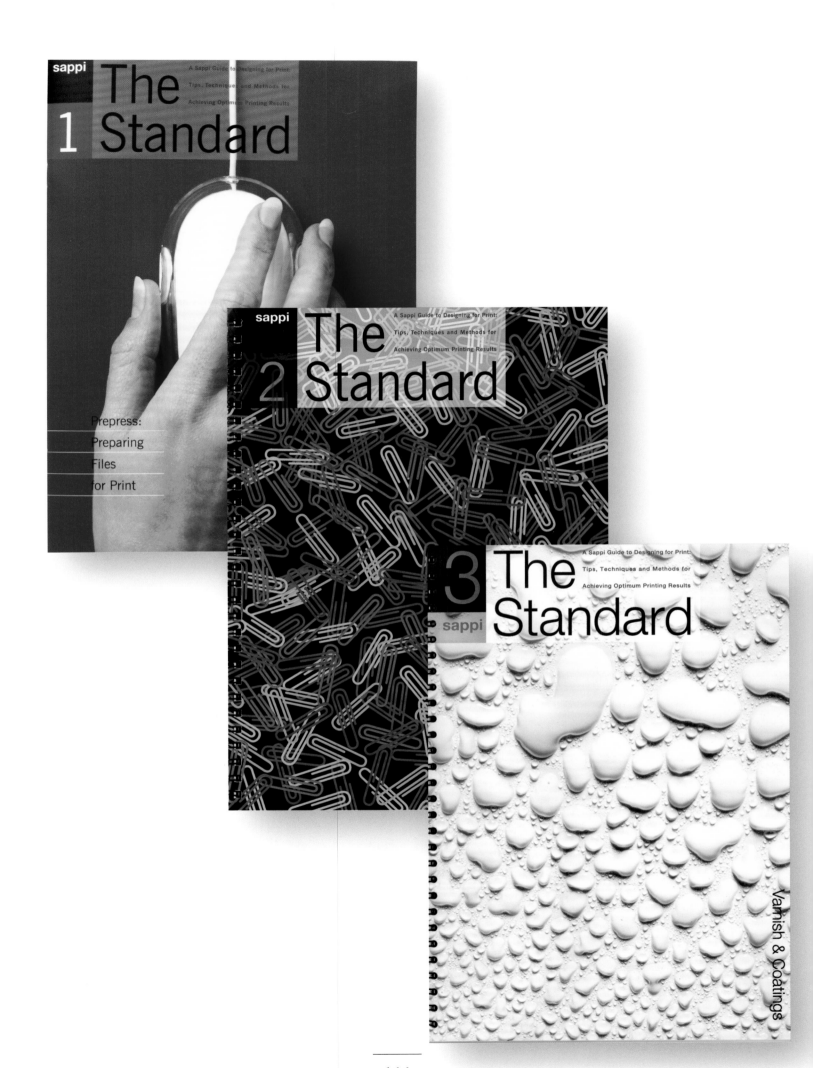

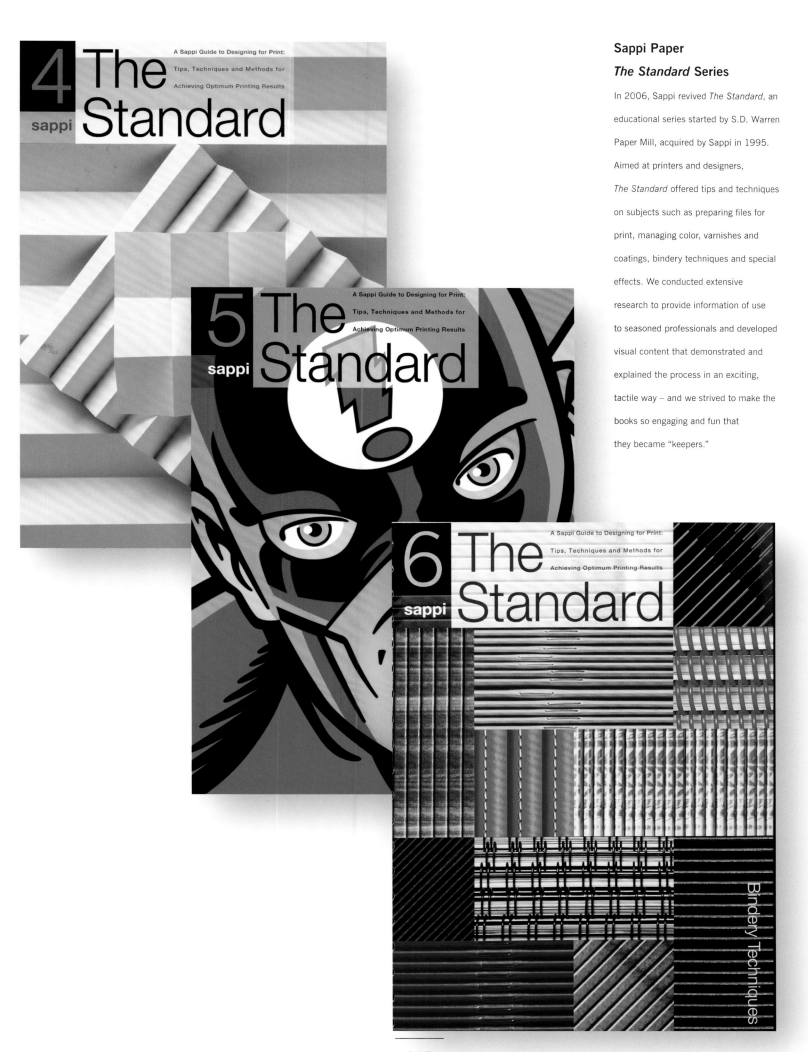

Sappi Paper
The Standard Series

In 2006, Sappi revived *The Standard*, an educational series started by S.D. Warren Paper Mill, acquired by Sappi in 1995. Aimed at printers and designers, *The Standard* offered tips and techniques on subjects such as preparing files for print, managing color, varnishes and coatings, bindery techniques and special effects. We conducted extensive research to provide information of use to seasoned professionals and developed visual content that demonstrated and explained the process in an exciting, tactile way – and we strived to make the books so engaging and fun that they became "keepers."

Sappi *The Standard 2* Managing color across finishes

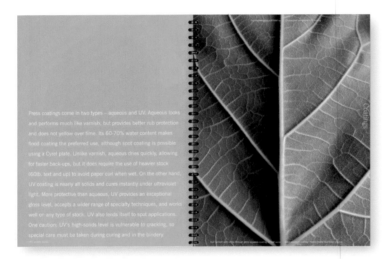
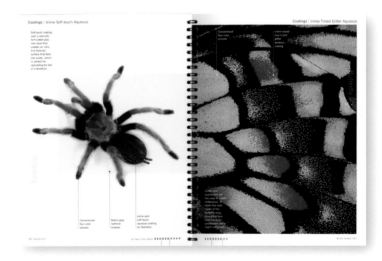

Sappi *The Standard 3* Coatings and varnishes

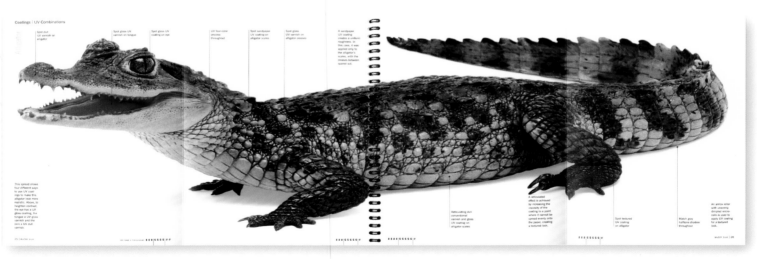

Sappi *The Standard 3* Multi-layered coatings and varnishes

Sappi *The Standard 4* Basics of folding

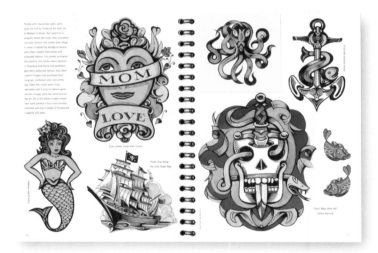

Sappi *The Standard 5* Special printing techniques

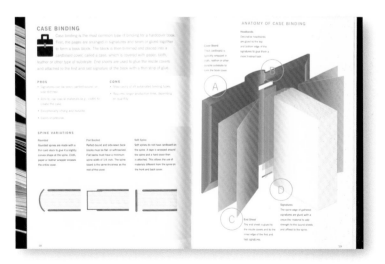

Sappi *The Standard 6* Binding techniques

IMAGINATION IS A LIMITLESS PLACE, FREE OF BOUNDARIES AND FILLED WITH POSSIBILITIES. IT WELCOMES ALL IDEAS, PRACTICAL AND FANTASTIC, SIMPLE AND COMPLEX, INVENTIVE AND MUNDANE, ALLOWING THEM TO EXIST UNJUDGED IN THE SAME TIME AND SPACE WITHOUT A SECOND THOUGHT. **IMAGINATION** INSPIRES CREATIVITY, NURTURING THE FIRST INKLING OF AN IDEA UNTIL IT EMERGES FULLY FORMED AND READY TO TAKE FLIGHT.

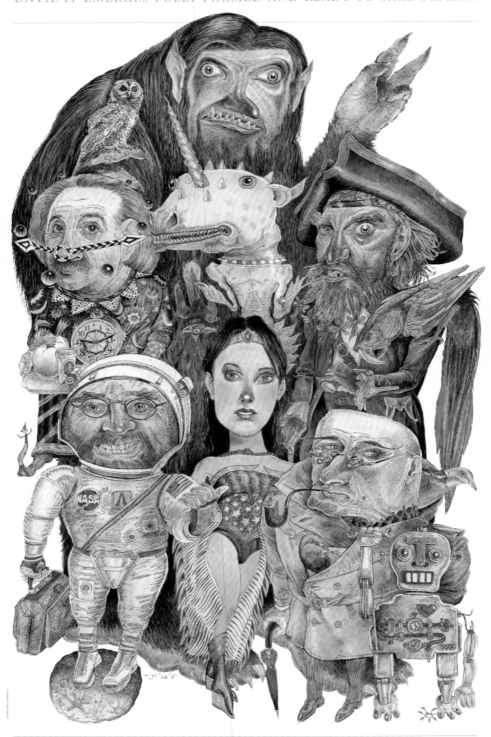

Sappi
The Standard 5
Posters

For *The Standard 5*
on special effects, we
developed a portrait
of characters that
"frequented" the
imaginary stores of
the 826 National
tutoring centers. The
poster, illustrated by
Jack Unruh, was tucked
into the back pocket
of each book.

Sappi
The Standard 5
826 National
Poster

The reverse side
of the portrait poster was
printed in a copper and
silver split fountain visible
from the back pocket
and, as it was unfolded,
revealed different words of
encouragement.

Oakland A's Promotion

Advertising agency Hal Riney & Partners asked us to design their promotion for the Oakland A's to help boost season ticket sales and plug group sales. Riney had already commissioned artist Dave McMacken, known for his illustration of record album covers, to create a series of illustrations for the A's team. McMacken's art, originally based on pinball machines, presented the opportunity to tout the A's many game records. This led us to use a play on words and treat McMacken's illustrations as record album art with a rundown of season ticket holder benefits on the back side. A faux "LP record" was tucked inside the jacket with the reverse side showing a list of the A's record-setting baseball stats.

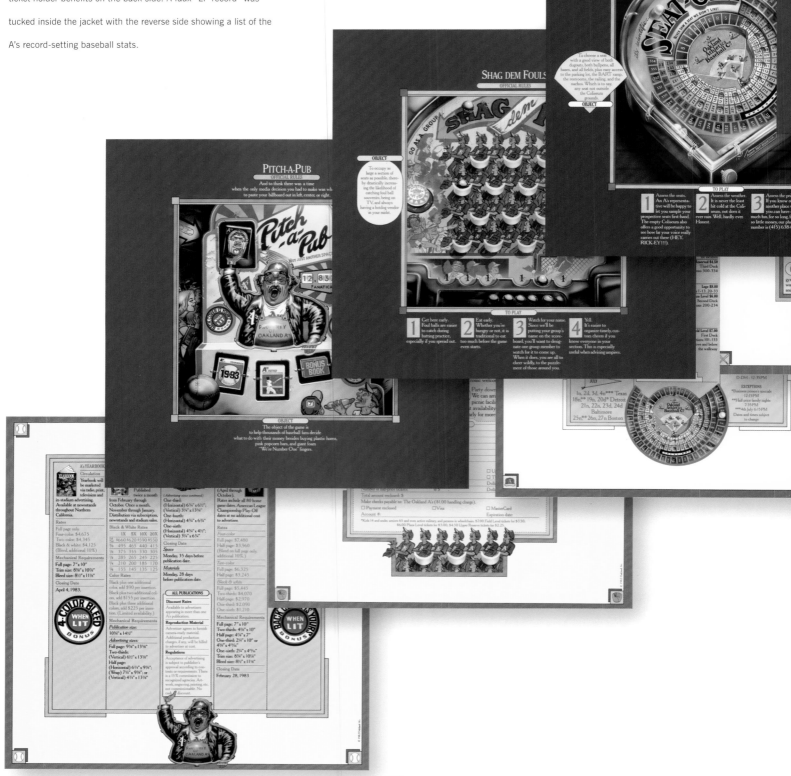

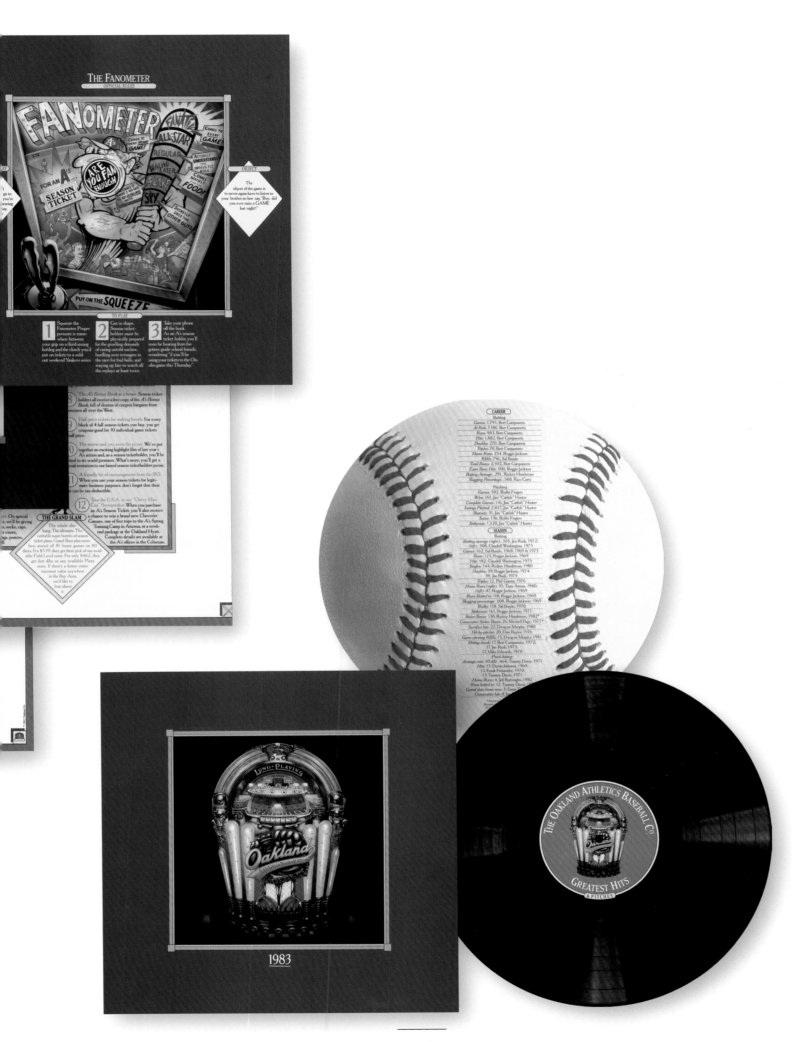

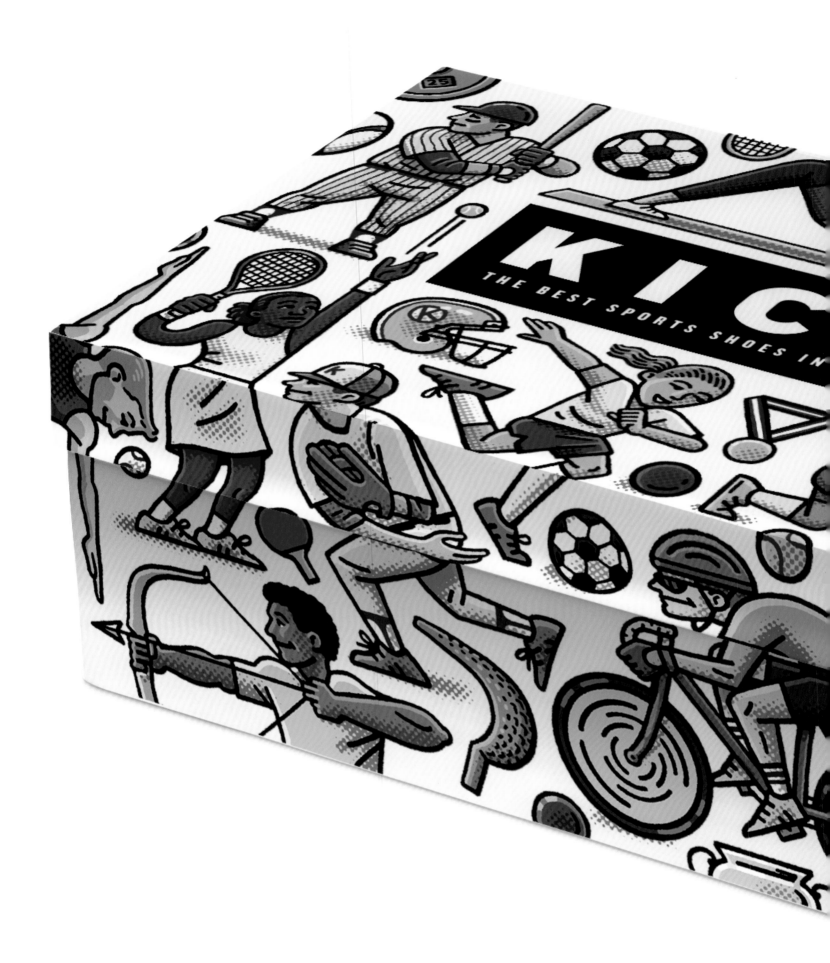

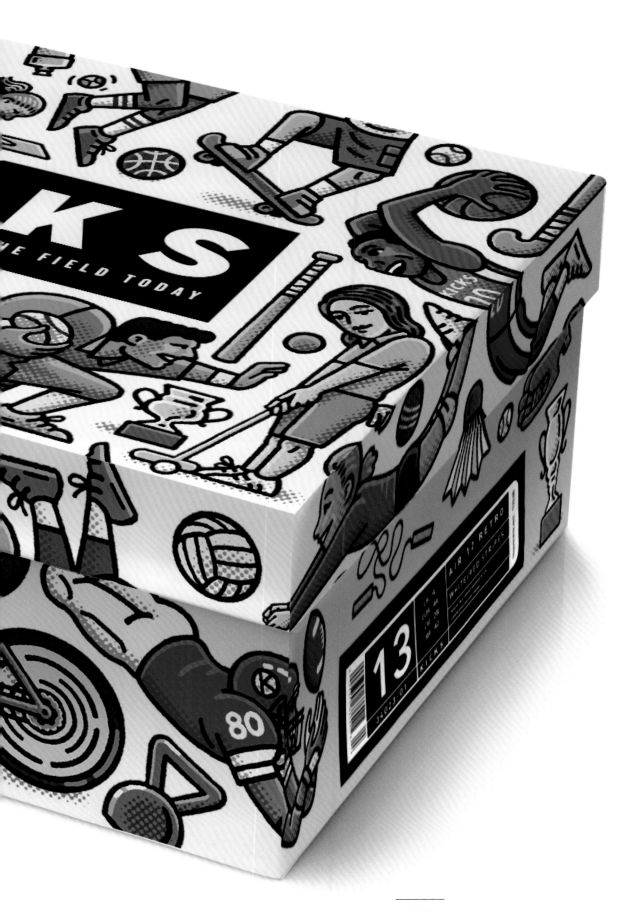

Sappi Paper
The Standard 7
Packaging

To demonstrate ways to engage and inform buyers when buying sneakers, we created an imaginary shoe brand and named it Kicks. We commissioned Mario Zucca to create a wraparound tapestry of entertaining sporting activities to make the product approachable and the box collectible.

"Honey, our shareholder list
has gotten completely out of control —
wish me luck."

Shareholder Communications Promotion

Humor, illustrated by the best *New Yorker* cartoonists, created a distinctive separation between Shareholder Communications Corporation (SCC) and their competition.

Using the cartoons available from Cartoon Bank and tailoring the captions for SCC brings a fresh approach to what is a humdrum but lucrative process in financial instruments. The promotion's use of cartoons to illustrate SCC's distinctive specialty persuades its readers with its fresh and unexpected tone.

Innovative manufacturing can precisely pick up, stack and fuse materials that make up the uppers of Nike shoes. The modularity of parts also enables people to truly customize their shoe, have it made in just a few hours and delivered to them in a matter of weeks. The NIKEiD line lets shoppers choose from an array of colors, styles, textures and materials such as leather, canvas, rubber, mesh, and suede and even choose the size and placement of the Nike Swoosh.

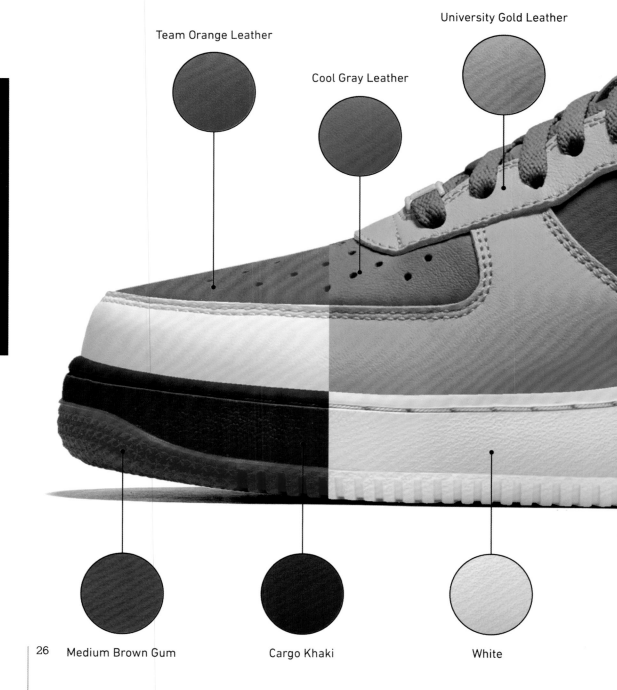

University Gold Leather

Team Orange Leather

Cool Gray Leather

26 Medium Brown Gum

Cargo Khaki

White

156

Game Royal Leather

Court Purple

Metallic Gold Leather

Wolf Gray Leather

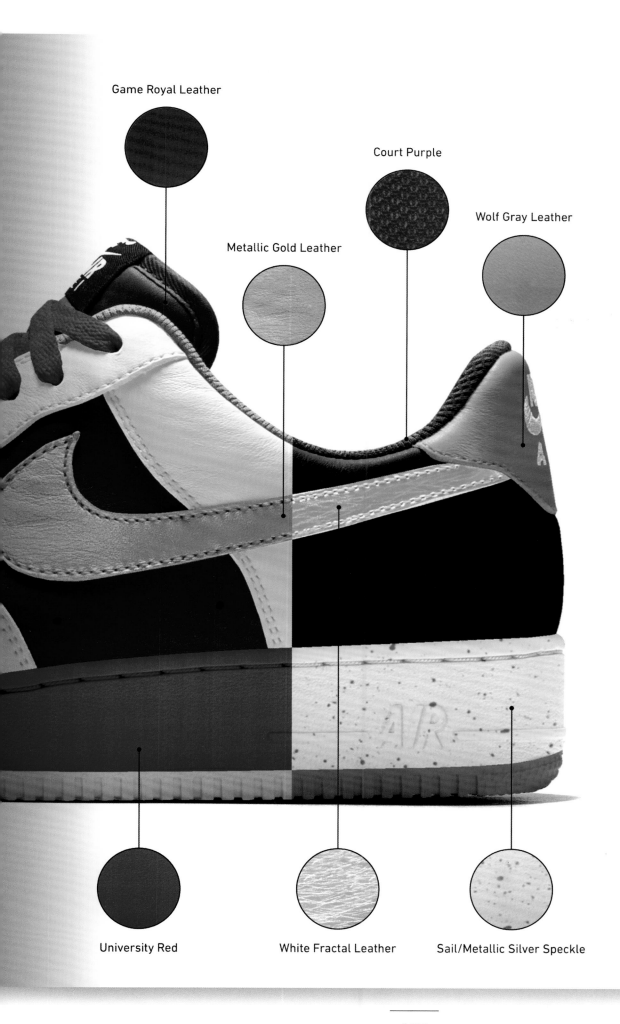

Sappi *Verticals:*
Fashion Industry

Diagramming is
a wonderful tool for
telling multifaceted,
complex stories.
Not only was the
unique flexibility of
customizing a Nike
shoe an expressive
example of innovative
personal fashion, it
was also an effective
way to demonstrate
new print techniques
to a sophisticated
design audience.

University Red

White Fractal Leather

Sail/Metallic Silver Speckle

AMERICAN ICONS SERIES:
8 NOTE CARDS & ENVELOPES

CI...
— Objects
W...

AMERICAN ICONS SERIES:
8 NOTE CARDS & ENVELOPES

ABRAHAM
— 16th *American President* —
LINCOLN

LINCOLN FINANCIAL FOUNDATION
COLLECTION, FORT WAYNE & INDIANAPO...

PHOTOS BY TERRY HEFFERNAN

AMERICAN ICONS SERIES:
8 NOTE CARDS & ENVELOPES

FLY
— *The Art and Sport o...*
FISHIN...

THE AMERICAN MUS...
OF FLY FISHI...
MANCHESTER, VERMO...

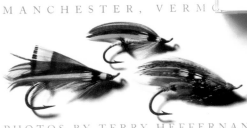

PHOTOS BY TERRY HEFFERNAN

AMERICAN ICONS SERIE...
8 NOTE CARDS & ENVELOPE...

HELMETS
— *in the* —
FIRE

LEBANON HISTORICAL SOCIETY
LEBANON, PENNSYLVANIA

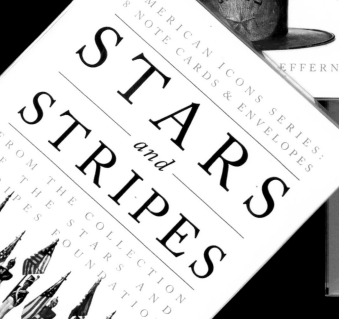

...FFERNAN

AMERICAN ICONS SERIES:
8 NOTE CARDS & ENVELOPES

STARS
and
STRIPES

FROM THE COLLECTION
OF THE STARS AND
STRIPES FOUNDATION

PHOTOS BY TERRY HEFFERNAN

ONS SERIES:
& ENVELOPES

VIL

— America's —

AR

CAL SOCIETY
NSYLVANIA

Y HEFFERNAN

RICAN ICONS SE
TE CARDS & ENVE

EORGI

merican Iconocla

'KEEFF

P GEAR FROM THE GE
EEFFE MUSEUM, SAN

TOS BY TERRY HEFFERNAN

AMERICAN ICONS SERIES:
8 NOTE CARDS & ENVELOPES

BASEBALL

—the Great American—

PASTIME

COLLECTION FROM THE NATIONAL
BASEBALL HALL OF FAME &
MUSEUM, COOPERSTOWN, NY

PHOTOS BY TERRY HEFFERNAN

AMERICAN ICONS SERIES:
8 NOTE CARDS & ENVELOPES

OBJECTS

of the

AMISH

ON HISTORICAL SOCIETY
ON, PENNSYLVANIA

Y TERRY HEFFERNAN

Terry Heffernan
American Icons
Commerative
Card Set

Terry Heffernan has had a
passion for photographing
American icons from museums
across the country, often by
receiving permission to shoot
whole collections in places like
the Fly Fishing Museum
in Vermont. We worked with
Terry to create eight boxed
sets of greeting cards for
museum retail shops.

Potlatch/Sappi
Field Studies **Series**

Telling stories is often
most effective when
expressed as variations
on a theme. The shared
graphic structure of
the split covers gives a
graphic identity to the
series, yet the unique
imagery used defines the
separate markets each
one conveys. This series
of *Field Studies* gives the
audience an inside look
at three vertical Potlatch
and Sappi markets:
finance, food and fashion.

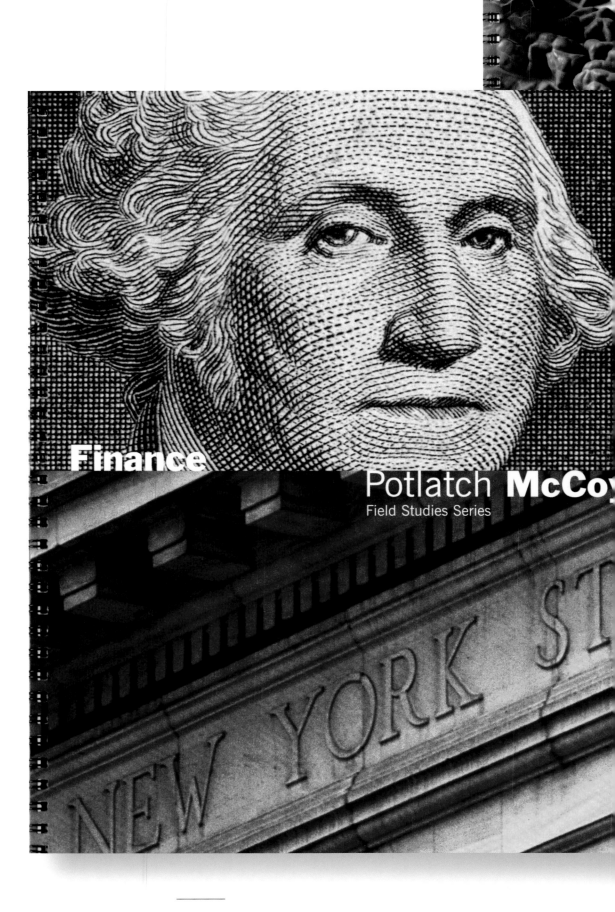

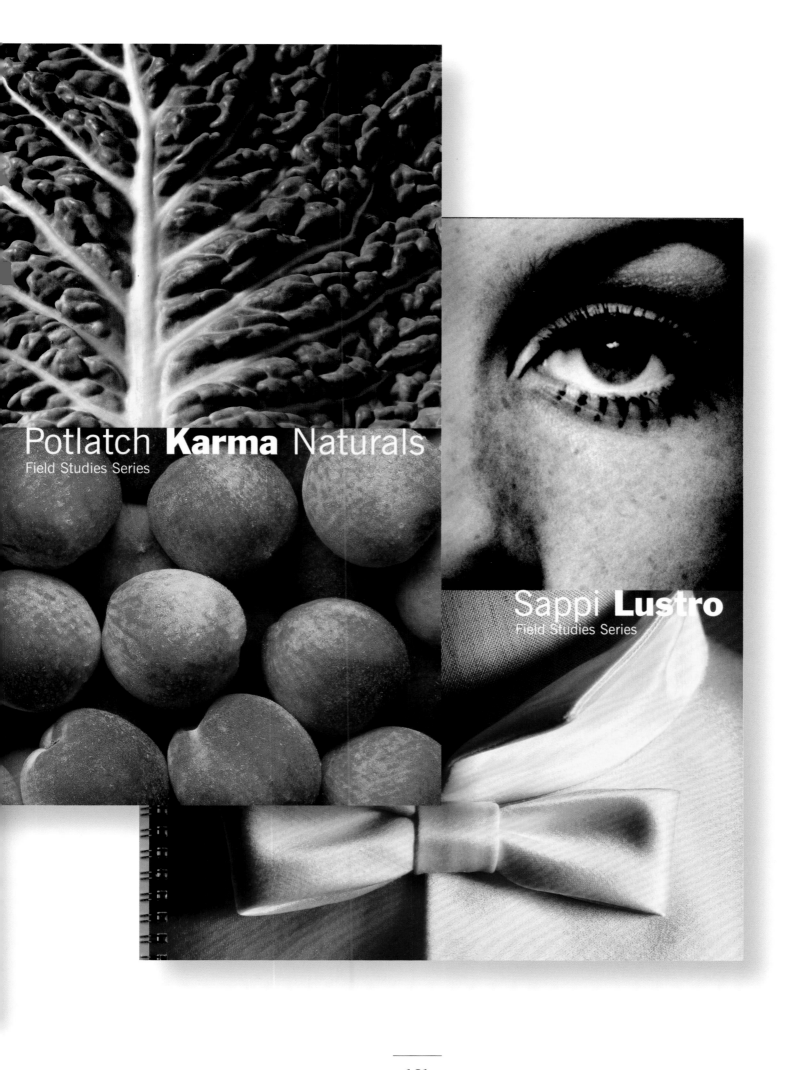

Potlatch **Karma** Naturals
Field Studies Series

Sappi **Lustro**
Field Studies Series

@issue:
Journal of
Business
& Design

A discussion about how designers and business clients frequently talk past each other without appreciating their problem-solving process led writer Delphine Hirasuna and me to start *@issue: Journal of Business and Design*, with the Corporate Design Foundation as a sponsor and Potlatch underwriting the publication. Through case studies and interviews, *@issue* demonstrated how smart design contributed to the financial success of a business. After 15 years, the journal became an online publication, *atissuejournal.com*. At its peak, *@issue* had a circulation of 100,000 readers for each edition.

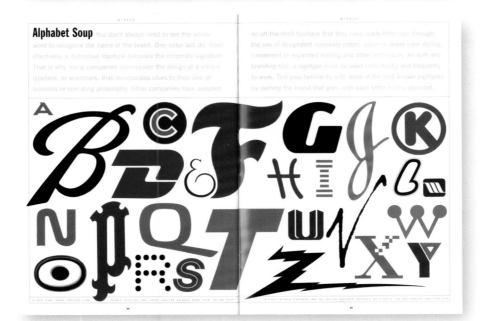

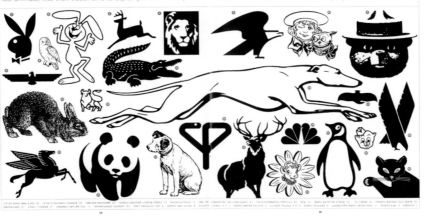

@issue **Quizzes**

One of the most popular features in *@issue* has been our engaging design quizzes, demonstrating the role that shape, color, logotypes and product mascots play in creating brand awareness. In many cases, we got requests from global corporations for reprints to deliver to their boards of trustees.

University of Southern California
View Book

USC asked us to create a college view book that wasn't a staid account of their offerings. They wanted a book that reflected L.A.'s cultural vitality, ethnic diversity and world-renowned academic reputation. Departing from the traditional dry view book format, we created a lively *Rolling Stone*–type publication filled with articles by the USC president as an astronaut, famous faculty and alumni as well as incoming freshmen recounting their experiences in Los Angeles. The university was dogged by a historic curse from the '50s, "USC: the **U**niversity of **S**poiled **C**hildren." With this view book, we had the opportunity to kill the curse and give a new look to the value of a great university in a niche environment of multiethnicity, high achievement and cutting-edge technology in a 21st century city.

PIONEERING THE FUTURE OF A WORLD-CLASS UNIVERSITY

An interview with Steven B. Sample, the president of USC since 1991. He is an electrical engineer, musician, outdoorsman and inventor. A tenured professor in the USC School of Engineering and a member of the National Academy of Engineering, his patents have been licensed to most of the world's major manufacturers of appliance controls and microwave devices. Dr. Sample regularly teaches a popular leadership course to undergraduates. Under his leadership, USC has solidified its status as one of the nation's leading research universities.

L.A. is a picnic—a big, amazing movable feast of great things to do, see, explore and have fun discovering. Whether it's food, hikes or museums; dancing, sports or mountains; people gawking, hawk watching or garden strolling, L.A. abounds in places and spaces to suit every taste and temperament. ♦ Below you'll find some of the most charming, awe-inspiring and even funny things about the West Coast's most vibrant city. Some of these spots are for the simplest of pleasures like a swim or a snack. Others are for strenuous workouts like skiing, surfing, hiking and mountain biking. Some, like the Getty Museum, you already will have heard of no matter where you live. Others, like the Museum of Jurassic Technology, you will be delighted to meet for the first time. ♦ The City of the Angels has so much to offer that even native Angelenos constantly discover new things about it. And you can too. Read on.

LOST & FOUND IN LA

BEST OPEN MIKE POETRY
The Cobalt Café, 22047 Sherman Way, Canoga Park. Where the next John Keats, Emily Dickinson or Federico García Lorca is polishing his or her images, iambics, and imagination. Open mike Mondays and Tuesdays at 8 p.m (sign up at 6:30). The Cobalt's a comfy, cool, spacious, West Valley dive with sandwiches, snacks and espresso. Sunday through Thursday you'll find inspired punk, ska and weirdo rock bands. Info (prices, cover, etc.) at 818-348-3789.

BEST FORCE FOR CULTURE
The billion-dollar Getty Center is constructed from travertine stone, all mined from one quarry in Bagni di Tivoli, Italy. The six buildings consist of a museum and research facilities on 124 acres of hilltop. The place is awesome, the panoramic view spectacular, the ever-changing gardens a delight. Admission is free ($5 for parking). The center has an impressive collection of decorative arts and American and European photography. There are also paintings, drawings, and sculptures by da Vinci, Cellini, Rembrandt, Turner, Friedrich, van Gogh, Cezanne and Degas. Closed Mondays. 1200 Getty Center Drive, 310-440-7300, www.getty.edu/museum

HANG OUT FOR FILM GEEKS
The American Cinematheque Series at the historic Egyptian Theatre. Czech Animation. Spanish Cinema. Classic Hollywood. GayPlexistan. Best of Slamdance. A Buñuel retro. Tributes to Willem Dafoe, Lasse Hallstrom, Spike Lee. Name the genre, name the star—eventually you'll find it or them at the Egyptian. 6712 Hollywood Blvd., 323-466-3456, www.americancinematheque.com

BEST NEWS STAND
Support independent bookstores! Like Book Soup for instance, which has a huge newspaper and magazine selection from everywhere. News, news, news making you world-weary? Need something profound to peruse? There's a dynamic bookstore inside; lots of postcards, too, and frequent in-person appearances by celebrity authors for readings, lectures and book signings. 8818 Sunset Blvd., 310-659-3110, www.booksoup.com

BEST ROCK-'N'-ROLL SUSHI
At Tokyo Delves you can dance, eat raw fish and toast the chef who slices and dices while grooving to the Village People's "YMCA." When you're done, you'll know why this neon-lit, boogie-down, North Hollywood sushi bar put the rock 'n' roll in rock-'n'-roll sushi. 818-766-3868.

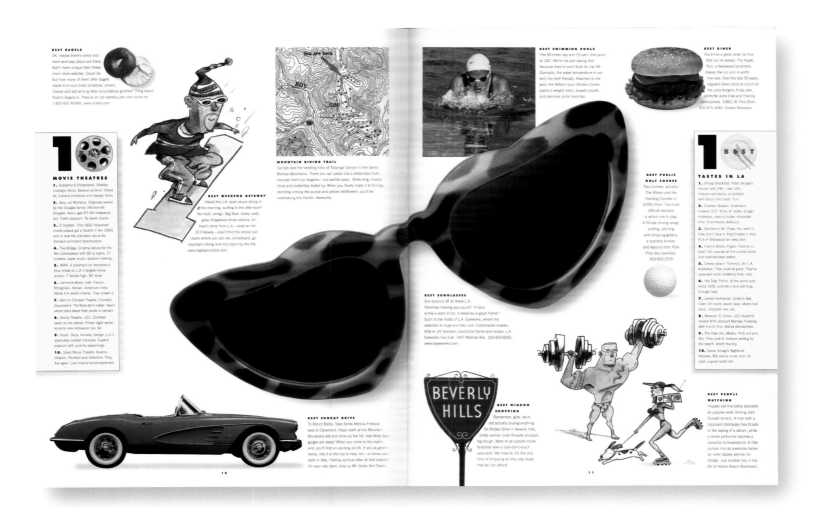

BEST BAGELS
OK, maybe there's some cool mom-and-pop place out there that's more unique than these chain store eateries. Could be. But how many of them offer bagels made from sun-dried tomatoes, onions, cheese and salt among other scrumptious goodies? Thing about Noah's Bagels is: They're an old standby you can count on. 1-800-931-NOAH, www.noahs.com

10 MOVIE THEATRES

1. Academy 6 (Pasadena). Shabby nostalgia decor. Several screens. Cheap fix. Current American and foreign flicks.

2. Aero, on Montana. Originally owned by the Douglas family (McDonnell Douglas, Aero—get it?) $5 independent. Fresh popcorn. Ta seven bucks.

3. El Capitan. This 1926 Hollywood movie palace got a facelift in the 1990s and is now the premiere venue for Disney's animated blockbusters.

4. The Bridge. Cinema deluxe for the film connoisseur with $5 to spare; 17 screens; super plush, stadium seating.

5. IMAX. A paramecium becomes a blue whale on L.A.'s largest movie screen. 7 stories high, 90' wide.

6. Laemmle Music Hall. French. Mongolian. Iranian. American indie. Name it in world cinema. They screen it.

7. Mann's Chinese Theatre. Formerly Grauman's. The flicks don't matter. Here's where stars leave their prints in cement.

8. Norris Theatre, USC. Comfiest seats on the planet. Friday night series screens new Hollywood bio; $4.

9. Nuart. Docs, revivals, foreign. L.A.'s absolutely coolest marquee. Superb popcorn with yummy seasonings.

10. Silent Movie Theatre. Keaton, Chaplin, Pickford and Valentino. They live again. Live musical accompaniment.

BEST WEEKEND GETAWAY
Heard the L.A. spiel about skiing in the morning, surfing in the afternoon? No myth, amigo. Big Bear Valley really gives Angelenos those options. An hour's drive from L.A.—east on the 10 Freeway—you'll find the snowy outdoors where you can ski, snowboard, go mountain biking and kick back by the fire. www.bigbearcentral.com

MOUNTAIN BIKING TRAIL
Cyclists love the winding trails of Topanga Canyon in the Santa Monica Mountains. There you can pedal into a wilderness that's minutes from Los Angeles—but worlds away. Birds sing, insects chirp and butterflies flutter by. When you finally make it to the top, standing among the purple and yellow wildflowers, you'll be overlooking the Pacific. Awesome.

BEST SWIMMING POOLS
The 50-meter lap and 25-yard dive pools at USC. We're not just saying that because they're ours! Built for the '84 Olympics, the water temperature is perfect: the staff friendly. Attached to the pool, the William Lyon Athletic Center sports a weight room, squash courts, and exercise cycle room too.

BEST DINER
You know a good diner by how fast you're seated. The Apple Pan, a Westwood landmark, makes the cut and is worth the wait. Over the last 50 years, regulars here come to count on the juicy burgers, fruity pies, perfectly done fries and friendly atmosphere. 10801 W. Pico Blvd., 310-475-3585. Closed Mondays.

BEST PUBLIC GOLF COURSE
Two courses, actually. The Wilson and the Harding Courses in Griffith Park. The most difficult decision is which one to play. A 50-tee driving range, putting, pitching and chipping greens, a practice bunker, and lessons from PGA Pros also available. 323-663-2555

10 BEST TASTES IN LA

1. Cheap breakfast, Pete's Burgers, Hoover and 34th, near USC. Huevos rancheros, scrambled with bacon and toast. Yum.

2. Cookies, Babalu. Enormous cookies (1/2" thick, 6" wide). Ginger, molasses, peanut butter, chocolate chip. Enormously delicious.

3. Damiano's Mr. Pizza. You want it, they don't have it, they'll make it. Also BJ's in Westwood for deep dish.

4. French Bistro, Figaro. Parents in town? Go upscale at this quietly lavish and sophisticated eatery.

5. Greasy spoon: Tommy's. An L.A. institution. They must be good. They've spawned more imitations than crab.

6. Hot Dog: Pink's. At the same spot since 1939, and the line is still long. Enough said.

7. Jewish traditional: Canter's Deli. Open 24 hours, seven days. Matzo ball soup, chopped liver, etc.

8. Mexican: El Cholo. USC students receive 50% discount Monday-Thursday after 4 p.m. Fun, festive atmosphere.

9. The Reel Inn, Malibu. Pick out your fish. They cook it. Outdoor seating by the beach. Worth the trip.

10. Sushi: Asagi's Nightclub. Karaoke, 80s dance music and, oh yeah, a great sushi bar.

BEST SUNGLASSES
Sun-bounce off all these L.A. Porsches making you squint? "A face is like a work of art. It deserves a great frame." Such is the motto of L.A. Eyeworks, where the selection is huge and très cool. Fashionable shades, tints or UV blockers, functional frame and lenses. L.A. Eyeworks has it all. 7407 Melrose Ave., 323-653-8255. www.laeyeworks.com

BEST SUNDAY DRIVE
To Mount Baldy. Take Santa Monica Freeway east to Claremont. Head north at the Mountain Boulevard exit and drive up the hill. Holy Moly, these gorges are steep! When you come to the road's end, you'll find an exciting ski lift. If you've got the nerve, ride it to the top to hike, ski—or throw snowballs in May. Feeling spiritual after all that cleaning? On your way back, stop by Mt. Baldy Zen Center.

BEST WINDOW SHOPPING
Remember, girls, we're not actually buying anything. On Rodeo Drive in Beverly Hills, pretty woman Julia Roberts dropped big dough. Most of us outside movie fantasies take a look-don't-touch approach. We have to. It's the only kind of shopping on this elite street that we can afford!

BEST PEOPLE WATCHING
Hippies sell friendship bracelets as puppies walk carting Jack Russell terriers. A man with a clipboard distributes free tickets to the taping of a sitcom, while a street performer teaches a passerby to breakdance. A biker pumps iron as awesome babes on roller blades admire his biceps. Just another day in the life of Venice Beach Boardwalk.

BEVERLY HILLS

10 11

neo

OF RIVER PAPER COMPANY · A JOURNAL OF INNOVATION AND REDISCOVERY · VOLUME 7 FALL 199

Fox River Paper
Promotion *NEO*

Each year, Fox River Paper invited a different design firm to produce a publication called *Neo* that showcased their selection of textured and colored recycled printing papers.

A New York public school. P.S.1, was highlighted about its transformation to a public gallery.

Eastern and western medicine were looked at and compared for similarities and contrasts.

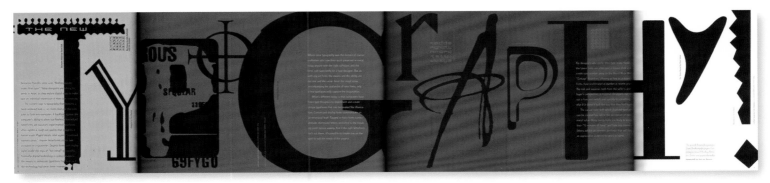

12 cutting-edge typefaces were spread over four different colored and textured papers.

The faces on money around the world were examined and analyzed.

All articles in *Neo* had recycled, earth-friendly themes that focused on revitalizing, redefining and renewing the familiar within our global culture.

LOCATION, LOCATION, LOCATION

Repositioning readers from their comfort zone

is an effective way to open them up to

new ideas. Be it physically, metaphorically or through

imagination, these changes in perspective allow

designers the opportunity to explore new ways of

introducing information to the reader.

United Airlines
Hemispheres
Magazine

Inflight publishing house
Pace Communications asked
us to redesign the United
Airlines inflight magazine.
Working with their team,
we came up with the name
Hemispheres, based on the
content of the publication.
"Hemispheres" spoke to
both a location on the globe
and the hemisphere of
the brain. We developed a
system to feature the works
of internationally renowned
artists on the cover by
curating posters from Alliance
Graphique Internationale
members.

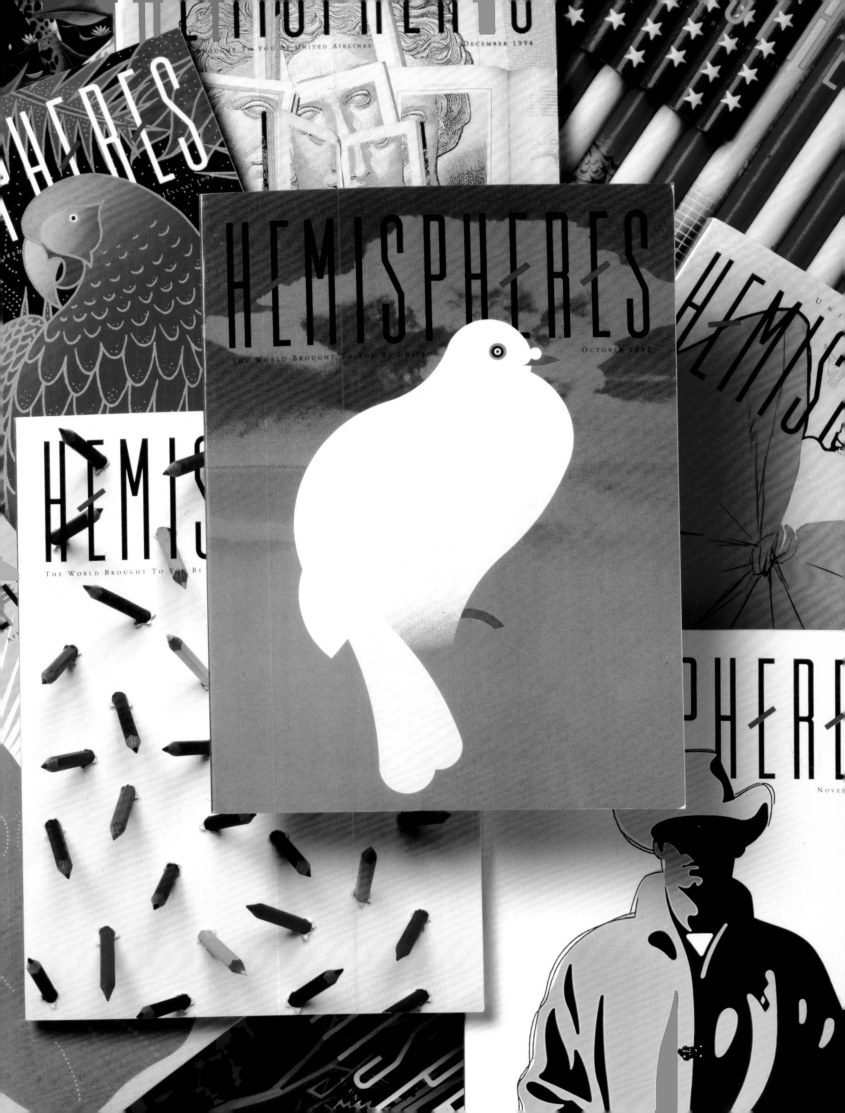

Hemispheres
Magazine

United travelers love to explore the world and enjoy new experiences. Our design staff together with Pace's editorial team developed a content strategy to create a rich and varied travelogue experience for the well-traveled and the inexperienced alike.

An over-the-top visual table of contents brought anticipation to the entire issue.

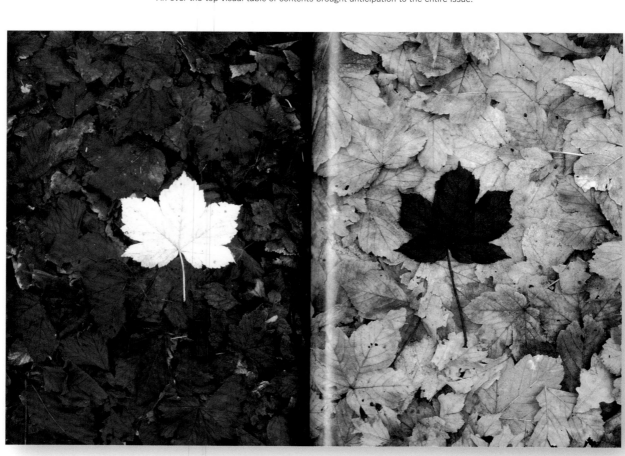

Each issue had an eight-page section on a contemporary artist, like Andy Goldsworthy.

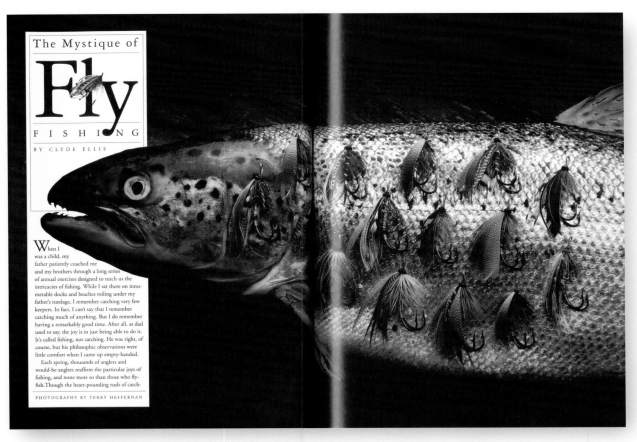

Each issue brought spreads on personal passions, from golf to fly fishing.

Each issue included knowledgeable recommendations on things to do, places to explore and three perfect days in the world's captial cities on little-known hideaways, local eating establishments together with local myths and legends.

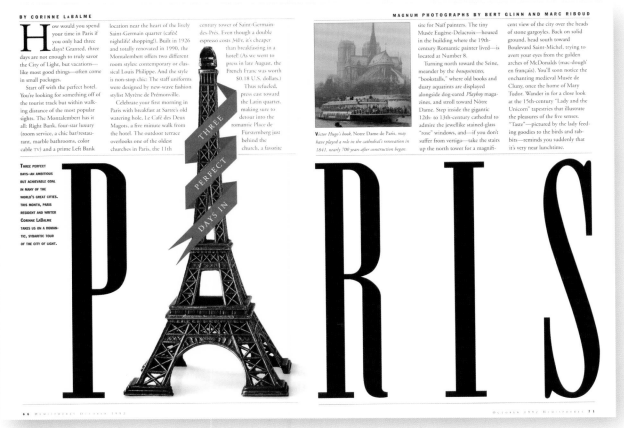

Three perfect days in a United destination. This issue was Paris.

Alcatraz Dining Hall Information Wall

The Golden Gate National Parks Conservancy asked us to design an information wall in what was the federal penitentiary dining hall on Alcatraz Island. It gave the public a sense of the convict's living experience. We brought in prison artifacts, detailed duties of the convicts, curious anecdotal stories, daily prison menus and photos from the Alcatraz archives.

ALVIN KARPAVICZ
AZ-325

Breakfast often included fruits such as pineapple, cantaloupe, and peaches.

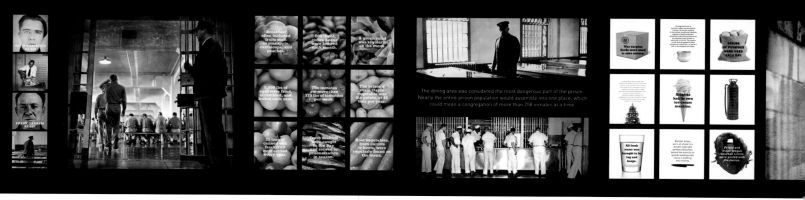

Alcatraz had its own ice cream machine.

Stewed Corn

Mashed Potatoes

Buttered Beets

Mocha Cake

Meat Loaf & Brown Gravy

Bread

172

Prison and major league baseball scores were posted with the menus.

A green salad was regularly on the menu.

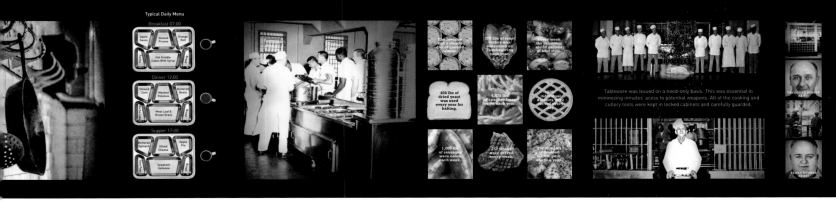

Inmates would illicitly brew beer made with yeast acquired from the kitchen. When their hiding places for the beer were discovered, a new place was found—inside an old fire extinguisher. This was never found by prison guards, and according to former inmate Darwin Coon, a batch was still fermenting in the extinguisher when the island closed in 1962.

500 individual desserts were served every day.

FLOYD DUNBAR
AZ-601

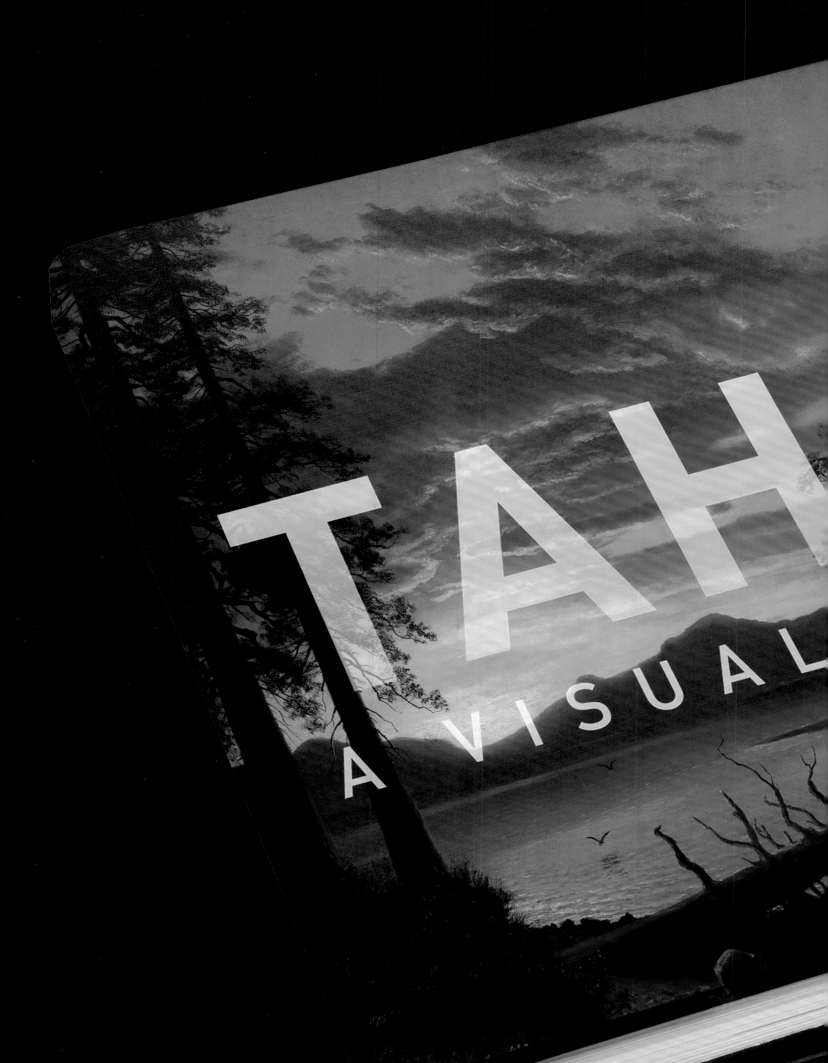

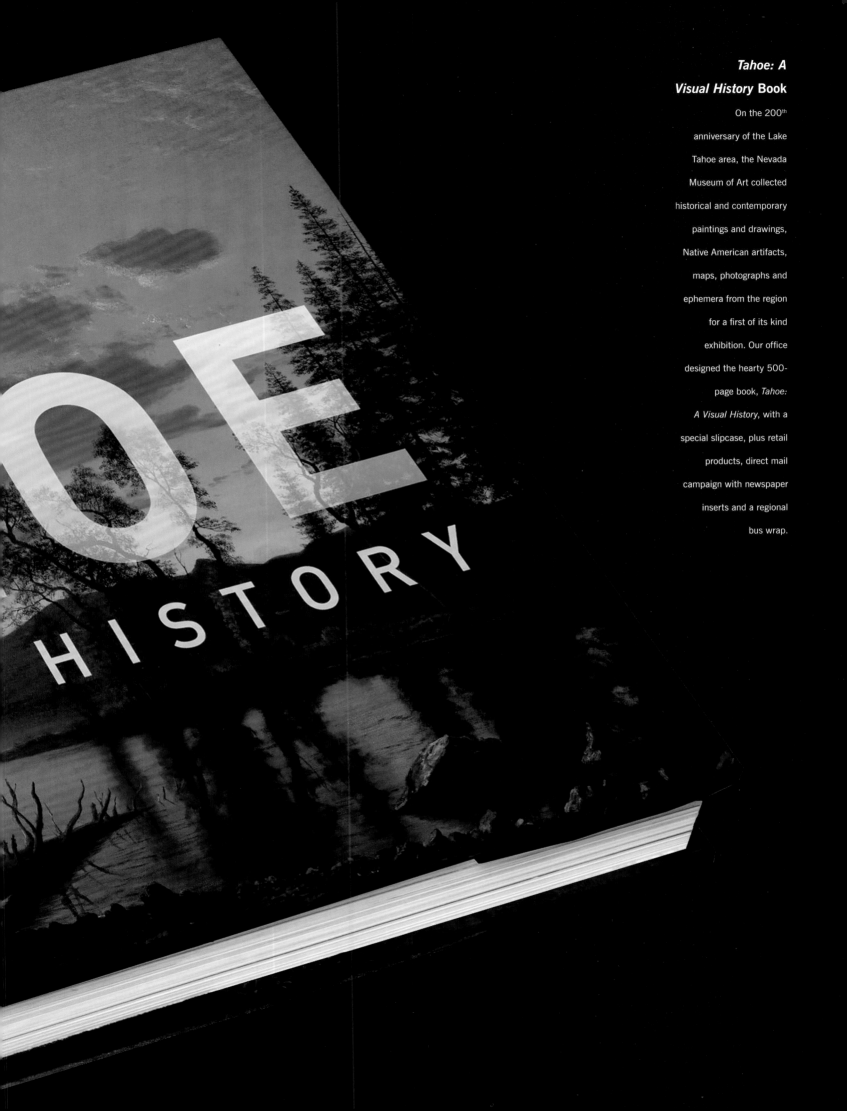

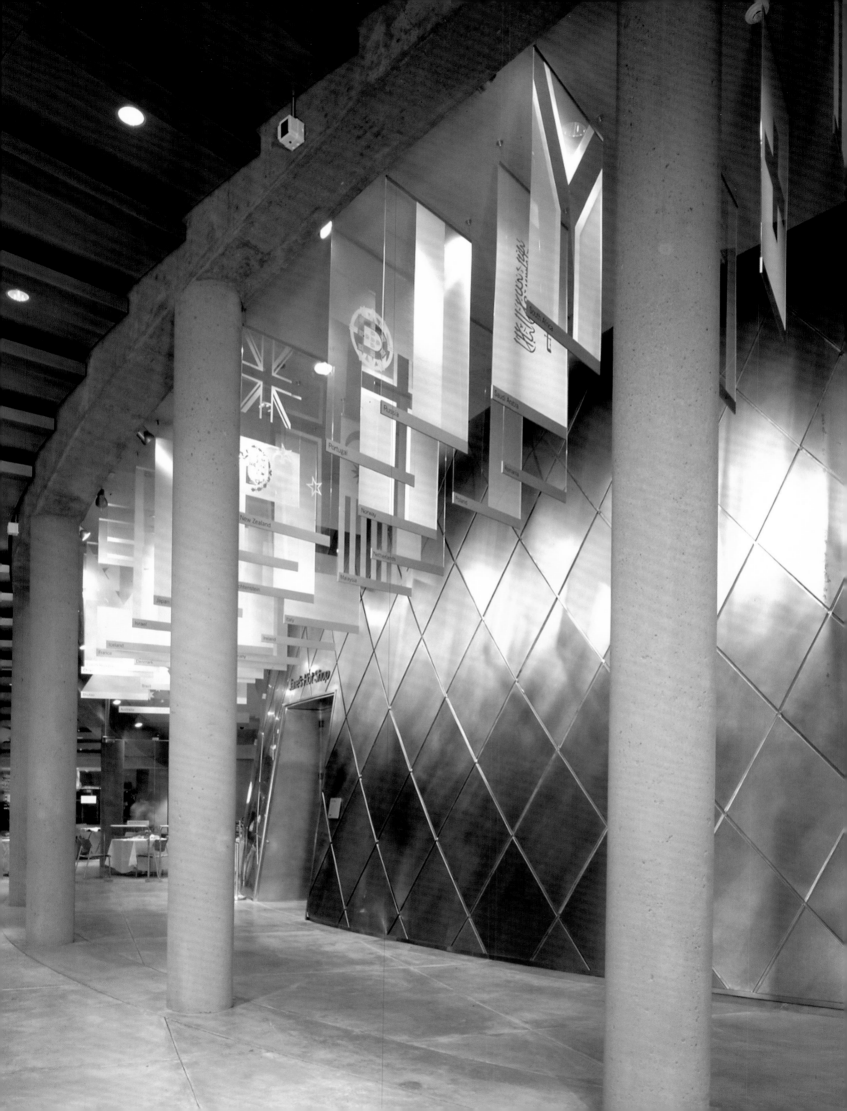

Museum of Glass Environmental Design

In 2002, we were contracted by the Museum of Glass in Tacoma, Washington, to create environmental graphics, a wayfinding system and signage for the new international museum. The clean chrome and glass architectural elements of the building inspired us to keep the look simple and transparent.

To complete the international identity of the museum, we created dozens of national flags out of clear and frosted lucite and hung them in the foyer of the building.

Royal Viking Line

Skald **Magazine**

Over a 15-year period, we were commissioned to produce *Skald*, a travel magazine for Royal Viking Lines frequent cruisers. We were looking for interesting and unique content that would appeal to a sophisticated global audience.

A contemporary look at the historical geography of Ancient China.

Each magazine contained a walking map within blocks of the ship's docking location.

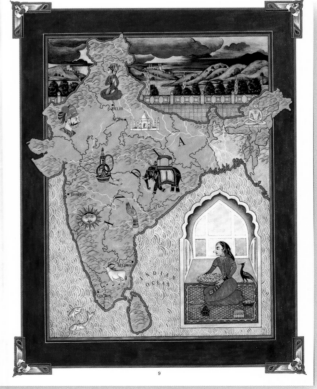

A literary look at Southwest Asia from the writings of Joseph Conrad and William Somerset Maugham.

A reflection on the Indian food consumed by the continent, illustrated with art reminiscent of 19th century Indian miniatures.

We tried to link the imagery and stories to regions of the world and experiences that RVL customers would encounter on each cruise tour. The art and photography were commissioned to look like a high-end travel magazine, not a promotional brochure.

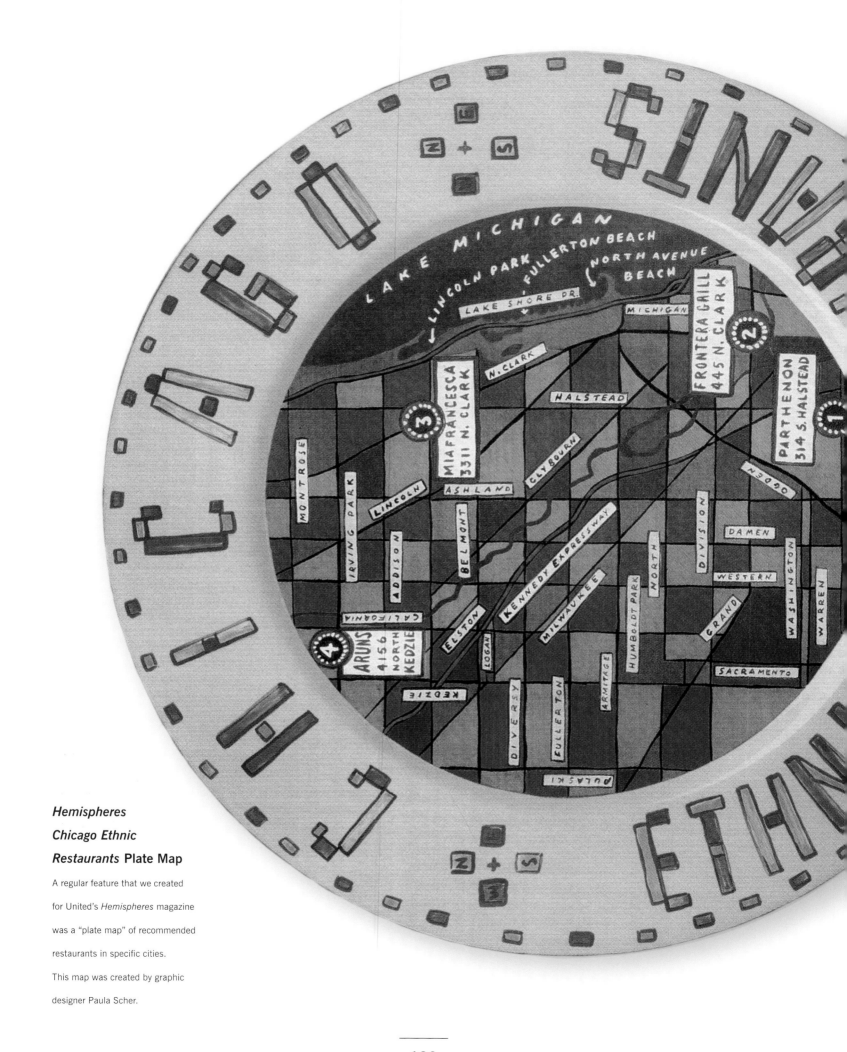

Hemispheres
Chicago Ethnic
***Restaurants* Plate Map**

A regular feature that we created
for United's *Hemispheres* magazine
was a "plate map" of recommended
restaurants in specific cities.
This map was created by graphic
designer Paula Scher.

Each year, Royal Viking Line
offered long-distance luxury
cruises to captivating parts
of the world. For RVL's Grand
Pacific cruise, we designed
a folding fan that featured
an illustrated map of
the cruise line's Asian route.

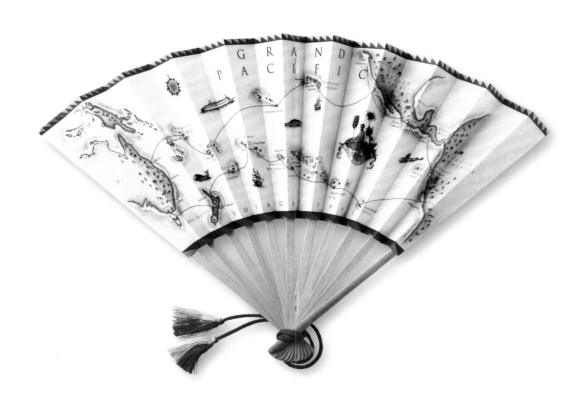

SF VIEWS
IMPRESSIONS OF THE CITY BY THE BAY • 15 DESIGNERS GIVE

HP GRAPHIC ARTS • HP.COM/GO/DISCOVERDIGITAL

DESIGNERS' IMPRESSIONS OF SAN FRANCISCO
MICHAEL MABRY

DESIGNERS' IMPRESSIONS OF SAN FRANCISCO
RICK VALICENTI

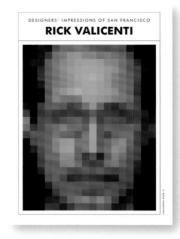

DESIGNERS' IMPRESSIONS OF SAN FRANCISCO
TOM GEISMAR

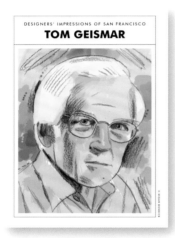

DESIGNERS' IMPRESSIONS OF SAN FRANCISCO
STEFAN SAGMEISTER

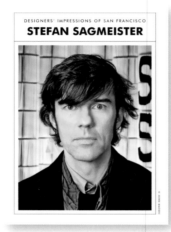

DESIGNERS' IMPRESSIONS OF SAN FRANCISCO
CHIP KIDD

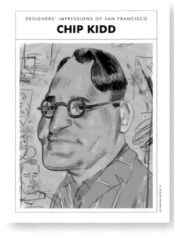

DESIGNERS' IMPRESSIONS OF SAN FRANCISCO
ERIK SPIEKERMANN

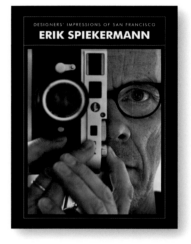

DESIGNERS' IMPRESSIONS OF SAN FRANCISCO
DANA ARNETT

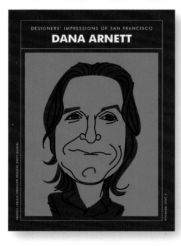

DESIGNERS' IMPRESSIONS OF SAN FRANCISCO
MASSIMO VIGNELLI

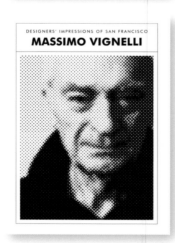

DESIGNERS' IMPRESSIONS OF SAN FRANCISCO
MICHAEL VANDERBYL

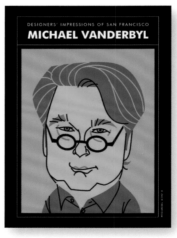

DESIGNERS' IMPRESSIONS OF SAN FRANCISCO
YVES BEHAR

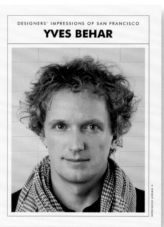

DESIGNERS' IMPRESSIONS OF SAN FRANCISCO
IVAN CHERMAYEFF

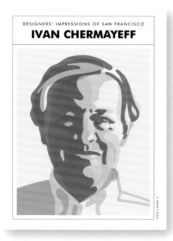

DESIGNERS' IMPRESSIONS OF SAN FRANCISCO
JENNIFER MORLA

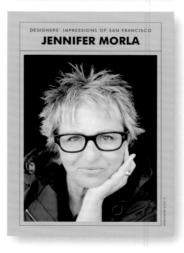

DESIGNERS' IMPRESSIONS OF SAN FRANCISCO
MICHAEL SCHWAB

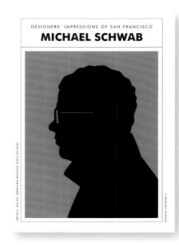

DESIGNERS' IMPRESSIONS OF SAN FRANCISCO
JESSICA HISCHE

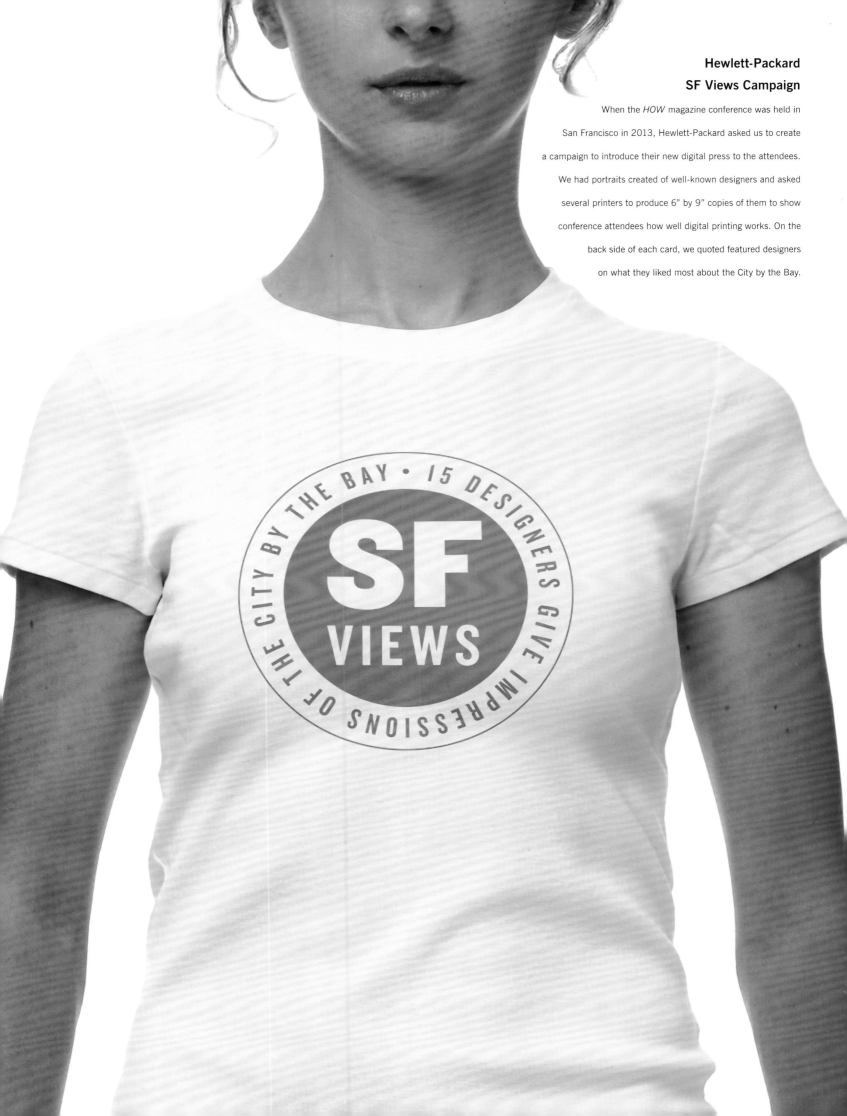

**Hewlett-Packard
SF Views Campaign**

When the *HOW* magazine conference was held in San Francisco in 2013, Hewlett-Packard asked us to create a campaign to introduce their new digital press to the attendees. We had portraits created of well-known designers and asked several printers to produce 6" by 9" copies of them to show conference attendees how well digital printing works. On the back side of each card, we quoted featured designers on what they liked most about the City by the Bay.

SF
VIEWS

CITY BY THE BAY • 15 DESIGNERS GIVE IMPRESSIONS OF THE

AIGA *California Design* Poster

When AIGA National decided to host their first regional design exhibition in California, I was asked to chair the jury, design the call

for entries, run the competition and organize the final selection for the AIGA Annual. My call for entries poster was an ambitious feat,

pulled off with the aid of photographer Terry Heffernan. A vintage 1946 Ford was a natural for depicting California's car culture.

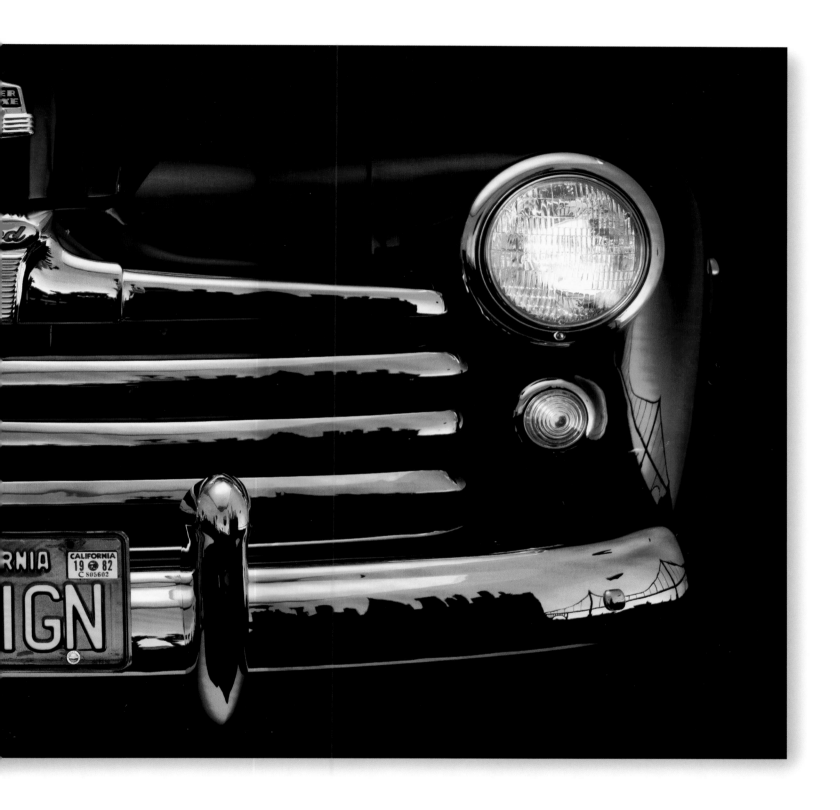

But Photoshop had not yet been invented, so no retouching was used to reflect the state's iconic landmarks off the chrome bumper and gleaming Fenders. We cut geographic

landmark silhouettes out of cardboard and then backlit the cutouts to suggest a golden sunset. With the aid of the DMV, we located the owner of the "Design" license plate and asked

her to lend it to us for the photo shoot. The poster was later chosen for inclusion in the New York MoMA and LACMA permanent poster collections.

Graphic Arts Center
The Best of
Portland Promotion

The Graphic Arts Center printing plant was located in Portland, Oregon, a deterrent for clients who preferred printing in Los Angeles, better known for restaurants, good weather and entertainment options.

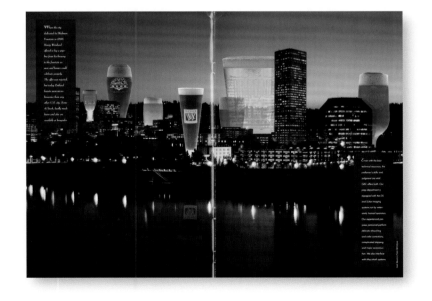

GAC asked us to convince clients to print in Portland. Our solution was to create a guide to Portland's many historical and unique cultural attractions, such as craft breweries, restaurants and museums presented together with great printing.

SOPHISTICATED

A traffic-stopping package
for a Manhattan-inspired cologne,
this wraparound image
illustrates how engaging imagery
can capture the excitement
of a visual concept.
Spectro C1S is considered the
ideal choice for offering
the structural integrity needed for
handling multi-sided folds
and a smooth coated surface that
brings out vibrant colors and
subtle details.

42

Sappi *The Standard 7*
Packaging Perceptions

Contrast is always important when highlighting

the difference between products. We chose to

demonstrate the printability of Sappi's premium

packaging coated stock by creating a high-energy,

dazzling fashion product line titled *Midtown*.

Boldly illustrated by Daniel Pelavin, the reverse

side of the sheet creates contrast with the names

of major cities around the world.

The uncoated side of
Spectro C1S sheets
provides a natural
look along with sharp
image reproduction.

47

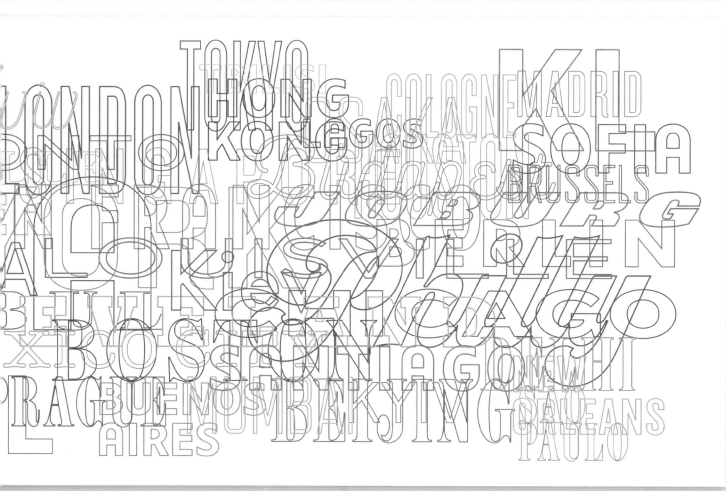

Spicers
Australia Tour
Poster

On a five-city speaking tour of Australia sponsored by Spicers Paper, I was asked to make my own poster, which I did standing under a giant ANZAC (Australia New Zealand Army Corps) hat with an American flag fan in the brim. This same hat theme was replicated for subsequent speeches in the United States.

HINI

Spicers Paper is pleased to invite you to a "conversation" with Kit Hinrichs, international designer, author and partner in Pentagram Design.

Kit's trip "down under" will include a series of candid, personal case studies on projects as diverse as annual reports, magazine design and packaging. His clients include United Airlines, Simpson Paper, Royal Viking Line, Norcen, Potlatch Corporation, Levi Strauss and The Nature Company.

AUST

SEPARATIONS: SHOW-ADS GROUP PRINTED ON: VOLARE PLUS 150GSM

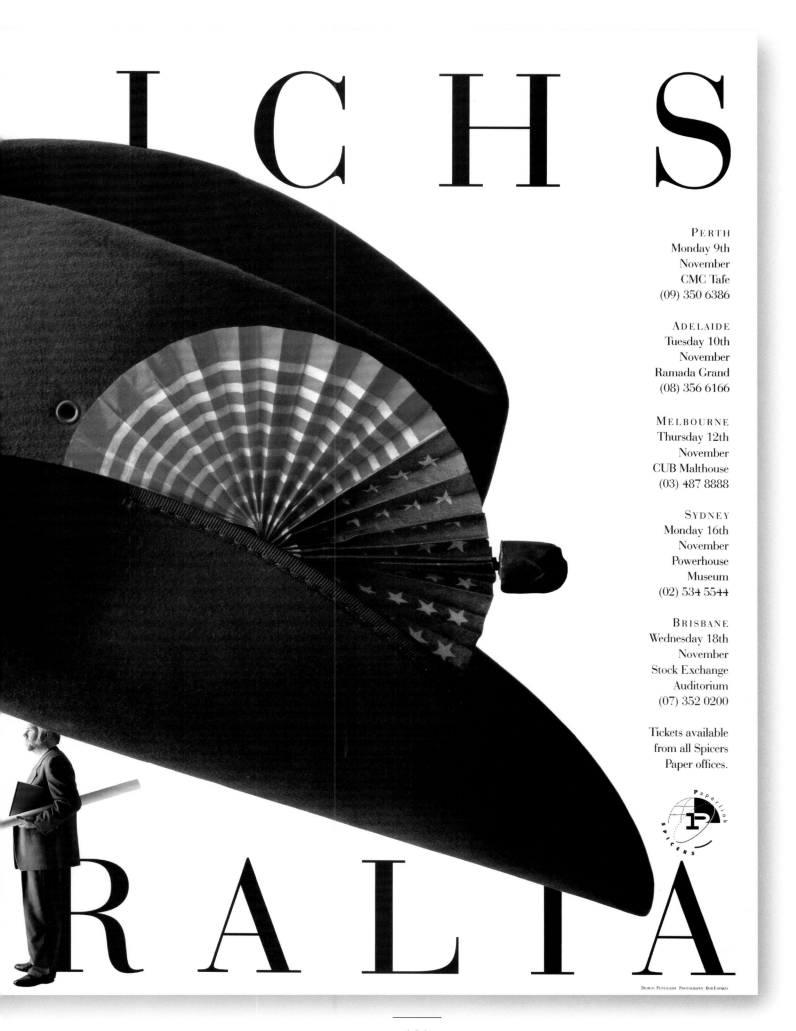

ICHS

RALIA

PERTH
Monday 9th
November
CMC Tafe
(09) 350 6386

ADELAIDE
Tuesday 10th
November
Ramada Grand
(08) 356 6166

MELBOURNE
Thursday 12th
November
CUB Malthouse
(03) 487 8888

SYDNEY
Monday 16th
November
Powerhouse
Museum
(02) 534 5544

BRISBANE
Wednesday 18th
November
Stock Exchange
Auditorium
(07) 352 0200

Tickets available
from all Spicers
Paper offices.

DESIGN: PENTAGRAM PHOTOGRAPHY: BOB ESPARZA

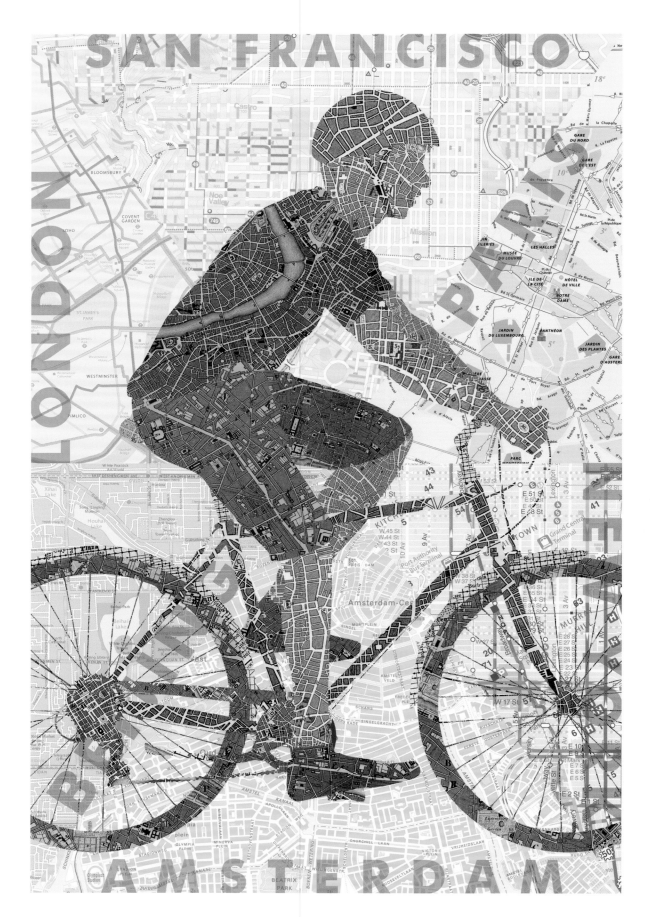

Ansel Adams
California **Book**

We were selected to design the first collection of California photographs made by Ansel Adams from the 1920s to the 1980s. The assignment included a lavish coffee table book, 25 collectible posters and an annual calendar celebrating Adams' finest California scenes.

PUBLIC Bikes Poster and Cataloge

A composite of international city maps was my way of suggesting the value of cycling everywhere in this poster created for PUBLIC Bikes in San Francisco. The poster was one of several dozen that were included in an exhibition, gallery auction and catalog.

SYMBOLS, METAPHORS AND CLICHÉS

Sometimes the expected, most traditional imagery is one of the most effective tools in telling a new story. We are comforted by familiar ideas, but seeing them in a new context, juxtaposed with different images or words, breaks new ground for fresh thinking and unexpected conclusions.

@Issue
Symbol Quiz

The magazine *@Issue* included a quiz in each edition to demonstrate the role that graphic design and symbols play in communicating vital non-verbal information in our everyday lives.

Corporate Branding

During the course of my career, our office has developed dozens of corporate brands. No two were alike because the goal was to communicate the unique identity of the company, not an extension of my own style.

STANFORD
LIVE

UltraViolet

Design Within Reach

Fisher Development

Piperlime

Black & White Ball

The Walt Disney Family Foundation

Melinda Gates, Pivotal Ventures

Fort Mason Center

Lulan

Gymboree

Blue Sky Founders Forum

Giants Enterprises

MarketingProfs

Red Herring

The Spark Awards

Luckyfish Sushi

Muzak

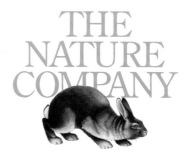

The Nature Company

Tragon

Larkin Street

Plus

Symantec

The Presidio Tunnel Tops

B2B Marketing Forum

University of California Riverside

NapaStyle

San Francisco Women Artists

Fuego Grills

Stanford Law School

CSPF Californians

Good Ventures

Columbus Salame

The Unexpected Table

San Francisco Center for the Book

Shocase

Casa Cornelia Law Center

The Constellation Brand

We were asked to create a branding program for an international entertainment, business, technology, arts and education center in Singapore. The "gathering of stars" symbol relates to the intertwining of premier entities and individuals from around the globe.

CONSTELLATION

Open Philanthropy

Classic Color Alchemy

University of San Francisco

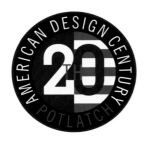

20th Century Potlatch

Safeco

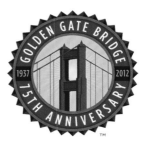

Golden Gate Bridge 75th Anniversary

Paradox Strategies

Cal Academy of Sciences

@issue:

@issue

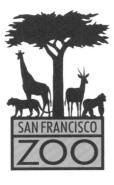

San Francisco Zoo

Economic Club of New York

Rancho Santa Fe Library

Emir of Qatar Commemorative Compass

While working on a development program for Claremont Lincoln University in Southern California, we were asked to create a unique gift for the Emir of Qatar to thank him for his contribution to religious tolerance and world peace. We created this "moral compass" from several layers of etched glass, a compass, along with a handmade wooden presentation box.

**PG&E
Corporation
Annual Report**

The 2007 Pacific
Gas & Electric annual
report focused on how
the adoption of smart
and dependable
energy practices can
transform the energy
profile of Californians.
These well known symbols
were translated to meet
PG&E's environmental
commitment.

**FROM THE NATIONAL BASEBALL HALL
OF FAME AND MUSEUM ARCHIVES**
TERRY HEFFERNAN, KIT HINRICHS & DELPHINE HIRASUNA

*100
Baseball Icons*
Book

Photographer Terry
Heffernan and I are
avid baseball fans, so
when he returned from
Cooperstown, New York,
after photographing
artifacts at the Baseball
Hall of Fame, we decided
to produce a book on
baseball icons, published
by Ten Speed Press. The
crossed bats and ball
is a time-worthy icon
to illustrate the national
pastime.

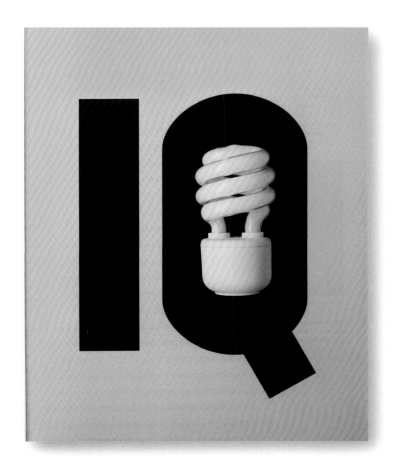

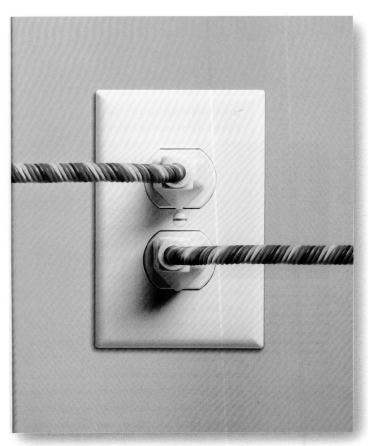

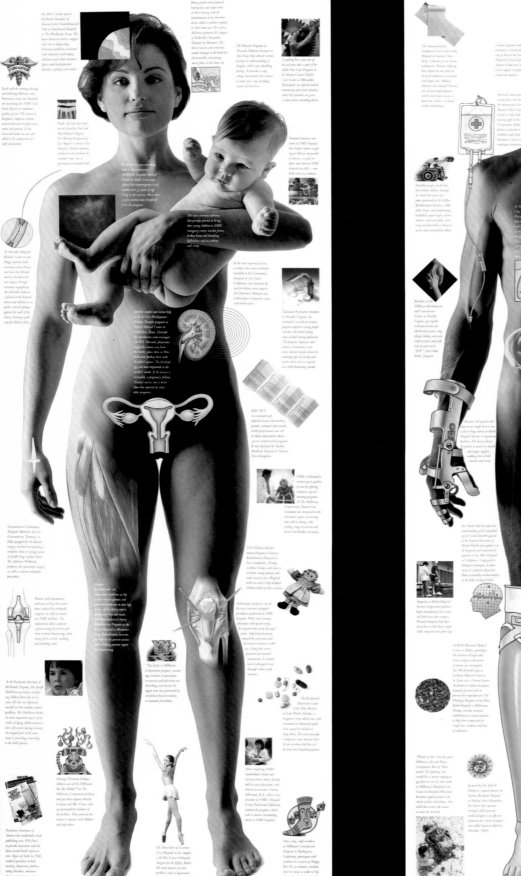

To celebrate Square

One Restaurant's

10th anniversary, we

took the metaphor of

"marking time on a wall"

and used silverware

in the same configuration.

**National Medical
Enterprise Annual
Report**

We literally demonstrated

the old adage "from

head to toe" to convey

the scope and breadth

of the National Medical

Enterprise's 5,000 medical

services. Superimposing

a combination of medical

illustrations, graphic images

and detailed captions over

the black-and-white model

photos communicates the

essence of the company's

capabilities.

Tenfold

Sacred Cows

Annual Report

A new player in the software world, Tenfold wanted to make a statement as to how their approach was different than the traditional software manufacturer. We suggested "myth busting" as the freshest way to slay four of the industry's metaphorical "sacred cows." The cover art was a play on "when cows can fly," with the engineers worried that the wings on the cow were not big enough to be able to lift the cow.

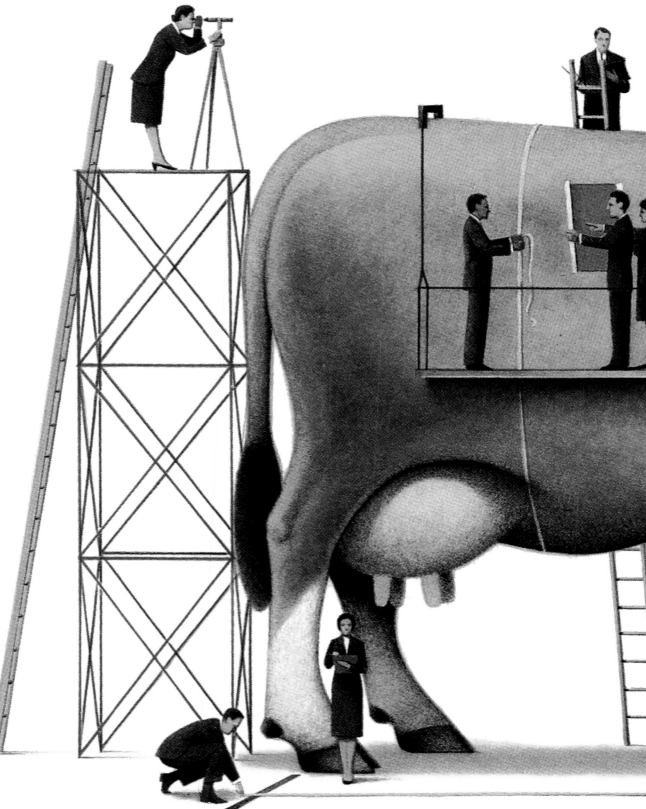

Sacred Cow Myth No. 1: The more time you take defining applications requirements, the more correct they will be.

Smith & Hawken | TO THE TRADE

SOURCEBOOK

CONTRACT FURNISHINGS 2006

Why Choose Smith & Hawken Premium Teak™ Furniture?

Our furniture starts with only the choicest cuts of Premium Teak—straight, smooth and free of knots—the best quality available. The wood is kiln dried for optimal water content, eliminating future shrinkage or expansion. Then each section is hand fitted, using snug mortise-and-tenon joinery that remains rock-solid year after year.

Handcrafted like other fine furniture, Premium Teak will endure for decades. Once in place, it requires virtually no maintenance and can be left outdoors year-round to weather naturally, eventually turning a silvery grey. Every piece is backed by our guarantee, which covers any manufacturing or material defects.

Premium Teak is ecologically grown on Javanese tree plantations managed by a government agency that permits the harvest of only mature trees, supervises reseeding and encourages villagers to grow crops for their personal use. We import no grey-market wood from threatened forests.

Smith & Hawken Catalog

High-end outdoor furniture retailer Smith & Hawken wanted their catalog customers to know that their products are as well made on the inside as they are on the outside. In addition to photographing merchandise in garden settings, we "dissected" the chairs and explained how quality went into every step of the construction process.

Why Choose Smith & Hawken Metal Furniture?

To the designer, metal's appeal lies not only in its strength but also its versatility—there are virtually no limits to the patterns, shapes and finishes that can be applied to metal furniture. Whether replicating the look of a centuries-old cast-iron bench or creating a contemporary aesthetic, metal offers endless possibilities.

Smith & Hawken's collections are made of either cast aluminum, iron or heavy-duty steel. Lightweight and nearly corrosion-free, our aluminum tables and chairs can be quickly rearranged for special events or moved out of the way for cleaning and storage. Our steel and iron pieces are remarkably sturdy and built to withstand heavy use in high-traffic areas.

All our metal furniture is appropriately finished to withstand the effects of weather and minimize rust. Choose from finishes ranging from gleaming aluminum to antique bronze to matte black.

Two commonplace but
disparate icons – the
Russian nesting doll and
a hand grenade – create
a powerful visual when
merged together on a
protest poster. This was
one of over 300 posters
sponsored by Graphis
and created by designers
around the world to
express their outrage at
the unprovoked attack on
Ukraine by Putin and the
Russian military.

"LIKE COMPARING APPLES AND ORANGES."—*Anonymous*

Potlatch

Apples & Oranges

For a Potlatch paper
promotional series called
Field Studies, we looked at
food in our culture, including
how apples and oranges are
used in many metaphors,
such as "an apple a day,"
"American as
apple pie" and more.

RUSSIA.
STOP THE KILLING!

CONVERSATIONS

Joline Godfrey is an
innovator in financial
education for children and
parents. Asked to design
the complete book and
cover of her top-selling
book *Raising Financially
Fit Kids*, we played
on the visual metaphor
of building strengths
with "financial equipment"
to nurture financially
mindful and creatively
generous children.

**ArtCenter
College of Design
Invitation**

Punctuation, the visual
signpost of dialogue,
can be very descriptive when
used as the symbol of
communication. The
quotation marks defined a
series of "Conversations"
between several disparate
groups of ACCD alumni.

216

COLLECTIONS AND DIVERSIONS

My design inspirations do not happen in a vacuum.

I surround myself with pop culture objects,

thousands of books, designer memorabilia, typography in

all forms, American flag collectibles, carved

Mexican folk art, a wonderful family who supports me,

and two cats that distract me.

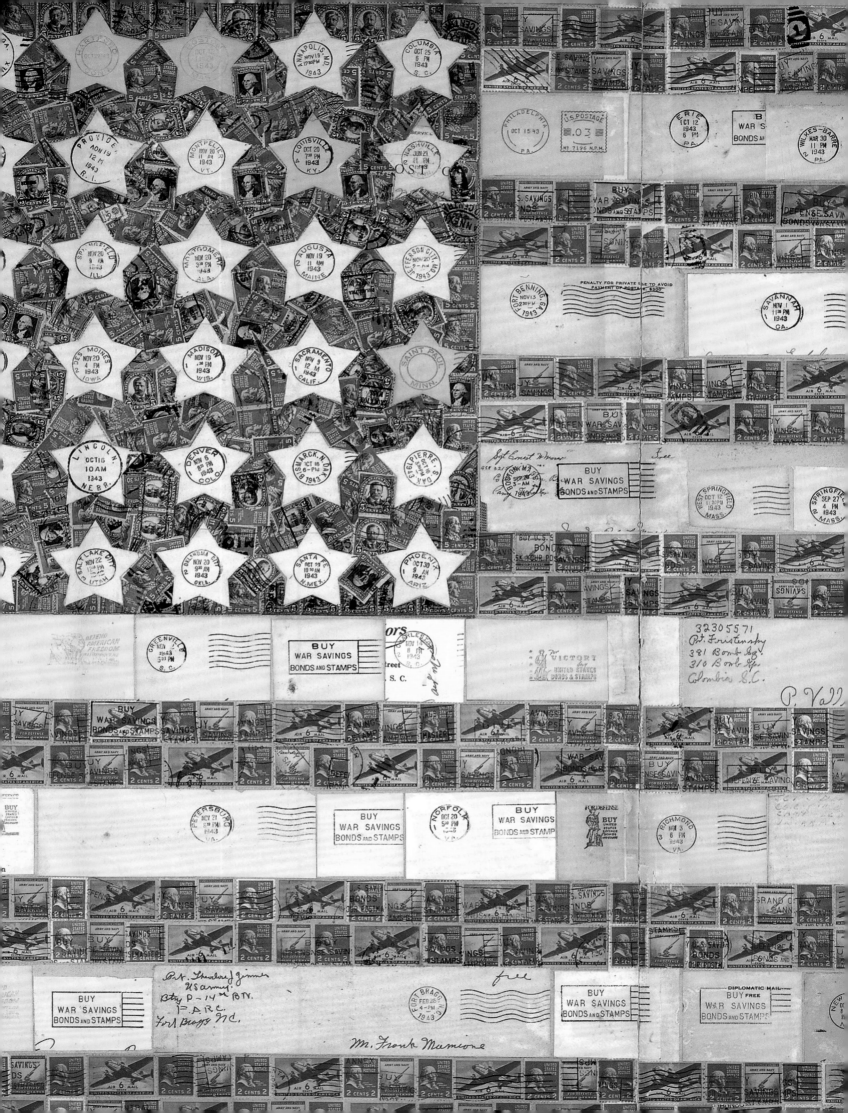

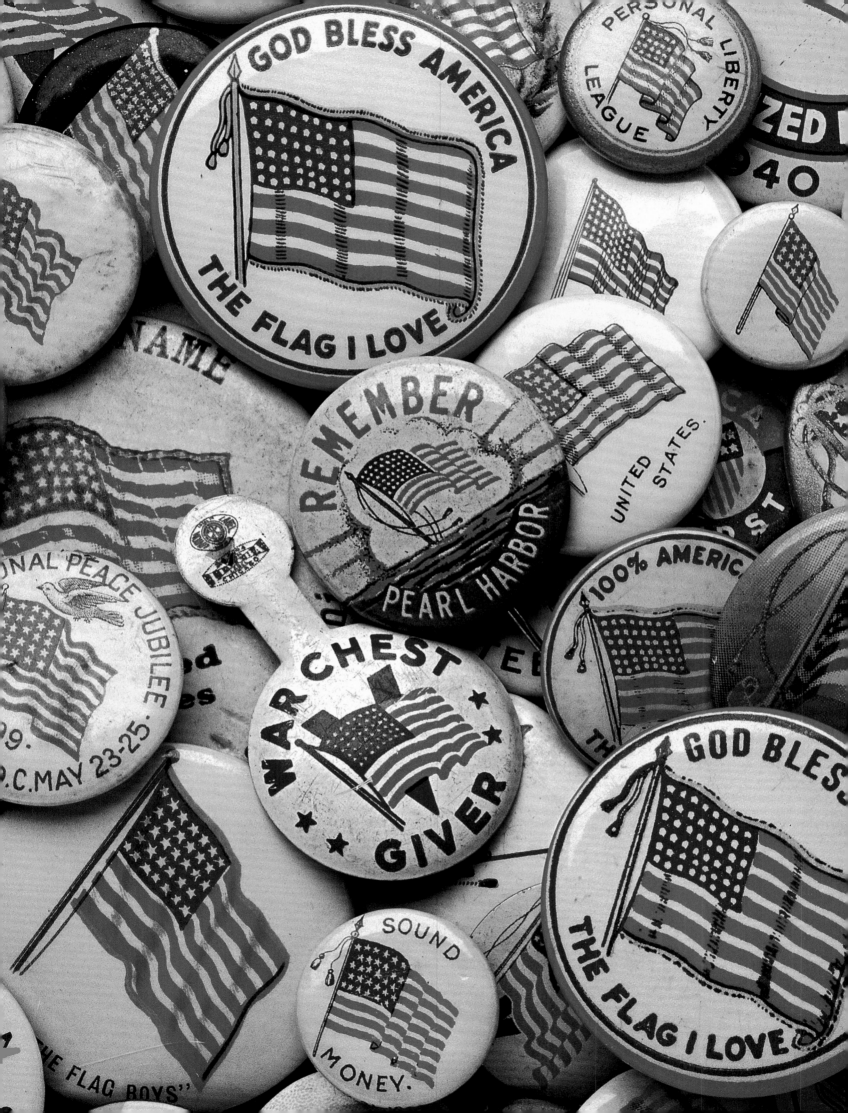

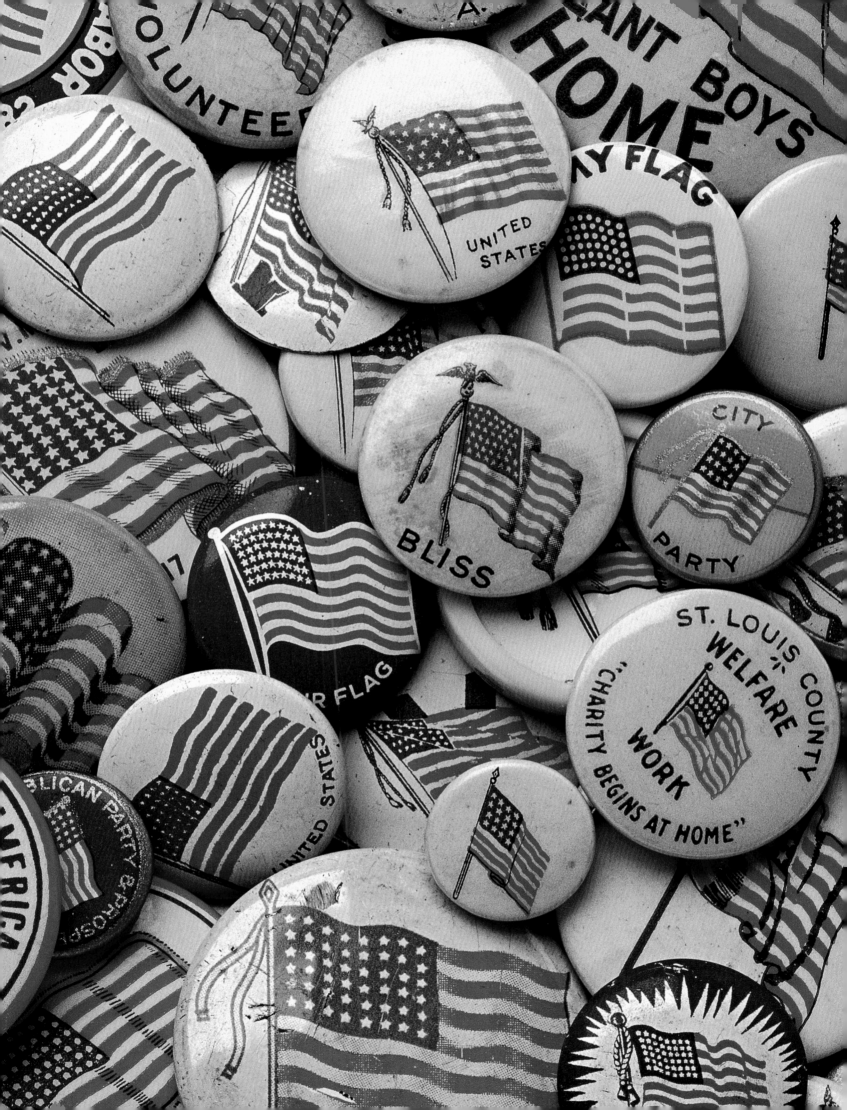

Patriotic
Flag Pins

From the previous spread, the patriotic flag buttons are one of the many sub categories of the Stars & Stripes Collection, along with Navajo weavings, portrait photography, WWI and WWII posters, children's toys, postage stamps, quilts and folk art.

Mexican Folk Art

My wife, Linda, and I
have collected folk art
for decades, which find
a home on our fireplace
mantel. These objects
are simple in form and
transparent in materials,
and you can always see
the hand of the craft
person who created it.

Promotional Advertising

Sometimes advertising promotions are so representative of an era that they trigger nostalgia for the spirit and soul of what life was like back then. Often created by unknown artists, such promotion live beyond the moment and become the visual image of the era.

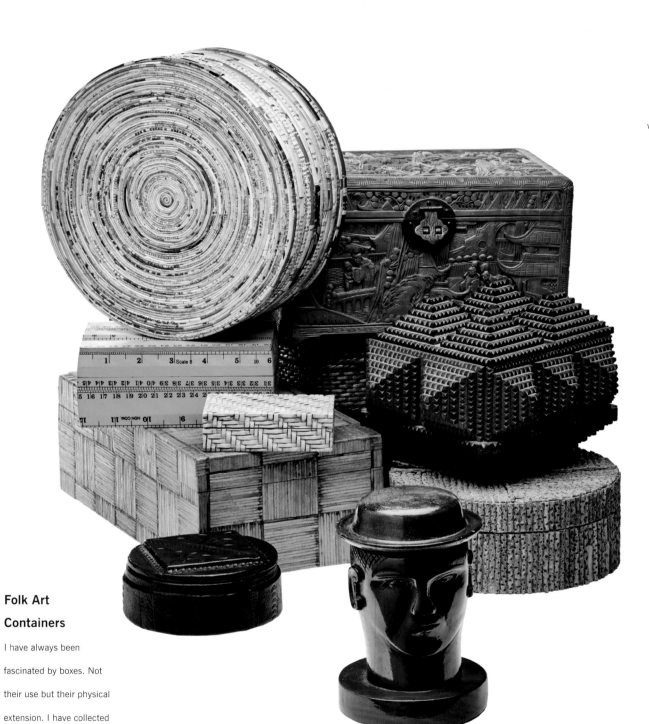

Folk Art Containers

I have always been fascinated by boxes. Not their use but their physical extension. I have collected handmade containers from tramp art, carved wooden boxes and leather containers to woven baskets and matchstick boxes from my global travels for years.

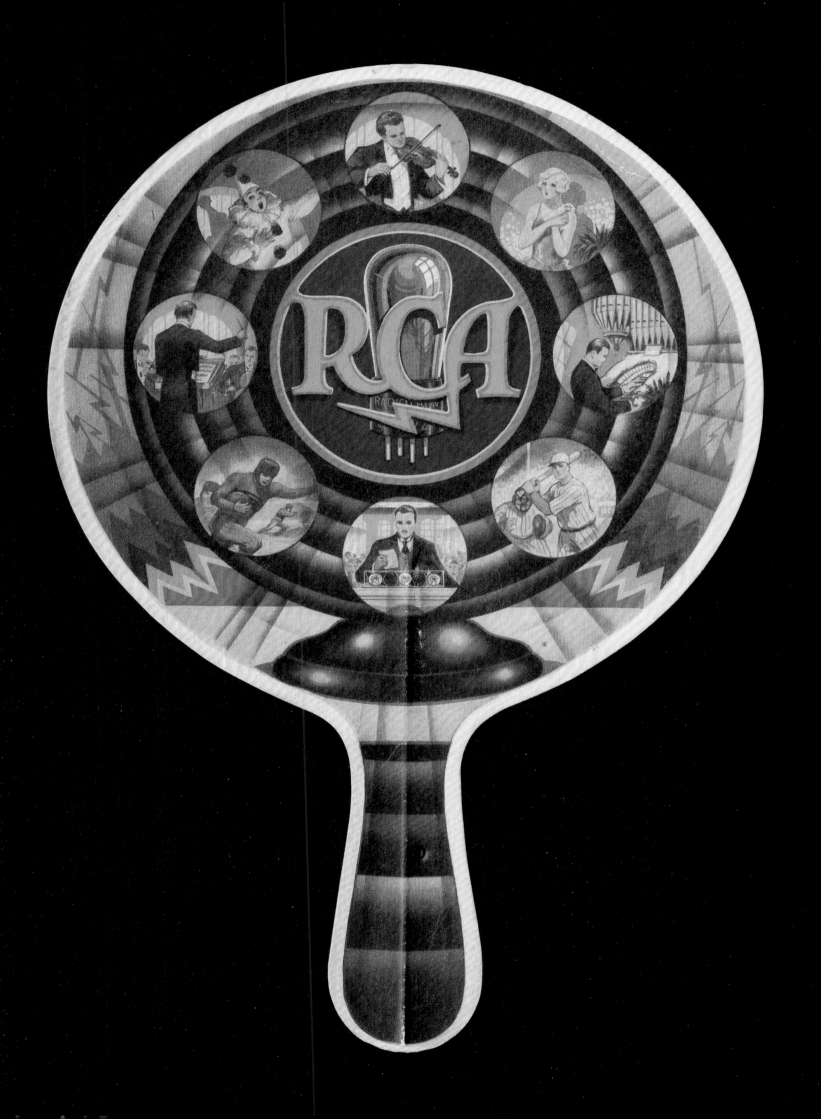

United States of North America

Flag Postcards

A favorite pastime is attending the vintage paper ephemeral shows, which give

me a glimpse of social interests and trends over time. This woman draped in the American flag was

charming, then I discovered multiple versions of the same woman, each time draped in a

different country's flag – an early example of cross-cultural marketing.

Baseball
Bobbleheads

Major League Baseball
began giving away
and selling bobblehead
mascots of players at
ball games in the 1960s.
Today's bobbleheads
are now made from
durable resin, and have
become as popular as
baseball trading cards.
Historically, bobbleheads
date back to France in
the 17th century and were
made of ceramic.

American
Flag Bearers

Miniature toy soldier sets
made of lead have been
around for centuries, and
every set included the
all-important flag bearer.
I've collected more than
1,000 flag bearers, from
historical to contemporary,
representing every branch
of the armed forces, Boy
Scouts, everyday citizens
and even astronauts.

Rockwell Kent Books

I have been an avid collector of books designed by
Rockwell Kent (1882–1971), since I first entered
the profession in the early 1960s. Kent's exquisite
engravings have graced classics like *Moby Dick, Paul
Bunyan, Candide* and *The Complete Works of William
Shakespeare*. Kent's transcendentalist philosophy
sees the divine spirit in all of nature, infusing his work
with a mystical energy that is uniquely his own.

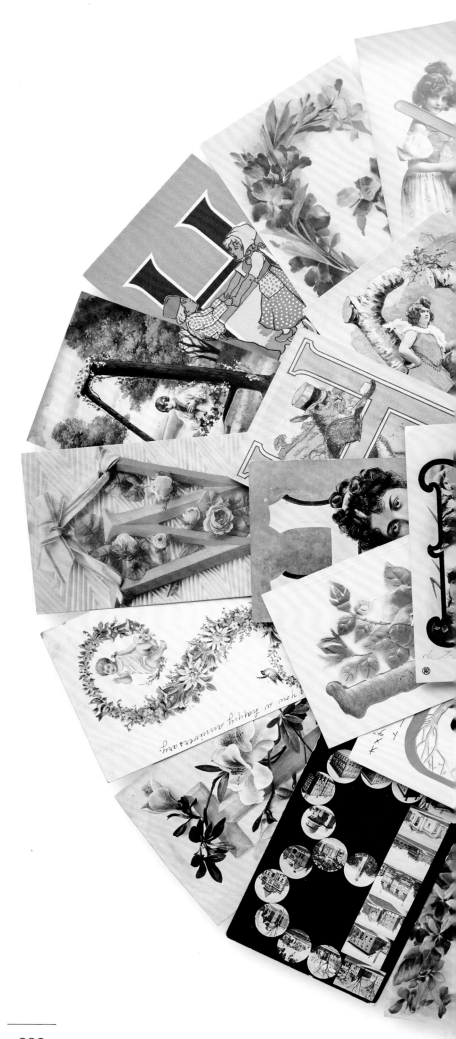

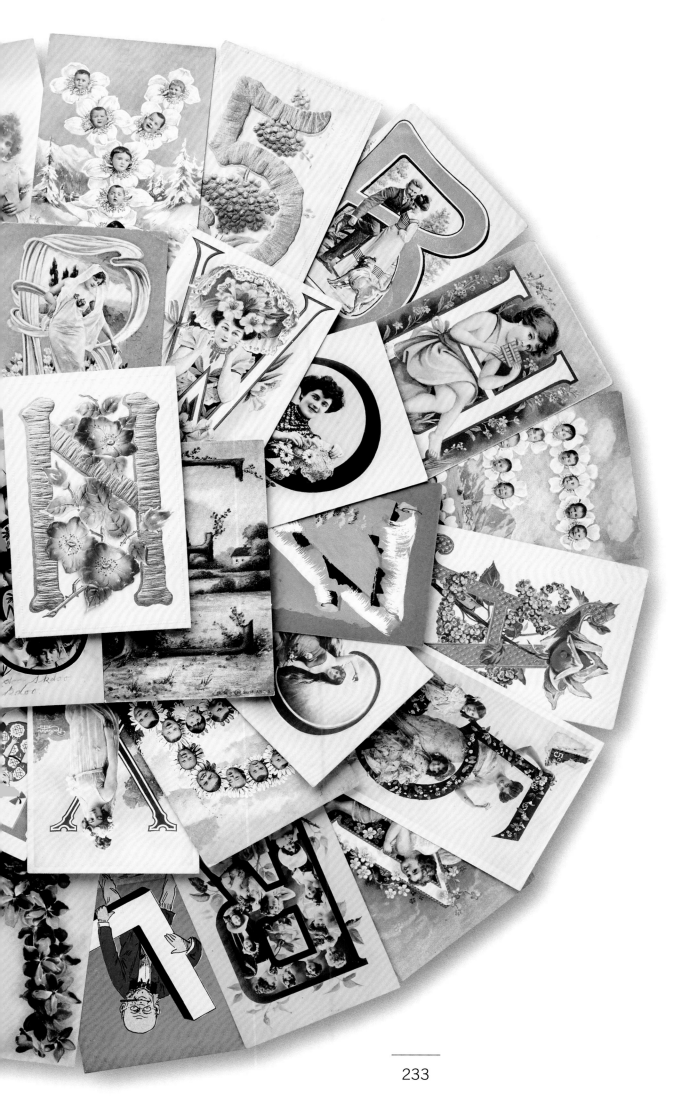

Victorian-era alphabet
postcards appeal to my
interest in typography and
how innovations in
printing, photography,
design themes and
production techniques
have evolved during the
intervening century in
the manufacture of
these collectible cards.

GETTING FROM A TO B

Everyone starts somewhere, and I wanted to

recognize the educators, partners, family, friends and

colleagues who have allowed me to thrive for

five–plus decades of design. I've attempted to collect the

names of the many hundreds of people who

have aided me throughout the years.

Professional Experience Studio Hinrichs, 2009 - present Principal and Creative Director, A national design firm with headquarters in San Francisco, specializing in branding, packaging, and environmental design, Pentagram Design Inc, 1986 - 2009 Partner and Creative Director An international design firm with offices in London, Austin, New York, San Francisco, Berlin Johnson, Pedersen, Hinrichs & Shakery, 1976 - 1986 Founder and Designer. A bi-coastal design firm with Vance Johnson, B. Martin Pedersen, Linda Hinrichs, Neil Shakery, New York and San Francisco, Hinrichs Design Associates, 1973 - 1976 Founder and Designer with wife & partner Linda Hinrichs, Russell & Hinrichs, 1966 - 1973, Founder and Designer with Anthony Russell Reba Sochis Design New York City, 1965 - 1966 Designer, Designers 3 New York City

The accompanying timeline graphically populates the past five decades. Part of the visualization of my journey is to orient you with the ebbs and flows of my career, growing up post–World War II in Southern California, with all the cultural changes that coincided with the seismic upheaval that America – and the world – found itself in during the last quarter of the 20th century. I trust that this simple biography helps to put all of this into context and gives you a window into that period of history for one designer.

1963
First real assignment, Cha Cha Cha album, done at ArtCenter

1964–1965
First design job at Designers 3 at 545 Fifth Avenue, NYC, at $85 a week

1960

1963
Graduated ArtCenter
Bachelor of Fine Arts

1963–1969
Served in
U.S. Marine
Corps Reserve

1974–1976
Taught at School of
Visual Arts
Instructor of
Graphic Design

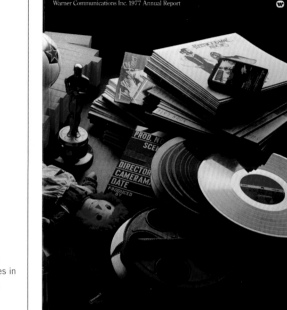

1972–1976
Formed Hinrichs
Design Associates in
partnership with
Linda Hinrichs

1966–1973
Formed Russell & Hinrichs
in partnership with Tony Russell.
Shown here from left to right:
Tony Russell, Linda Hinrichs and
Kit Hinrichs.

1965–1966
Worked at Reba
Sochis Design

1974–1977
Engaged by Warner Communications,
to design their annual reports

1970

KIT HINRICHS
ILLUSTRATOR
AND DESIGNER
150 E. 35th ST.
NEW YORK, 16
CALL 532·1288

1966
Opened first
office, sharing space
with Tony Russell at
150 E. 35th Street,
New York City

Moved office to Flatiron District on 5th Avenue

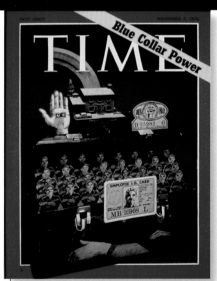

Moved to new office in Manhattan

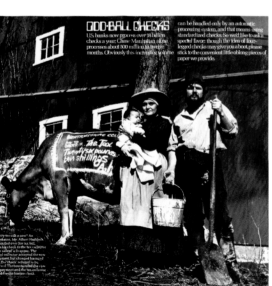

1970
Commissioned by *Time* to
create five assemblage covers
for the magazine

1968
Comissioned by Chase
Manhattan Bank to design
Odd-Ball Checks window
exhibit

1974
Asked by LetraGraphix to
create a print promotion

1973
Created self-promotion named
One, based on a series of
"firsts"

THE NATURE COMPANY CATALOG

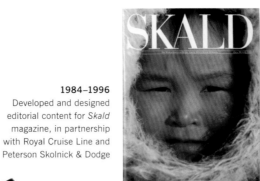

SKALD

1984–1996
Developed and designed
editorial content for *Skald*
magazine, in partnership
with Royal Cruise Line and
Peterson Skolnick & Dodge

1983–1995
Designed and branded
all materials for The
Nature Company,
including catalogs,
packaging and identity
development

1976–1986
Co-founded Jonson Pedersen
Hinrichs and Shakery
(JPH&S), a bi-coastal firm
with Vance Jonson and
B. Martin Pedersen working
from New York, and Linda and
Kit Hinrichs and Neil Shakery
operating in San Francisco

Moved office from New York to San Francisco's Embarcadero Center

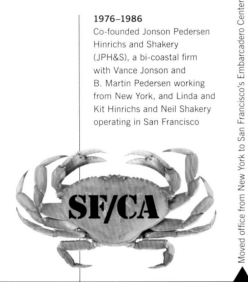

SF/CA

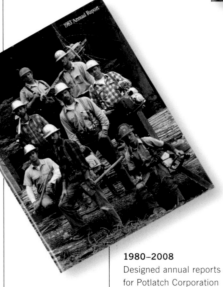

VEGETABLES

Moved JPH&S office to Davis Street

1985
Designed first retail book authored
by Delphine Hirasuna and
published by Chronicle Books

1980–2008
Designed annual reports
for Potlatch Corporation
for nearly 18 years

1980

1979–1980
Taught graphic
design course at
Academy of
Art College

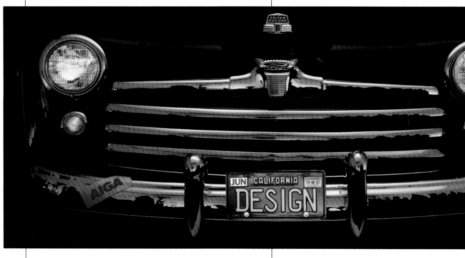

1983
Designed the call for entries
poster for AIGA's first regional
design show. The poster is
now included in the New York
MoMA permanent collection.

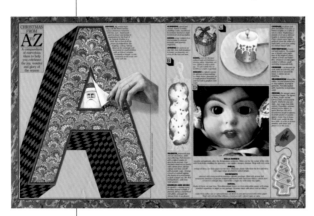

1976
Awarded ADC
Gold Medal for McCall's
Christmas edition

Crocker
National
Corporation
1979 Annual
Report

1979
Commissioned by
Crocker National Corporation
to design their annual report
and handle other design
projects for the bank

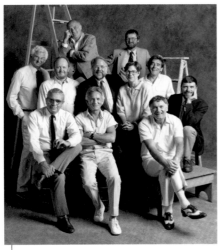

1987
Enlisted AIGA designers across the U.S. to create original American flag art pieces that were displayed in an exhibition and developed into the book, *Stars & Stripes*

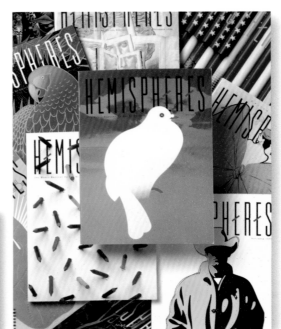

1986–2009
The San Francisco office (Linda Hinrichs, Neil Shakery and Kit Hinrichs) merged with Pentagram partners in London and New York. Kit stayed with Pentagram for 23 years, heading the West Coast office.

1987
Developed and styled an inflight magazine, called *Hemispheres*, for United Airlines

1990–1992, 1995–1997
Taught design and illustration at California College of Arts and Crafts

1987
Commissioned by Gymboree to rebrand their identity and develop new packaging

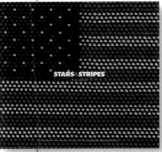

1990

1987
Designed Pentagram Papers 14, *Stars & Stripes*, Kit's first Pentagram Paper

1986
Designed Beaux Arts Ball, a fundraising gala for the San Francisco Museum of Modern Art

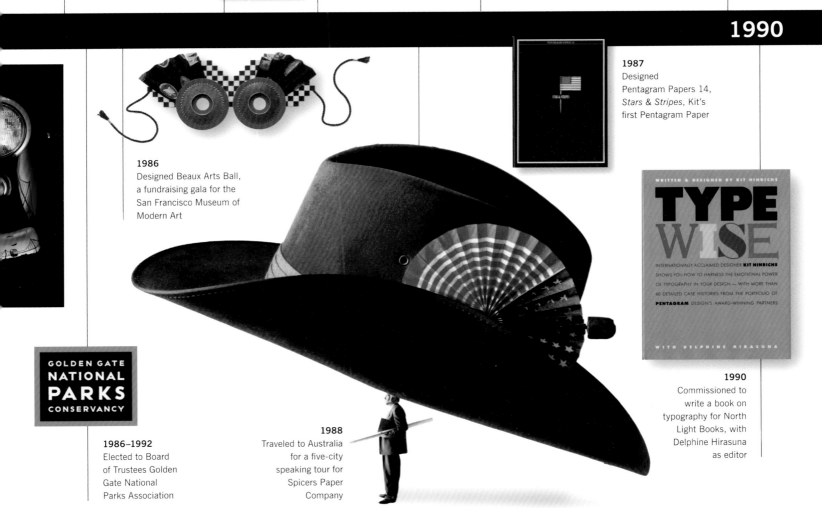

GOLDEN GATE NATIONAL PARKS CONSERVANCY

1986–1992
Elected to Board of Trustees Golden Gate National Parks Association

1988
Traveled to Australia for a five-city speaking tour for Spicers Paper Company

1990
Commissioned to write a book on typography for North Light Books, with Delphine Hirasuna as editor

1988–1994
Served on the national board of the AIGA

1996
Designed a series of annual reports for Transamerica Corporation

1999
Designed promotion for an exhibition of art from the Whitney Museum and the San Jose Museum of Art

ArtCenter

1997–2019
Served on the Board of Trustees of ArtCenter College of Design

SAN JOSE MUSEUM OF ART

AMERICAN ART 1900–1940 A HISTORY RECONSIDERED

SELECTIONS FROM THE PERMANENT COLLECTION OF THE WHITNEY MUSEUM OF AMERICAN ART

1990
Designed a series of annual reports for US West Bank

Moved the Pentagram Office to Tehama Street, SOMA

1990

1990
Created an exclusive portfolio/catalog of Renaissance garden furniture for Craig Johnson's Country Matters

1991
Handled branding for Clark's Shoes in-store promotional displays

1991
Developed all promotional materials for the launch of Quest, Simpson Paper's new line of recycled papers

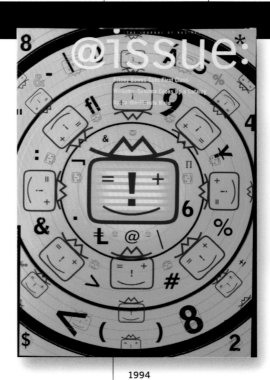

@issue:

AGI

1993–Present
Inducted into Alliance Graphique International

1994
Founded @issue: Journal of Business & Design with Delphine Hirasuna and the Corporate Design Foundation

1997
Created Pentagram Papers #25, featuring souvenir albums

SFMOMA

1998–2001
Served on SFMOMA's Design and Architecture Accessions committee

240

2001
Curated a *Long May She Wave* exhibition held at the George H.W. Bush Presidential Library

2000
Designed Pentagram Papers 31, featuring hinagata kimonos from a 19th century Japanese pattern book

2000
Created branding for Muzak, an audio architecture company

2001
Designed a series of fancifully illustrated packaging for Dreyer's Dreamery ice cream

September 11, terrorists attack twin towers in New York City

2001
Long May She Wave, published by Ten Speed Press, showcased much of Kit's American flag collection.

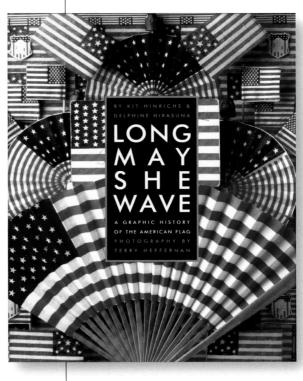

2005
Spearheaded the AIGA's Risk/Reward business conference held in San Francisco

2000

2005

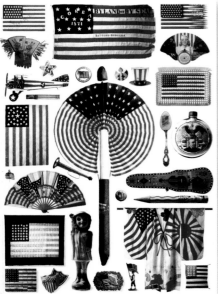

★ Stripes & Stars: A Graphic History of an American Icon ★ The AIGA National Design Center, Fifth Avenue & 22nd Street, New York ★ June 28 to August 25, 2000 ★ From the Collection of Kit Hinrichs ★ Supporting Sponsors: Potlatch & Pentagram

2000
Curated a *Long May She Wave* exhibition held at AIGA's national headquarters in New York City

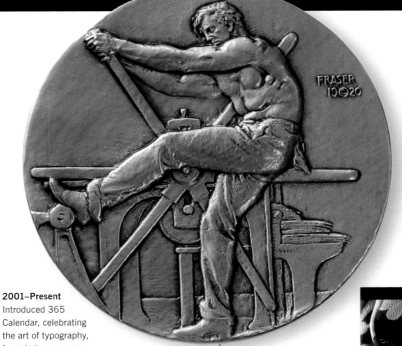

2001–Present
Introduced 365 Calendar, celebrating the art of typography, for sale in museums and retail shops

365

2004
Named a Medalist at the 90th Anniversary of the AIGA National Conference

2005
Designed *The Art of Gaman: Arts and Crafts from the Japanese American Internment Camps*, written by Delphine Hirasuna and photographed by Terry Heffernan

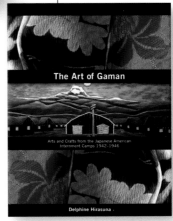

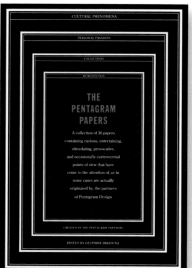

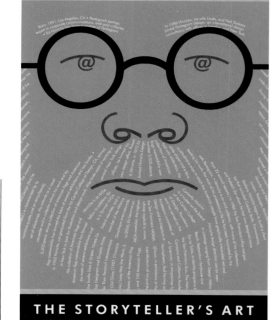

2008
Created *100 Baseball Icons* showcasing Terry Heffernan's photos from the Baseball Hall of Fame

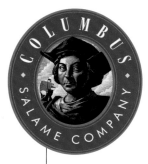

2006
Contracted by Chronicle Books to compile all Pentagram Papers to date into a commemorative book

THE STORYTELLER'S ART

2005
Commissioned by Columbus Salame to design new logo and to brand trucks, packaging and point-of-sale materials

2008
Honored with a retrospective exhibition at Sacramento State University and ArtCenter College of Design

2005

DESIGN WITHIN REACH

2005
Developed brand identity and catalog design for the launch of Design Within Reach

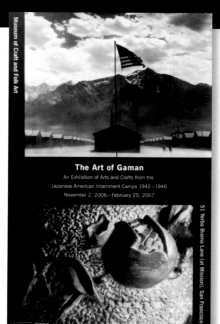

2006–2013
Designed the first exhibition of *The Art of Gaman,* which toured art museums in 15 cities in the U.S. and Japan

2005
Redesigned brand identity for the University of California, Riverside

2008
Created an exhibition of Tom Geismar's robot collection at Seattle's EMP Museum

2008
Created the brand identity and packaging for Fork in the Road Foods

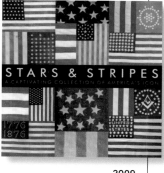

STARS & STRIPES

2009
Curated a major flag exhibition at the Nevada Museum of Art in Reno

2009
Studio Hinrichs moved from South of Market to San Francisco's historic Presidio.

2014
Harvard Business School asked us to create the book jacket for *Collective Genius*, a study of innovative firms, including Pentagram.

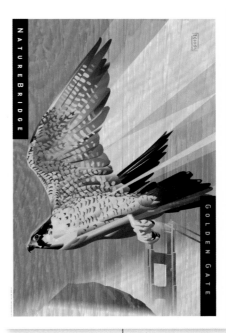

2013
Launched *Obsessions*, a series of small books on topics that arouse passion, created in partnership with Delphine Hirasuna

2016
The Kauffman Center commissioned us to design a book about their Kansas City-based performing arts center.

2017 Given Lifetime Achievement Alumni Award by ArtCenter College of Design

2018
Developed a series of original art posters to raise funds for NatureBridge's national park programs

2018
Organized ephemera exhibition, *Flags on Paper,* at the San Francisco Center for the Book

 2010 **2018**

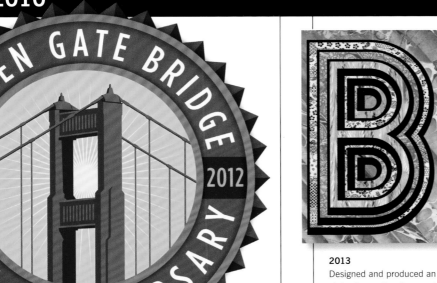

2013
Designed and produced an alphachrome typeface and card set for retail sale

2018
Created brochure for Sappi Paper that challenged myths about coated and uncoated papers

2012
Developed the branding program commemorating the 75th anniversary of the San Francisco Golden Gate Bridge

2013
Curated the *Long May She Wave* exhibition at Frazier History Museum in Louisville, KY

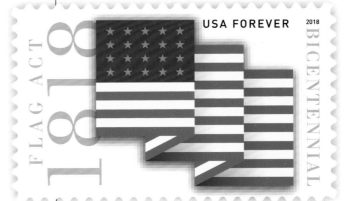

2018
Commissioned by the United States Postal Service to create a commemorative stamp marking the 200th anniversary of the Flag Act of 1818

2018
Commissioned to develop *Verticals*, a promotional series on Sappi Paper's vertical markets

2018
Designed "111 Thursday Night Dinner Menus," a book celebrating the menus of spectacular Thursday night dinners for Mary Austen

2018
Honored with the Ladislav Sutnar Prize by the Artistic Board of the Ladislav Sutnar Faculty of Design and Art in the Czech Republic

"LIVE YOUR LIVES BOLDLY, KEEP THE DOORS OPEN FOR OTHERS!"

A FILM OF THE EXTRAORDINARY LIFE OF
MAYOR ED LEE
SAN FRANCISCO'S MAYOR FROM 2011-2017

2018
Branding for the Partnership for the Presidio's "Tunnel Tops" park program

2019
Documentary film poster to honor Mayor Ed Lee for Chinese Historical Society of America and Rick Quan

2018
Identity for the Red Bridge Group in San Francisco

AMERICAN ICONS
TERRY HEFFERNAN

20 TYPEFACES FOR 2020

2018
Engaged by the Museum of Craft and Design to design a uniform look for their exhibition catalogs

2019
Developed a legacy book celebrating photographer Terry Heffernan

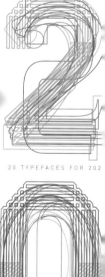

2018
Commissioned by Chronicle Books to create a package of memorabilia celebrating San Francisco's iconic cable cars

2020
Continuing poster campaign for San Francisco Antiquarian Book Print and Paper Fair

2020–2021
Branding for Open Philanthropy, a nonprofit foundation

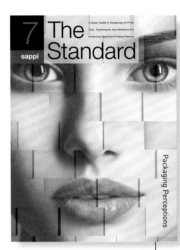

2064

2019
Moved Studio Hinrichs to a new North Beach location

2022
Created branding for Center for Architecture + Design, an AIASF nonprofit foundation

2022
Completed *Packaging Perceptions* series for Sappi Paper's Standard 7

2020

2023

20 TYPEFACES FOR 20

PARYDOX
STRATEGIES

2020
Celebrated the 20th Anniversary of the 365 Typographic Calendar

2020
Developed a branding program for Paradox, a business strategy firm

RUSSIA.
STOP THE KILLING!

2022
Created brand program for the Constellation, an entertainment/arts and technology center in Singapore

2022
Worked with Graphis to organize an international Ukrainian protest poster campaign in response to the Russian invasion

My desire in assembling this list of friends, staffs, interns, partners, business associates and design colleagues is to recognize and thank you for your help and influence you have had on me throughout my 50 years in design. I have attempted to remember all of you, but please forgive me if your name has been missed.

Partners

Lorenzo Apicella
James Biber
Michael Bierut
Robert Brunner
Theo Crosby
Alan Fletcher
Colin Forbes
Michael Gericke
Kenneth Grange
Fernando Gutiérrez
Peter Harrison
Luke Hayman
David Hillman
Linda Hinrichs
Angus Hyland
Vance Jonson
Mervyn Kurlansky
John McConnell
Abbott Miller
Justus Oehler
B. Martin Pedersen
Woody Pirtle
John Rushworth
Anthony Russell
Paula Scher
Neil Shakery
DJ Stout
Lisa Strausfeld
Daniel Weil
Lowell Williams

Staff Designers & Associates

David Hisaya Asari
Jackie Astle
Gary Barker
Lenore Bartz
Karen Berndt
Rick Binger
Nicole Bloss
Karen Boone
Alice Bybee
Fidel Calderon
Anders Carpenter
Amy Chan
Carrie Cheung
Benjamin Chia
Belle Chock How
Amy Compeau
Anne Culbertson
Chloe Cunningham
Terri Driscoll
Rob Duncan
Nissa Ellison-Walsh
Takayo Muroga Fredericks
Sarah Gardner
Susan Grabicki
Clive Hacker
John Hanusek
Paul Hardy
Tanya Hernandez
Gloria Hiek
Judy Hsu
Brian Jacobs
Jacqueline Jones
Natalie Kitamura
Casey Kiyohara
Nancy Koc
Zoey Li
Peter Lim
Lorraine Louie
An Luc
Anita Luu
Julio Martínez
Charles Mastin
Sandra McHenry
Catherine Messina
Piper Murakami
Myrna Newcomb
Colleen Newland
Dang Nguyen
Mary Powers
Kashka Pregowska
Michele Ronsen
Teri Roseman
Jessica Rosenberger
Ryan Scher
Erik Schmitt
Laura Scott
Vered Shapira
Christy Silva
Maria Wenzel Stanford
Stephanie Steyer
Leslie Loftus Stitzlein
Deborah Taffler
Kern Toy
Susan Tsuchiya
Sara VanSlyke
Barbara Vick
Taylor Wega
Stephanie Willemsen
Maurice Woods
Yael McShane Wulfhart
Shirley Yee

Project Managers

Bill Baney
Madison Bencomo
Kate Bolen
Christy Brand
Diana Dreyer
Laurie Goddard
Mark Goldman
Julie Peterson Goonan
Amy Hoffman Jacobs
LuRay Joy
Gayle Marsh
Charlene O'Grady
Jon Schleuning
Sara Slavin
June Lin Umfress
Margaret Wedgwood
Adi Wise

Illustrators & Photographers

Marshall Arisman
Charles M. Ballestamon
Barbara Banthien
Bob Barner
Guy Billout
John Blaustein
Cathie Bleck
Lou Brooks
Gerald Bybee
Seymour Chwast
Jeff Corwin
John Craig
Regan Dunnick
Bob Esparza
Ann Field
Jeffrey Fisher
Vivienne Flesher
Charly Franklin
Douglas Fraser
Craig Frazier
Milton Glaser
Andy Goodwin
Martin Haake
Dan Hayes
Michael Hecht
Terry Heffernan
Ryan Heffernan
Steven A. Heller
John Hersey
Jody Hewgill
Patrick Hruby
Gerard Huerta
Henrik Kam
Lisa Keenan
Tim Lewis
Ed Lindlof
Tom Lulevitch
McRay Magleby
John Mattos
Jock McDonald
Wilson McLean
Eric Myer
Everett Peck
Daniel Pelavin
François Robert
Barry Robinson
Kim Haggin Rossi
Laurie Rubin
Douglas Sandberg
Ward Schumaker
Michael Schwab
Joshua Seftel
Elwood Smith
Nancy Stahl
Dugald Stermer
David Stevenson
Holly Stewart
Ken Thompson
Tom Tracy
Zach Trenholm
Mark Ulriksen

Jack Unruh

Rob Villanueva

Philippe Weisbecker

Jeff West

Mick Wiggins

David Wilcox

Writers & Editors

Betsy Brown

Owen Edwards

Steve Heller

Delphine Hirasuna

Rita D. Jacobs

Alyson Kuhn

Nancy Murr

Ben Peterson

Linda L. Peterson

Christine Schillig

David L. Skolnick

Printers

Cilla Bachop

Susan Rosenberg Battat

Doug Bittenbender

Matt Blanchette

Kim Blanchette

Adam Blanchette

Ken Clark

Bob DeMercurio

Chip Foreman

Tim Hamilton

Paul Harding

Jeff Hernandez

Pete Lovegrove

Ted Marston

Randy Parkes

Allen Strohmeier

Jesse Williamson

Herb Zebrack

Lori Zarate

Clients & Business Associates

Sean Adams

Deb Aldrich

Jim Allen

Ronald J. Arena

Catherine Barner

Anne Baskerville

Natalya Blumenfeld

Agnes Bourne

Greg Brandeau

Marna Braunstein Clark

Patricia Burke

Ken Clark

Rory Davis

Daniel Dejan

Alla Efimova

Laura Des Enfants

Sam & Betsey Farber

Rob Forbes

Tina Frank

Phil Gatto

Paul Gin

Joline Godfrey

Joyce Goldstein

Patti Groh

Julie Haas

Katherine Heron

Linda Hill

Joe Isaak

Jack Jensen

Nancy Johnson

Patti Judd

Kenny Kahn

Lee Knight

Peter Kuchnicki

Peter Lawrence

David Macmillan

Kirsty Melville

Greg Moore

Paul Neal

David Placek

Mary Siegrist

Jenn Stine

Kathleen Sullivan

Kathy Tierney

Tim Tobias

Emily Truelove

Dave Van de Water

David Walker

Alice Waters

Aaron Wehner

Ann Wolfe

Nika Wynnyk

Ron Young

Nina Zagat

Design Colleagues

Sang-Soo Ahn

Doug Akagi

Hans-Ulrich Allemann

Charles S. Anderson

Primo Angeli

Philippe Apeloig

Dana Arnett

Bob Aufuldish

Mary Austin

Saul Bass

Dr. Leslie Becker

Jim Berté

John Bielenberg

Bruce Blackburn

Jennifer Bostic

Michael Braley

Gaby Brink

David R. Brown

Lorne M. Buchman, PhD

Kathleen Burch

Chuck Byrne

Yves Béhar

Ken Carbone

Bill Carson

Shelby Carr

Matthew Carter

Enrico Chandoha

Ivan Chermayeff

Bob Ciano

Matthew Clare

Patrick Coyne

Michael Cronan

Bart Crosby

James Cross

Dennis Crowe

Tim Culvahouse

Richard Danne

Louis Danziger

Robert Davidson

Stephen Doyle

Andy Dreyfus

Phil Dubrow

Scott Emblidge

Manija Emran

Louise Fili

Cathy Flanders

Willy Fleckhaus

Sheharazad Fleming

Karin Fong

Tobias Frere-Jones

Christina Freyss

Stephen Frykholm

Carmen Garza

Siegfried Gatty

Steff Geissbühler

Tom Geismar

Carin Goldberg

Mark Goldman

Fritz Gottschalk

Shawn Greene

Ric Grefé

April Greiman

Bonnie Grossman

Laura Guido-Clark

Su Mathews Hale

Paul Hardy

Eric Heiman

Jessica Helfand

Karin Him

Jonathan Hoefler

Takenobu Igarashi

Mirko Ilić

Xerxes Irani

Alexander Isley

Jennifer Jerde

Beth Johnson

Joel Katz

Clark Kellogg

Ethel Kessler

Chip Kidd

Chang Sik Kim

Max Kisman

Alan Klawans

René Knip

Jerry Krauser

Deanna Kuhlmann-Leavitt

Dana Kurtzman

David Lancashire

Emily Laskin

Pum & Jake Lefebure

Anette Lenz

Jean-Benoît Lévy

George Lois

Uwe Lösch

Herb Lubalin

Ellen Lupton

Michael Mabry

John Maeda

Elan Manasse

Michael Manwaring

Dorothy Marschall

Mitchell Mauk

Bob Matsumoto

Katherine McCoy

Martha Metzdorf

James Miho

Clement Mok

Jennifer Morla

Bruno Oldani

Michael Osborne

Jordan Otis

Morrow Otis

Shel Perkins

Rex Peteet

Doug Powell

Adrian Pulfer

Chris Pullman

Dan Reisinger

Robert Miles Runyan

Stefan Sagmeister

Arnold Saks

Greg & Pat Samata

Mel Sant

Gerald Scarfe

Arnold Schwartzman OBE

Mary Scott

James Sebastian

Dick Sheaff

Tracey Shiffman

Don Sibley

Nancy Skolos

Leslie Smolan

Henry Steiner

Jennifer Sterling

Lucille Tenazas

Steve Tolleson

Jack Tom

Niklaus Troxler

Rick Valicenti

Michael Vanderbyl

Massimo Vignelli

Douglas Wadden

Carol Wahler

Jessica Walsh

Angie Wang

Michael Weymouth

Alina Wheeler

Jon Wilkman

Trish Witkowski

Fred Woodward

Richard Saul Wurman

Tamotsu Yagi

Matthew Yan

Roland Young

Neal Zimmermann

SPECIAL THANKS & CREDITS

Concept & Creative Direction

Kit Hinrichs, Studio Hinrichs

Design & Production

Dang Nguyen Chloe Cunningham

Carrie Cheung

Major Photography

Terry Heffernan

Text & Editing

Delphine Hirasuna

June Lin Umfress Kate Bolen

Introduction

Steven Heller

Publisher

B. Martin Pedersen, Graphis

Videographer

Rob Villanueva

Print/Color Consultant

Kim Blanchette

Major Typography

News Gothic MT WTC Our Bodoni

ISBN: 978-1-954632-03-5

© Studio Hinrichs 2022